Illustration for Fashion Design: 12 Steps to the Fashion Figure

Gustavo Fernandez

DISC INCLUDED

PEARSON

Prentice Hall

Upper Saddle River, New Jersey 07458

Library of Congress Cataloging-in-Publication Data

Fernández, Gustavo.
 Illustration for fashion design: 12 steps to the fashion figure / Gustavo Fernandez.
 p. cm.
 Includes index.
 ISBN 0–13–111911–7
 1. Fashion drawing. I. Title.
 TT509.F5 2007
 741.6'72—dc22

2006029313

Editor-in-Chief: Vernon R. Anthony
Production Editor: Emily Bush, Carlisle Editorial Services
Production Liaison: Janice Stangel
Managing Editor: Mary Carnis
Manufacturing Manager: Ilene Sanford
Manufacturing Buyer: Cathleen Petersen
Senior Marketing Manager: Leigh Ann Sims
Marketing Assistant: Les Roberts
Media Project Manager: Lisa Rinaldi
Senior Design Coordinator: Miguel Ortiz
Cover Designer: Linda Punskovsky
Cover Art: Courtesy of Gustavo Fernandez
Formatting: Carlisle Publishing Services
Printer/Binder: RR Donnelley & Sons

Pearson Education Ltd.
Pearson Education Singapore, Pte. Ltd.
Pearson Education Canada, Ltd.
Pearson Education—Japan

Pearson Education Australia PTY, Limited
Pearson Education North Asia Ltd.
Pearson Educación de Mexico, S.A. de C.V.
Pearson Education Malaysia, Pte. Ltd.

PEARSON
Prentice
Hall

10 9 8 7 6 5 4 3 2 1
ISBN 13: 978-0-13-111911-6
ISBN 10: 0-13-111911-7

Dedication

This book is dedicated to my parents Adalberto and Nilda Fernandez and to my companion and partner Felix Garcia. Thank you for your love and support. I thank God every day for having the three of you to share this with. I could not have done it without you. I love you.

Este Libro es dedicado a Mis Padres Adalberto y Nilda Fernandez y a mi compañero Felix Garcia por todo su apoyo y Amor. Le Doy gracias a dios cada dia Por tenerlos en mi vida y poder compartirla con ustedes. Los quiero.

Contents

Preface

The ability to draw has been the subject of debate for as long as people have been able to do so. Most people accept the theory that it is an innate ability—either you have it or you do not. As an educator, I do not subscribe to this school of thought, because I have had the opportunity to help students intimidated by the thought of taking a drawing class. I have also had countless students who put off their dreams of designing because of this very fear. This fear is made worse by the fact that the standard books and materials in fashion education assume that the student possesses a basic knowledge of drawing. As a result, this approach to fashion illustration appeals to the individual's ability to follow set rules and measurements rather than rely on visual comprehension of space and dimension. By using these instructions and the 12-step method within, anyone can create a fashion figure and begin to understand the dynamics of the body almost immediately.

Drawing clothes poses a challenge beyond that of just drawing the human figure. The great masters such as da Vinci and Michelangelo studied the properties of gravity and light and their effects on fabrics. Today we must take from their studies and short hand what they uncovered to accommodate for this fast-paced industry. By using lines and arrows we can put in place a method to understand fabrics and garment construction better and more quickly.

Markers provide a quick source of color for designers and when used properly can prove to be a very pleasant medium to work with. They make rendering fabrics easy and offer a huge variety of colors as shown in the chapter on rendering. When using markers in conjunction with the methods shown, the results can be quick and accurate.

Garment construction is the framework of every design. By placing stylelines on the fashion figure as they can be found on dress forms, the designer can complete the design and make it ready for construction as it appears on paper. This book can aid in creating beautiful art as well as in creating designs that can actually be made and function while remaining true to the designer's original concept.

As an instructor I spent many hours searching through book after book trying to combine the best parts and offer them to my students: the children's chapter from one, menswear from another, and accessories from yet another. In truth, designers will design everything from purses to children's wear. This book is my attempt to help the designer lay a foundation from which creativity can develop and flourish in every area of fashion design.

In this age of technology we easily delegate our shortcomings to computer programs that homogenize art and try to equate the click of a mouse to the masterful stroke of a brush, but in reality machines are no match for human emotion. This emotion starts as an idea that flows from the brain through the hand and with little more than a pencil to aid it manifests itself on paper. It is at this quintessential moment that a designer is at his or her very best.

One of the main objectives of this book is to give precise, reliable instruction to promote confidence and creativity.

Acknowledgments

This book is the culmination of 11 years of research and instruction. I would like to thank first all of my students for their challenges and questions. I hope I have answered them all for you. I would also like to thank Vern Anthony of Prentice Hall for this incredible opportunity. Ida Thomshinsky for believing in a young instructor and recognizing my efforts. Special thanks to the following reviewers: Sephia Asmar, International Academy of Design and Technology, Tampa, FL; Merissa Turner, Art Institute of Design, Vancouver BC;

Gwendolyn Lewis Huddleston, Art Institute, Los Angeles, CA. Irina Ivanova, the Art Institute of Fort Lauderdale, Miami Beach, FL; Donna Sapp, The Art Institute of Dallas, Ft. Worth, TX; Michele Wesen Bryant, FIT, New York, NY. To David Bercuson and Janet Hernandez for all the legal help. I would also like to thank Erick Cornish, Rick Zacikowski, John Hyun, and Daniel Gonzalez for all your work on the CD-ROM. I would also like to thank Janice Stangel and Mary Carnis at Prentice Hall and the incredible team at Carlisle Publishing Services for their hard work in putting this book together—in particular Emily Bush.

Gustavo R. Fernandez

Foreword

I have had the pleasure of teaching with Gustavo Fernandez for the last five years at Design and Architecture Senior High School in Miami, Florida. We work together teaching senior fashion students for a semester of Fashion Design and Fashion Illustration.

I am so pleased that Gustavo's book is to be published because I know, with my 26 years of experience teaching Fashion Design and Fashion Production, that his method works.

I watch Gustavo skillfully demonstrate his twelve-step technique to students that have minimal drawing skills. Within six classes, they can successfully draw and dress a fashion figure. By the middle of the semester, they can draw several different poses and render fabrics realistically using design markers. By the end of the semester, they produce professional looking presentation boards, complete with mood boards, color stories, fabric swatches, flats, and elegant fashion figures in a variety of poses.

Using these skills, students create presentation boards and build portfolios that lead to acceptance at the most prestigious and competitive fashion design schools nationwide and internationally, including The Fashion Institute of Technology and London School of Fashion.

My students and I are anxiously awaiting this book. We know it will be a comprehensive guide to successful fashion illustration.

Rosemary Pringle
Fashion Design Program Head

Introduction

SUPPLIES AND MATERIALS

The tools chosen to draw ideas are crucial to the outcome of the creations. Artists prefer a variety of materials for different reasons. In this chapter you will find discussion of the materials needed in order to follow the step-by-step instructions in this book. These recommended supplies may vary in brand names, but the tools themselves must be the same or similar.

Artists and designers must find the materials appropriate for their work and individual styles. However, remember that time is always of the essence when it comes to design, so choose art supplies that will facilitate the best results in the least amount of time.

PENCILS

Graphite pencils are suggested for preliminary or rough sketches. However, any drawing pencil will do. Many brands and densities of lead are available. Testing the pencils before purchasing them is recommended. If you tend to be heavy handed, a harder lead may be better for you. A lighter lead is suggested if you are light on your paper. For beginners, one good pencil will suffice. It is not necessary to get sets of pencils unless full pencil illustrations are desired.

ERASERS

It would appear that choosing such a seemingly unassuming tool would be of no consequence. However, this may not always be so. When choosing an eraser, consider the paper you will be using and the type of pencil you will use. Although erasers vary from removable tip type to battery powered, revolving, and hand-held apparatuses, the best, and the only one recommended in this text, is the kneaded eraser. This pliable puttylike mass does not disintegrate into messy flakes; instead, it cleans a surface without destroying it. This particular type eraser can last years and is cleaned by simply kneading out the graphite.

RULER

Some type of ruler is needed. A plastic see-through ruler with clearly visible measurements is recommended. The ruler should indicate six-tenths of an inch and distinguish measurements by varying thicknesses of the lines.

TRACING PAPER

An artist will probably use more tracing paper than any other type of paper. Overlaying your own work to achieve the perfect image is an important part of the creative process. Overlaying is putting paper over paper in order to choose the best lines and transfer them to achieve a more finished clean outline. Many unsuccessful attempts may be discarded before the drawing is ready to be transferred as a final design. Tracing paper provides an inexpensive alternative to working on more expensive paper until the work is ready to enter its final stages of color application. Finished work should never be presented on tracing paper; it does not receive color well and tends to smudge easily.

MARKER PAPER

Translucency is the main difference among most brands of marker paper. The heavier types absorb color well but may not be as good for grading color with a blender. They also are not good for working on both sides of the paper. Beinfang translucent marker paper is good, sturdy paper that can absorb a lot of color and will reduce bleeding. Bleeding means color spreading on the paper. However, these qualities may make it unacceptable for presentations because colors may change depending on the surface on which it is used. This problem is easily overcome by simply double mounting your work first on a white paper, such as Bristol, and then transferring the drawing itself.

MARKERS

Pantone Tria System Markers are the first choice for markers. They provide good color and the triple tip provides optimum flexibility.

BLENDERS

Blenders are colorless markers that smooth streaks and blend colors seamlessly.

LINERS

Black ink liners are indispensable for drawing flats and achieving a clean graphic effect on your artwork. Most brands are acceptable; however, be sure that whatever brand you decide to get has liners available with varying thicknesses such as tips 005–07. Most liners will run if the paper becomes saturated.

COLOR PENCILS

When choosing color pencils, look for a set with colors that closely resemble your markers. Because pencil is used mostly to enhance and bring out details, rather than as a base, it is important that the markers and pencils not clash. The most widely used color pencils are oil based, and they are also the ones recommended in this book. Smudging is never a problem. Once the pencil color is applied to a surface, there is a limit to the amount one can layer before the marking becomes slick and resistant to further application.

CHAPTER 1

The Body

In order to best illustrate fashion, a designer must capture the best attributes a garment has to offer. Using a good croquis provides the proper venue to do so. Although some people prefer to draw on a flat frontal view of the body, this does little to convey the mood of a collection. The best way to present a garment is to use a three-quarter view of the figure. This will enable you to see the front, the side, and a bit of the back. The three-quarter-view figure, which is shown in the accompanying diagram, does just that. It combines a three-quarter stance with a true contrapposto position (weight on one leg), and, as is customary in fashion design, a pelvic box thrust, which allows the fabric to drape properly and uninterrupted. Other positions can be used successfully and are necessary for composition. This, however, is the most basic and frequently used pose.

When teaching to draw and use the figure, the most commonly used method is the 8 1/2 head method, which creates a variance in size according to the individual perception of large or small. To use the 8 1/2 head method, begin by focusing on the size of the paper. Set measurements will help you to appropriately use the available space of the paper, letting the drawing dominate the spaces so the eye does not perceive negative space. I have found that once I draw the body and begin to see the distortions of the croquis as normal, it becomes difficult to draw the human figure in its true proportions. At first, a ruler will be necessary but with continued practice, your eye will adjust, thus enabling you to use a more freehand approach. Beginners, however, do much better with structure and methodology.

In the following chapters, you will find step-by-step and comprehensive instructions for drawing the croquis, but beware, these approaches are based on measurements and not simply perception. Every step must be followed carefully and methodically in order to achieve maximum results. Fractions of a centimeter can cause distortions, so be careful. Most students using this method make mistakes because they do not properly following each step rather than because of an inability to draw. In conclusion, take your time, enjoy creating new designs, and remember, you will get out as much as you put in.

Here we find three sizes to the figure. It is important to use a size that is proportionate to the size of the space in which you are placing the figure as well as to accommodate the number of figures that are included in one composition. Much empty or dead space on a paper may diminish the impact of a good drawing. Use any of these predetermined sizes to complete the following 12-step exercise. You may also select your own figure size. Each of the following steps provide key points that are necessary to follow in order to be successful at this process.

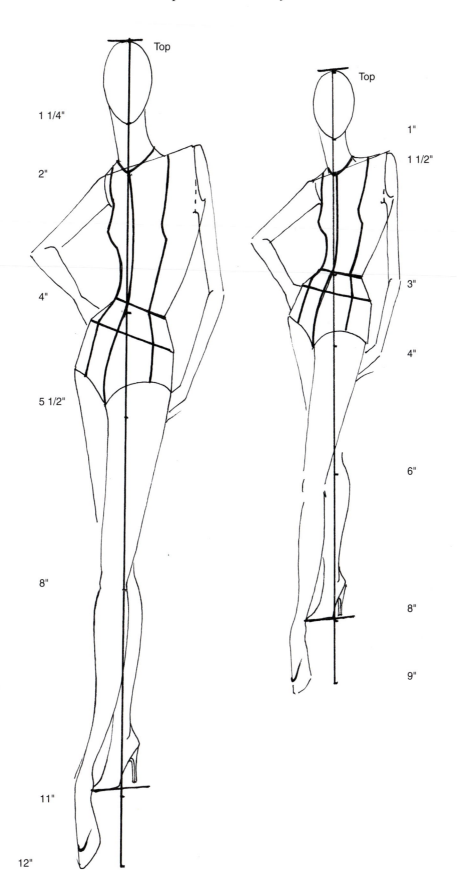

Top

1 1/4"

2"

4"

5 1/2"

8"

11"

12"

Top

1"

1 1/2"

3"

4"

6"

8"

9"

The 12 Steps

Follow each step carfully, because every step directly affects the outcome of the next. Take your time and move on to the next step only when you are sure you have successfully completed the one you are working on. Use a ruler only where reffering to a specific measurement. Using a light, sketchy line when drawing the rest of the body will give a more natural and less mechanical outcome.

Step 1: Plumb Line

Create a plumb line. The plumb line is a straight line in the figure from the pit of the neck to the center of gravity on a true contrapposto pose. The position of this line will always hit one foot at the bottom leaving one leg to move freely as is the case in the accompanying diagram. It is very important not to mistake the plumb line with the center of the body.

Step 2: Reference Points/Measurements

Use a series of predetermining reference points or measurements to fit the size of your paper (e.g., 11 1/2 × 14). These specific points are placed on the plumb line as dots. They are 1 1/4″ for the head, 2″ for the shoulder line, 4″ for the waistline, 5 1/2″ for the pelvic box, 8″ for the knees, 11″ for the back foot, and 12″ for the front foot.

Step 3: The Head

To create the head, begin with a front view of the face and head. Create an oval of equal proportions on both sides of the plumb line. *Note:* Every step from this point forward will have a direct effect on the next step. When using this method, every step must be done with great care so as not to distort any part of the figure, which may create a domino effect.

Step 4: Shoulders and Waist

Step 4 is best done in two parts.

1. Draw the shoulder line. The length of the shoulder line must be equal to 1 1/2 heads in length to one side of the plumb line and must not extend more than 1/4″ past the other side of the plumb line. This is crucial in making the figure look one-quarter of the way turned.

2. Draw the waistline using half of the measurement of the shoulder line for the entire waist. Place it on the plumb line at an opposite angle to the shoulder line but using the same rule: no more than 1/4″ past the plumb line and draw the remainder to the other side of the plumb line. (Remember, use opposite angles.)

Step 5: Neck

Enclose the area from the head to the shoulder line. Remember that the neck comes from the sides of the head not from the bottom (see diagram). One side appears longer because one shoulder is dropped and the other side appears shorter because the other shoulder is elevated, both angle the same way.

Step 6: Closing the Torso

PART 1—To close the side of the body that shows the most contour of the upper torso, you must first understand three things: (1) the first of these shapes represents the shoulder (see diagram), (2) the second part represents the bust (see diagram), and (3) the bottom curves out to create the pelvic thrust (see diagram). *Note:* The apex of the bust must be halfway between the shoulder line (2″ mark) and the waistline (4″ mark).

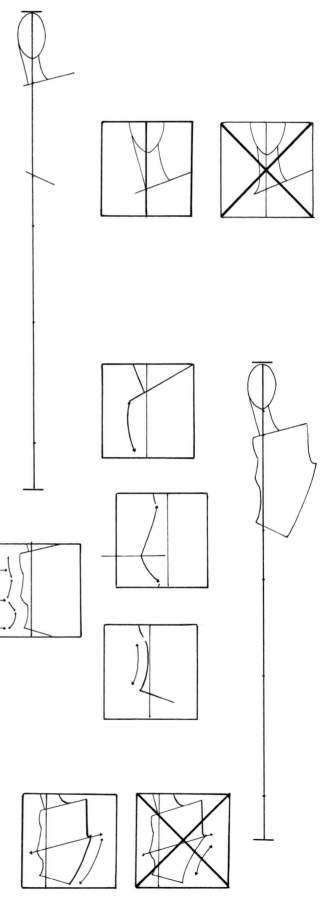

Shoulder

Bust (Apex)

Pelvic Thrust

Closing the Torso

PART 2—Closing the other side of the figure is less complex, but keep in mind one wrong curve can throw the entire figure off. Begin by drawing a straight line from the other side of the shoulder line down to the apex of the bust on the angle of the shoulder (see diagram). A small reversed "J" shape at the end will be useful. From the end of the reversed "J" shape, swing out and away from the figure causing the back to appear swayed as is needed for the pelvic thrust. *Note:* If you shape this line in the opposite way or toward the figure, the distortion will be great and you will have eliminated one-third of the body.

Step 7: Creating the Pelvic Thrust

Find a new center for the lower part of the body to create the pelvic box. To do this, go to the next point on the plumb line (5 1/2″ mark) and extend 1/4″ out to the front. Then, find the intersection of the waistline and the plumb line and, with a soft smooth curved line, connect the waist to your new mark to create a new center (see diagram).

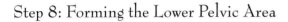

Step 8: Forming the Lower Pelvic Area

Open up the end of the pelvic area to allow a place for the legs. Use a full semicircle for the front leg and a slight "S" curve pointing high at the front for the back leg (see diagram). The full length of this shape is equal or slightly less than the full length of the shoulder. Anything longer than the shoulders will make the hips look big.

Step 9: Finding the Hip Line

Approximately 1/4″ of the distance from the top of the curved line that extends from the waist (4″ mark) to the end of the pelvic box (5 1/2″ mark), draw in a hip line following the angle of the waist with a length longer than that of the waist but shorter than that of the pelvic box (see diagram).

Pelvic opening
is too narrow

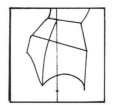

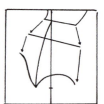

Step 10: Closing the Pelvic Box

Now you can complete the bottom half of the torso, or pelvic area. It is important when forming the pelvic area to draw straight lines. The rounder the lines are the heavier the figure will look. Straight lines will make the figure appear thin. To complete the pelvic area properly, use two straight lines, one from the waist to the hip line and the other from the hip line down to the opening for the legs (see diagram).

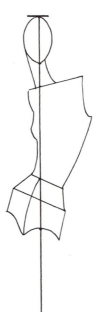

Step 11: Legs

PART 1—When drawing legs, it is best to begin by drawing a gesture line (straight line with general movement of limb) first. Then, add the general shapes to create a graceful silhouette (see diagram). *Note:* It is important with this particular pose that the back leg always remain in the same place; only the front leg can be moved.

To begin, draw a straight line from the center of the semicircle at the end of the pelvic box to an area near or on the knee mark (on the plain line at 8″ mark) and another straight line from the knee to the 11″ mark. On the pose featured here, the front leg is simply extended diagonally over the back leg. The ankle is at the 11″ mark for the front leg and the foot will extend a full inch beyond that, ending the figure at the 12″ mark.

The back leg remains the weight bearing leg. Start at the top of the other side of the pelvic box and draw a line straight toward the 8″. The front leg will, at some point, intersect or obscure some of the back leg. This will vary according to the positioning of the front leg.

Keep the center of the leg near or on the plumb line and curve the back. Refer to the chapter on shaping the arms and legs. Lastly, but very importantly, end the back leg at the 11″ mark to emphasize depth.

PART 2—When shaping the legs, begin with general shapes and curves to achieve a graceful contour. The fashion figure's proportions allow for the legs to be at least three-fourths of the height of the body. Most artists who want to exaggerate the figure do so by elongating the legs. However, as a rule, never elongate the figure from the knees up, always from the knees down. In particular, the leg should never be longer from the pelvic area to the knee than from the knee to the end of the foot. This will cause the leg to look distorted, as was mentioned previously, because most of this figure consists of legs. Good shape is important. Follow the accompanying diagrams and pay close attention to the arrows in the diagrams in order to shape the legs properly. Note that most of the shape occurs in the inner part of the leg so pay special attention when drawing in this area.

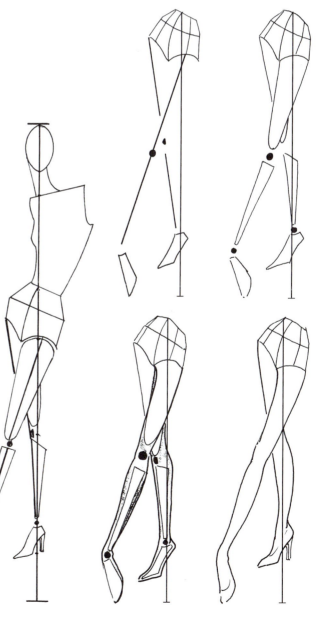

Bottom Top

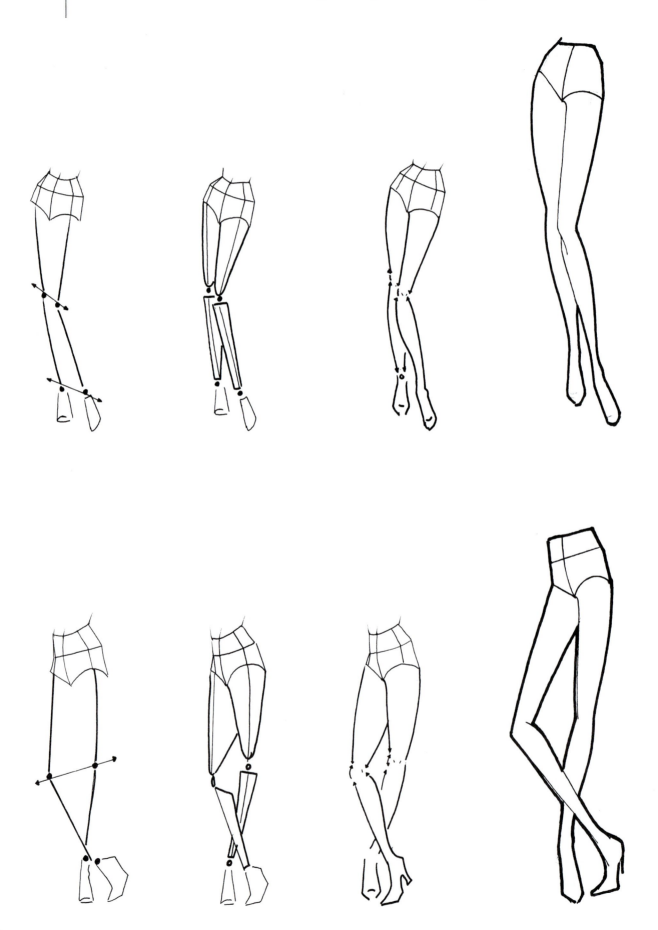

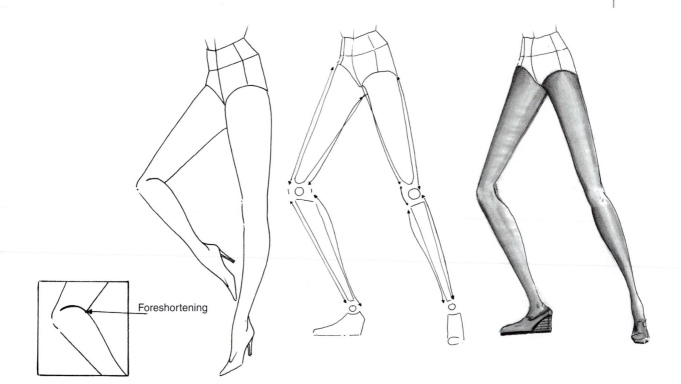

Foreshortening

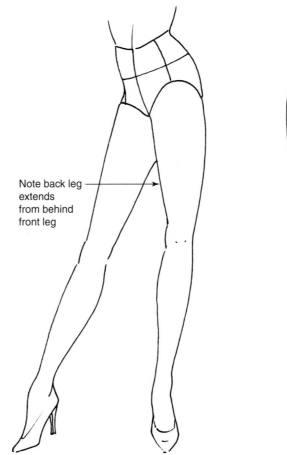

Note back leg
extends
from behind
front leg

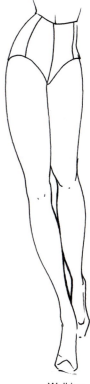

Walking

Step 12: Arms

Use the same shapes and methods to draw the arms that you used to draw the legs. The length of the arms is the crucial element to keep in mind when drawing these extremities. Start with a straight line from the center of the arm hole shape to the elbow, at that point, begin another straight line that will guide the position of the forearm to keep the arm proportionate with the rest of the body. The elbow should be parallel to the waistline and the wrist parallel to the bottom of the pelvic box (see diagram). The hand should extend beyond the wrist, allowing a 1/2″ for the palm and a 1/2″ for the fingers. (The hand is as big as the face.)

A figure with long legs must have the arms proportioned accordingly. There are many positions available for the arms; therefore, this guide may change. Like the legs, most of the shape for the arms occurs on the inner part of the arm. Do not draw extremes when shaping the arms; this may make them look too muscular. Use straight lines and smooth curves to get the best results.

Now that the figure is complete, it is important to understand that the three-quarter-view pose only facilitates the suggestion of movement for the front leg, whereas the back leg remains stationary on the plumb line below the pit of the neck. Before attempting to draw other poses, it is a good idea to master all the leg, arm, head, hand, and feet positions that can be used with this pose.

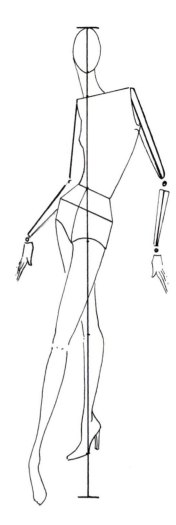

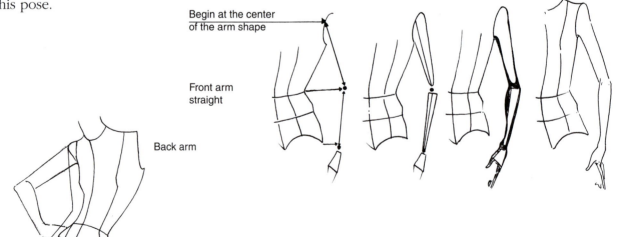

Begin at the center of the arm shape

Front arm straight

Back arm

This is a template that illustrates some of the different positions this stance offers. By using tracing paper, you can trace this figure and dress it. Remember not to move the back, as shown in heavy black line.

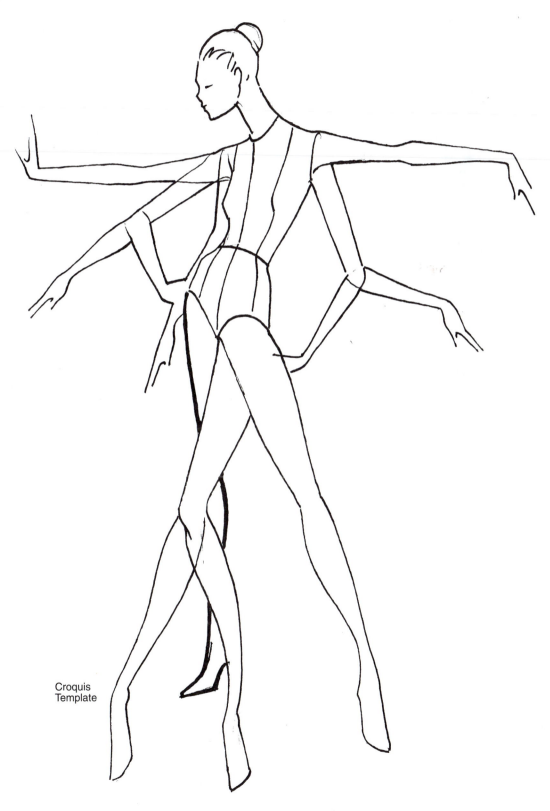

Croquis
Template

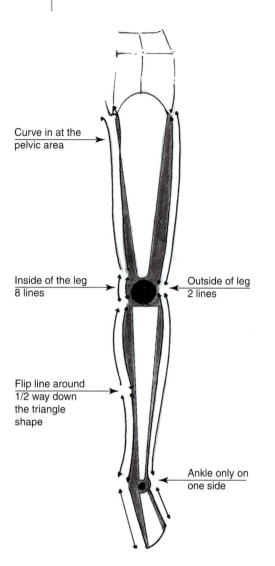

Curve in at the
pelvic area

Inside of the leg
8 lines

Outside of leg
2 lines

Flip line around
1/2 way down
the triangle
shape

Ankle only on
one side

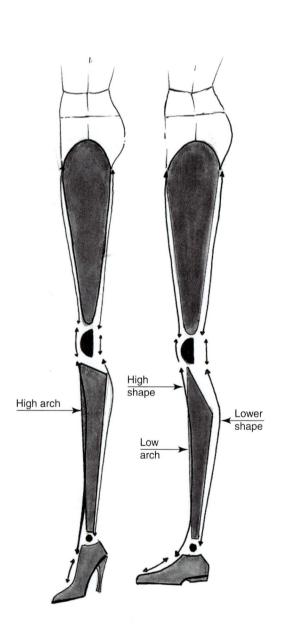

High arch

High
shape

Low
arch

Lower
shape

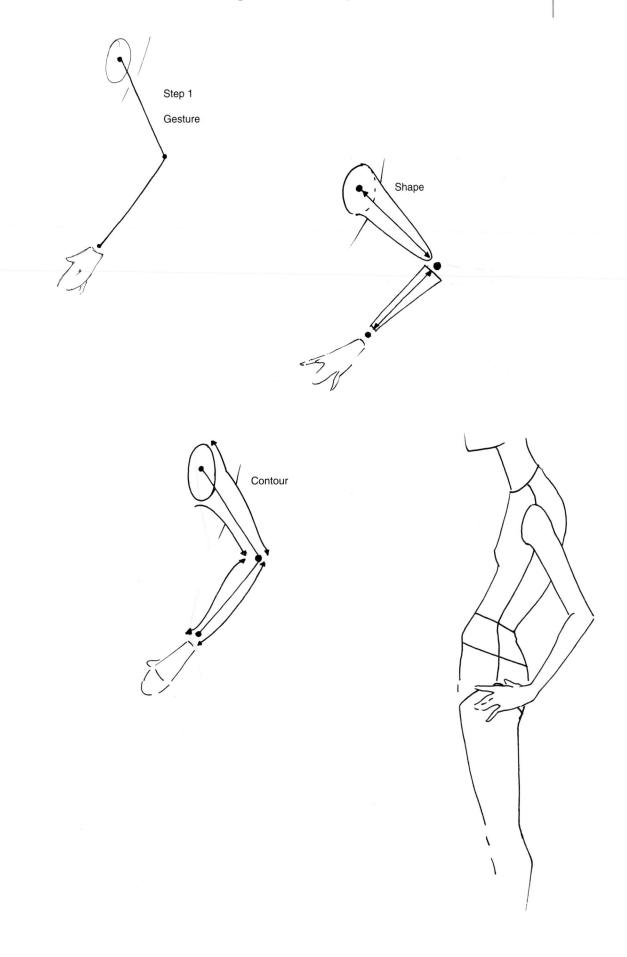

Step 1

Gesture

Shape

Contour

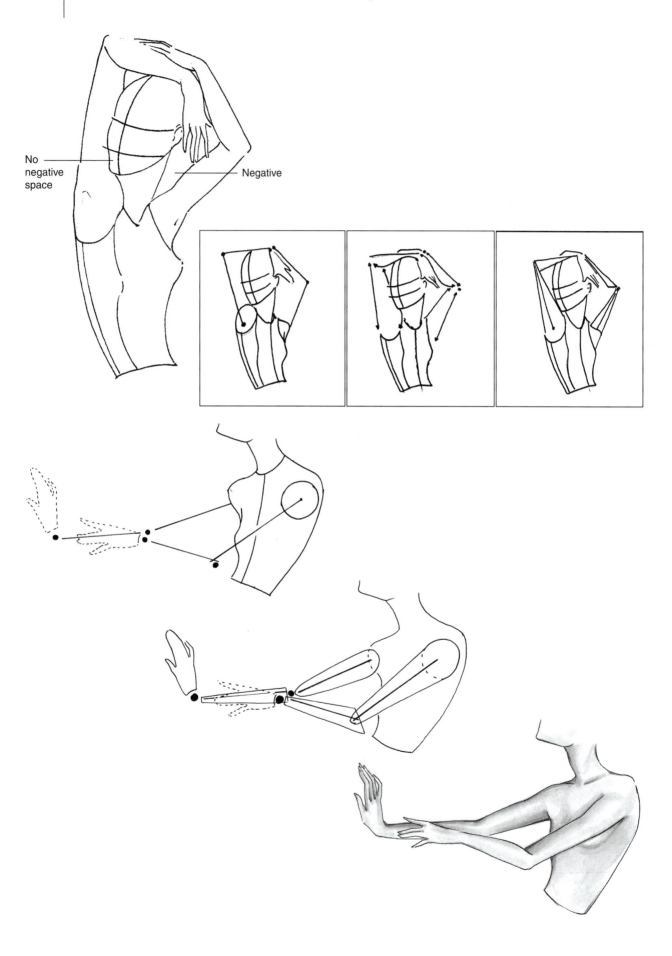

No
negative
space

Negative

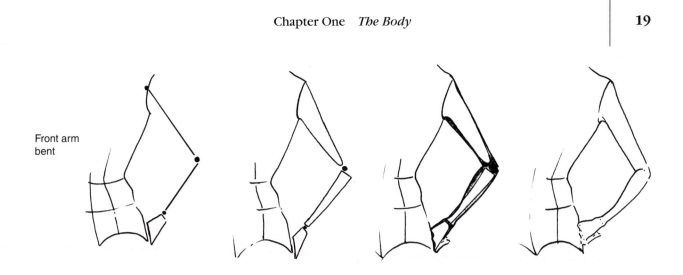

Front arm
bent

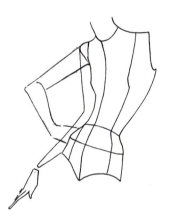

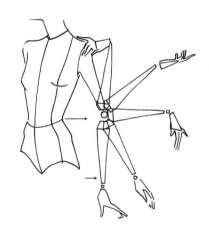

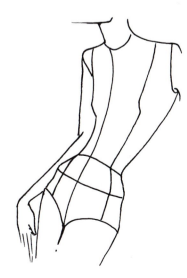

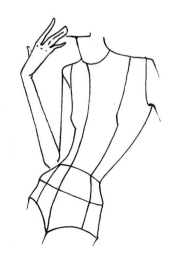

Three-Quarter-View Croquis

For a variation on the three-quarter-view pose, shift the weight to the front leg so that the back leg is free to move. Use the first six steps described earlier in the chapter to begin. The accompanying diagrams present a brief review; for an in-depth explanation of all the steps, refer to the earlier section of this chapter.

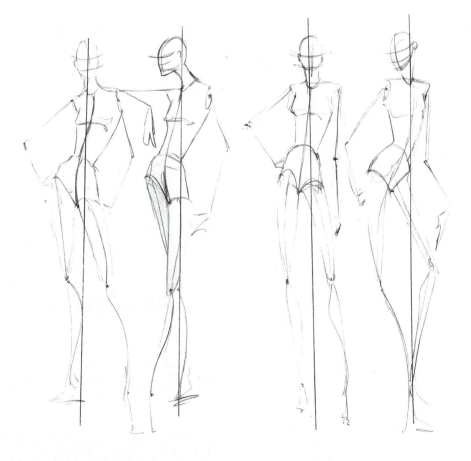

Step 7: Opening the Waist

This is the point at which the figure will begin to change. Open the waist simply by changing the angle of the waistline. Position the waist at the same angle as the shoulders. Do not attempt to make the waistline bigger or smaller; use the same size line as previously instructed. The length of the waistline is half the shoulder length.

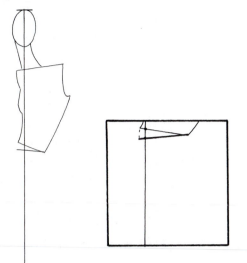

Step 8: Finding a New Center

At the marking for the end of the pelvic box, add a dot 1/4″ to the right of the plumb line. After marking that point, connect the intersection of the new waistline and the plumb line with the new point to the right of the plumb line using a slight curve.

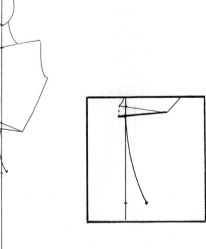

Step 9: Opening the Pelvic Area

From the newly established center, create an opening for either leg. For the front leg, draw a semicircle; for the back, an "S"-curve line pointing toward the top left corner of the page. The full length of this shape is similar to that of the shoulder line. This will ensure an hourglass figure.

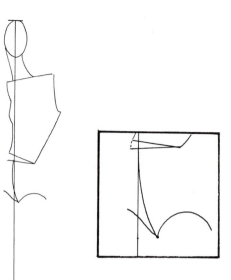

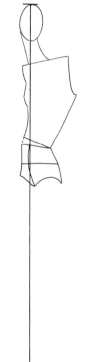

Step 10: Closing the Pelvic Box
(two-part step)

PART 1—Find the hip line. This line is located one-quarter of the distance from the waistline to the end of the pelvic box along the newly created center. The length of this line will vary for each croqui. A good rule of thumb is to keep the hip line longer than the waist but shorter than the width of the pelvic box, which is about the width of the shoulders.

Once the hip line is established, close the area on the front side using a line that comes in and goes out. This makes the right side different from the left in that it creates an indentation where the back leg comes out. This is because the back leg is relaxed. Once the front leg is under the pit of the neck, or in other words on the plumb line, we can move the back leg without affecting the balance. If the back leg is completely straight, there will be little to no indentation. This will vary from pose to pose and must be adjusted accordingly.

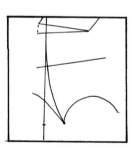

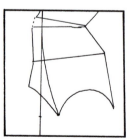

Step 11: Legs

The leg to consider foremost is the front one be-
cause this is the one bearing the body's weight.
Keep this leg on or near the plumb line. If it is po-
sitioned anywhere past the plumb line, the figure
may look off-balance. Begin by using a straight
line for the placement and shape of the leg.

The back leg can now appear to be free to
move. This leg may be longer or shorter than the
front leg, depending on its position. The pelvic
area may change slightly, depending on whether
this leg extends outward or downward. However,
use a straight line to establish its position before
attempting to shape or finalize it in any way.

Step 12: Arms

The position of the arms may vary. Use the same
rules and shapes described earlier in the chapter.
For more on shaping arms, refer to that section
earlier in the chapter.

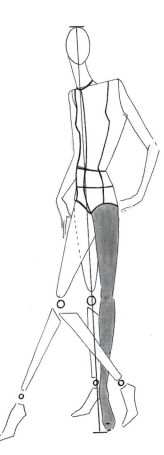

Illustration for Fashion Design: 12 Steps to the Fashion Figure

Side View

Step 1: Plumb Line

Draw a plumb line to ensure that the figure will stand properly and to establish balance.

Step 2: Reference Points/Measurements

Add reference points to the plumb line using set measurements to establish proportion.

Step 3: The Head

Choose a shape for the head remembering that the head moves independently from the body. Various shapes will work. The shape in the accompanying diagram is most conclusive for beginning a side, or profile, view. The placement is three-quarters of the way toward the front of the figure. Refer to Chapter 2 on profile view of the head for more information.

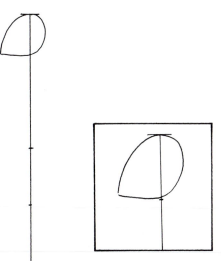

Step 4: Shoulders and Waist

Because only one arm is visible, a shoulder line is not needed. Establish the placement of the arm using an oval shape. Place the oval starting at, but not surpassing, the shoulder mark. In length, this oval should extend halfway between the shoulder mark and the waist mark.

Step 5: Waist and Legs

Place a line for the waist at or touching the plumb line. There is more flexibility to the sideview pose than with the three-quarter-view pose because the partially obstructed view of the back leg allows both legs to appear to move, no longer restricting the anchoring of one leg to support the weight. The legs may be apart to make it look as if the figure is walking, thus leaving the center of gravity in the middle between both feet as the weight shifts from one foot to the other. Be careful not to position both feet on either side of the plumb line because this may make the figure appear to be leaning or falling.

Step 6: Closing the Torso

To close the neck, draw a line from the center of the shape used for the head toward the neck mark and turn out to form the bust. The shape from the bottom of the bust to the front of the waistline will vary depending on where you have positioned the waistline.

Step 7: Closing the Back

To close the back, begin at the back of the shape established for the head and draw a line down to meet the back of the waistline. The shape of the back area may vary too.

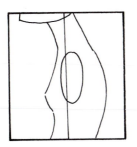

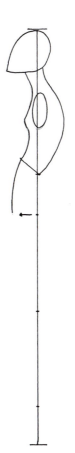

Step 8: Finding the Center

To find the center, simply draw a line from the front of the waist as shown in the diagram. In essence, this line is a continuation of the front of the torso.

Step 9: Opening for the Leg

Draw a full semicircle for the leg.

Step 10: Closing the Pelvic Box

The front was closed by finding the center of the figure in step 8. To close the back, simply close the area from the back of the waistline to the back of the semicircle, thereby shaping the backside.

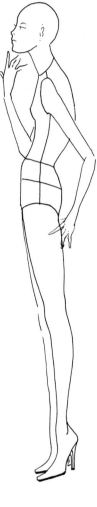

Step 11: Legs

Remember when positioning the legs to draw a straight line from the center of the leg, which emanates from the front of the semicircle used to open the pelvic area. In the side view pose, there is more flexibility with the positioning of the legs. It is worth mentioning again that both legs must not be positioned off to one side of the plumb line at the same time.

Step 12: Arms

Only the front arm will show fully. Use a straight line to capture the gesture, then, once the length and movement have been established, add shape and contour the musculature.

The back arm may come out at various points usually to the front, although the elbow may be visible at the back especially where the waistline exposes the forearm and hand.

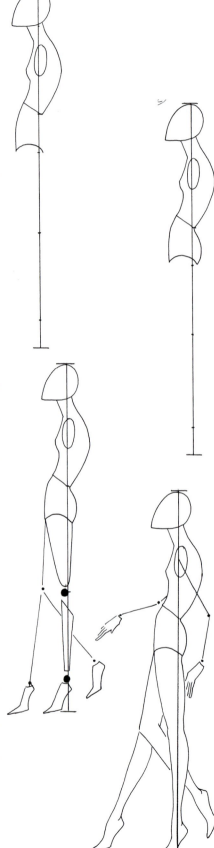

Trouble Shooting

1. Why does the neck look so long?

A long graceful neck is much more desirable for the croquis than the proportions used for drawing an actual person. However, if the distortion is too great, try some of these helpful hints. First, check your measurement. Ensure the head does not appear smaller when adding the features. Second, check the shoulder line. It must have a good angle. If it is to flat, the neck will look long.

2. Why is it that when I draw a line from the sides of the head for the neck it looks so wide?

Try using a straighter line rather than a curved line and remember to keep the width the same all the way down.

3. The shoulders on my figure look too big. How can I fix that?

It is important to know why this happened so it does not happen again. This may have occurred because the head is too wide or the shoulder line was not exactly one-and-one-half heads. However, because we started using a series of straight lines and the body is not made of lines, but rather a series of curves and contours, this area must be addressed. Follow the accompanying diagrams.

4. Why are the hips on my figure so small?

Remember that the full length at the 5 1/2″ mark to the opening of the pelvic box on the two views discussed must be the same as the full width of the shoulders. This includes the "S" curve pointing toward the top of the page and the semicircle attached.

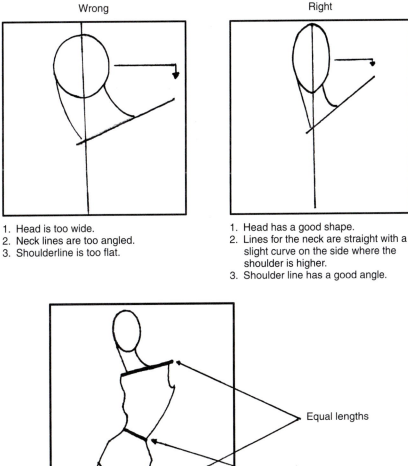

Wrong

1. Head is too wide.
2. Neck lines are too angled.
3. Shoulderline is too flat.

Right

1. Head has a good shape.
2. Lines for the neck are straight with a slight curve on the side where the shoulder is higher.
3. Shoulder line has a good angle.

Equal lengths

1/2 the length of both these lines

5. **When I swing the front leg out, on three-quarter view the back leg and hip look funny.**

The back leg does not move from its position; however, when the front leg swings forward, it causes a strain on the back leg and, in turn, it becomes shapelier. As the front leg swings back, it relaxes the strain on the back leg and gets straighter.

6. **Why does my figure look too big?**

A figure may look too big if students forget to draw the back foot higher up on the page. If both feet are even, the figure will look distorted.

7. **Is the bust too big on my figure?**

If you have to ask, the answer is probably yes. Do not draw emphasis to the bust because it is difficult to dress around a large curve. Think of the typical fashion model's physique, and work to achieve that silhouette.

8. **Why do the arms look funny?**

Length is usually to blame for distorted-looking arms. Follow the diagram on arms presented earlier in the chapter, and work to achieve the exact measurements as set by the reference points. Then work on a good shape.

9. **What can I do if I am having trouble shaping the pelvic box?**

Check three areas. First, the waistline should be exactly half the width of the shoulder line. Second, make sure the hip line is exactly one-fourth of the distance from the new center line, for which you should have come out 1/4″ at the pelvic mark to the bottom of the pelvic box. Third, examine the openings for the legs at the bottom of the pelvic box to ensure that the width of this whole shape is about the same as that of the shoulder line from one end to the other and at the same angle of the waist.

10. **When I try to change positions the figure appears to be falling.**

This almost always happens because of moving the wrong leg by mistake. This is very simple to check. Be sure the plumb line touches one of the two feet. If it does not, the figure will probably appear to be tipping over. On a true contrapasto (weight on one leg) pose, however, if the weight is distributed, the plumb line will end up in the center between the feet.

Style Lines

By the time you are ready to add the fashion design to the croquis, you should have a good understanding of the figure. It is important to have established, well-placed style lines or the clothes may be off-center on the figure, causing them to look awkward.

Understanding Style Lines

The seams on a dress form the style lines. They not only divide the body into quarters but also serve as the map that shows where important construction and design elements belong. Without these lines, an undressed figure cannot be referred to as a croquis. In order for a figure to be considered a croquis, it must have style lines (see diagrams). They are the single most important element for this figure and its key components. Unless you are a trained artist in figure drawing or model drawing, do not attempt to dress a figure whose style lines have not been well established.

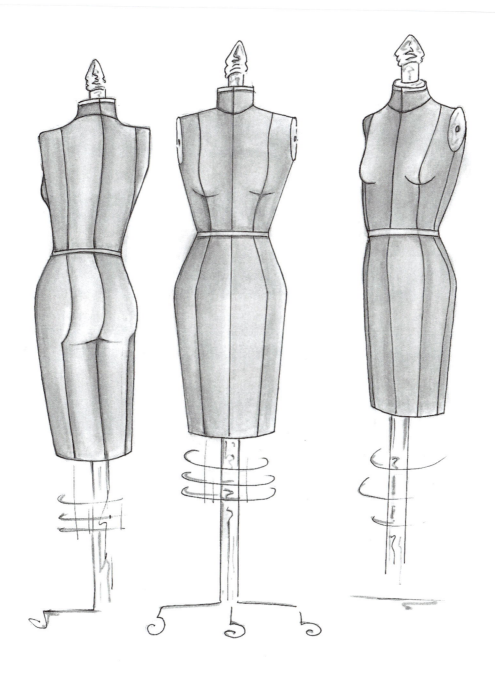

Neckline

The rounded area around the neck should reach its deepest point at the pit of the neck, or at the intersection of the shoulder line and the plumb line.

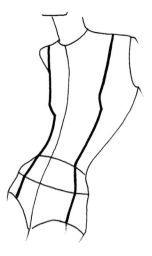

Center Line

The center line extends from the pit of the neck to the bottom of the pelvic box. This line is used for any detail that would follow the center of the body, such as button front closures on tops, waistband belts, inseams, and zippers on bottoms. These are only some of the most commonly used purposes for the center line.

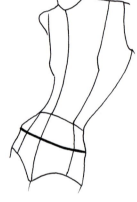

Waistline

The waistline is the dividing line between the upper and lower body. When drawing this line, it is best to curve it slightly. The highest or lowest point must be at the center front of the body. It is helpful to remember that anything that finishes at the waist or above it curves up and anything that finishes below the waist or hips curves down.

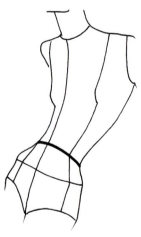

Princess Lines

Princess lines divide the body into quarters and serve as the guide to placing certain features of the garments' construction, such as darts on woven tops and bottoms, pleats, and pockets. When drawing princess lines, the side with the body's contour shows the style line slightly on the shoulder, becoming the side of the figure that shows the contour of the bust, and turning slightly forward again as seen in the pelvic area.

On the other side, place the line squarely in the center of the the shoulder using the contour of the bust for shape. It continues to the center of the waist, to the center of the hip line, and ends at the bottom of the pelvic box.

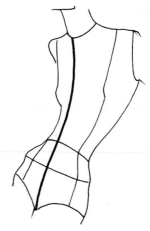

Hip Line

The hip line is one-quarter of the distance between the waist and the bottom of the pelvic box. When using the 12-step method, the hip line should already exist on your figure, as should the arm hole.

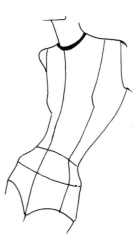

The accompanying diagrams show style lines as they appear on the body in different positions. When a designer has a good notion of construction and style lines are correctly placed, this will help the artist present the clothes in a way that is appealing to view. It is also more accurate than a simple sketch.

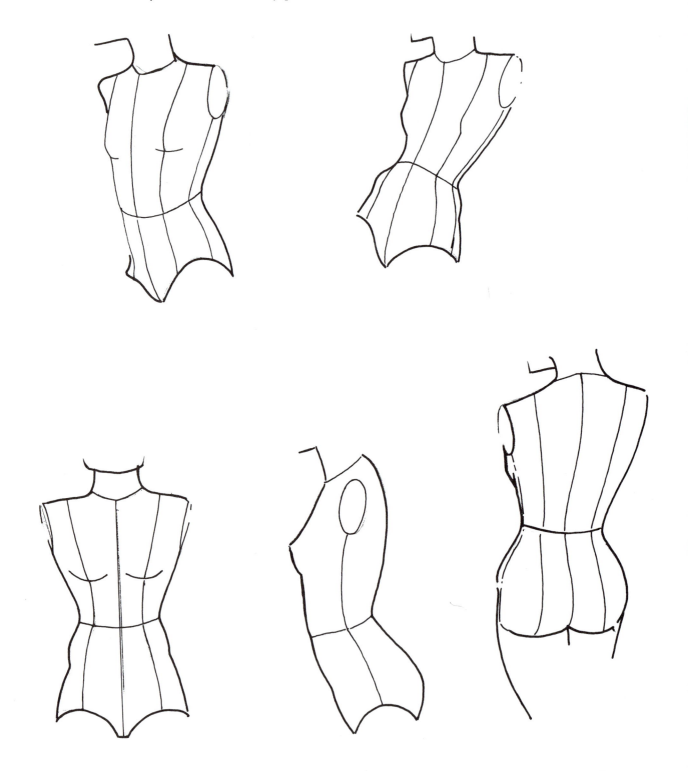

CHAPTER 2

Faces, Hands, and Feet

Front View of the Head

Step 1: Shape and Reference Lines

A. Draw an oval or egg shape using the wider area for the top of the head.

B. Then divide your shape in the middle horizontally and vertically.

One-quarter of head shape

Top

C. Once you have divided your shape into quarters, divide the bottom in half.

Step 2: Eyes

Place the eyes so that their centers are right where the triangle intersects the first horizontal line. Make sure that the distance between the eyes is one eye's width, and the distance from the outer edges of the eye's shape to the sides of the head is half of the eye shape (see diagram). This helps ensure proper positioning.

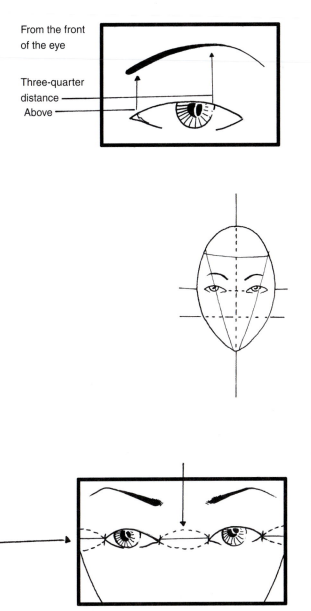

Step 3: Eyebrows

Placing and shaping the eyebrows can be crucial in giving expression to the face. Shaping them oddly or placing them in peculiar positions may make the figure look mean, angry, or sad. To properly place the eyebrow, begin directly above the front of the eye. How high up is entirely up to you, but it is preferable when drawing women to use a thin, high arched brow to give a feminine look. Arch the eyebrow to the outside of the center of the eye or three-quarters of the way to the outside of the eye. Keep the brow high off the eye because dropping the brow too close to the eye may create a masculine look. (See the accompanying diagrams.)

Step 4: Nose

The nose is the simplest of the features to draw. The only thing to remember is to use the proper shape (see diagram). The actual shape of the nose is determined by shading and not necessarily by a line. The placement of the nostrils, represented by small dashes, should be near the horizontal line that divides the bottom part of the head and on either side of the plumb line or center line. Place the nostrils above this point but not below. The width of the nose is determined by how far apart the nostrils are.

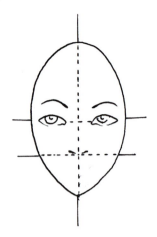

Step 5: Mouth

Place the mouth directly under the nostrils. To determine the length of the mouth, draw diagonal lines from the outside corners of the eyes to the chin (see diagram) or extend the lip line over the existing triangle shape as it appears on the example. *Note:* at this point, erase the two sides of the triangle and curve the top of the triangle to create a hairline.

Once you have finished with the front facial features, add the ears. They extend from the horizontal line dividing the head in half to slightly above the second line which divides the oval horizontally. Make the ear wider on top coming in diagonally.

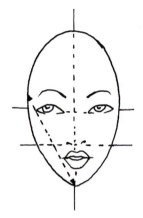

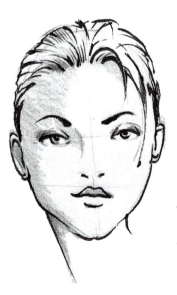

Three-Quarter View

Step 1: Shape

The shape of the three-quarter view is the same shape as would be used for the profile. However, it is divided differently, and it is placed on the plumb line in a slightly different position so the neck does not seem too long.

Step 2: Dividing the Shape (Guidelines)

First, divide the shape in half horizontally, then divide the bottom section in half. To find the center of the face, use the same line and angle of the outer edge—the one on the left of your shape. This will vary depending on how much or how little can be seen of the contour side and how turned the face is.

Step 3: Facial Contouring

On the top section, make an indentation for the brow and eye socket. On the middle section, extend out for the cheekbone. And for the bottom section, continue diagonally toward the center line of the face leaving some space to shape the chin.

Step 4: Adding the Features

The top horizontal line indicates the placement for the eyes. (Refer to shaping the features for the front view of the eye.) The lower line provides a good reference for the nose, using a circle as is done on the profile view. Determine the placement of the nose. (Refer to shaping the features for the front view of the face.)

Step 5: Shaping the Face

Most of the shaping of the face should be done at the jawline and the back of the head. This may vary according to each individual's taste.

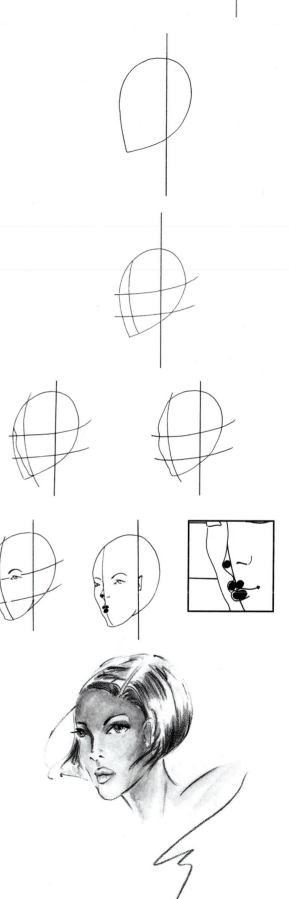

Profile View

The shape used to form the profile view of the head can be referred to as a perfect teardrop shape. Its position on the plumb line is important. When working with the profile, it is best to position three-quarters of the shape in front of the plumb line directly over the shoulder. It can be positioned to appear as if looking straight across or slightly downward (see diagram). Positioning and shape of the profile view is of absolute importance in keeping the rest of the steps uniform.

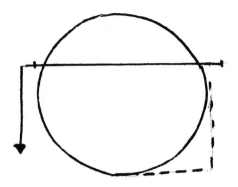

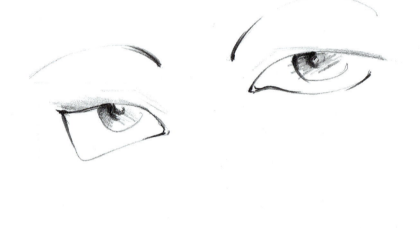

Step 1: Shape

If you are having trouble drawing the profile head shape freehand, try drawing a circle first and adding a corner in order to create a working plan (see diagram). Place the shape three-quarters of the way past the plumb line or divide the shape vertically three-quarters on one side and one-third on the other.

Step 2: Dividing the Shape

Divide the shape horizontally in the center, then divide the bottom portion in half with another horizontal line.

Step 3: Finding the Features

Before drawing in the contour of the face, place some circles to guide the placement of the different features. The first of these will represent the tip of the nose. This circle must be placed in the area between the top horizontal line dividing the shape in half and the second line dividing the bottom half into quarters. Then using two more circles for the lips, place one directly under the second horizontal line for the top lip and another circle placed slightly under the First (usually back from the first) as shown on page 42.

Step 4: Shaping the Profile

Now is the time to make this shape into a face. First, go to the horizontal line that divided the shape in half. Make an indentation for the bridge of the nose, and then extend the line out toward the first circle and around that shape to form the upper part of the nose. Next, sketch from the nose circle shape straight to the intersection of the lower horizontal line. This completes the center of the face. To shape the bottom half of the face, sketch a curve out on top of the first circle, creating a point. Then follow along the contour of both circles, creating the contour of the mouth. Curve back under the second circle to create a point under the bottom lip. Although this shape might seem odd at first, when all the lips are sketched in it will make a nicer profile than rounded edges. (See diagram). Once you shape the bottom lip, dip back around the back circle and back toward the corner or your shape, completing the chin.

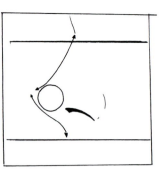

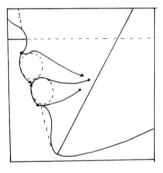

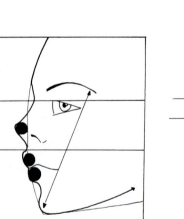

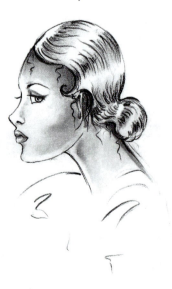

Step 5: Adding the Features

For details on adding the features, refer to the next section on shaping the features for the profile view. Remember, the outer corner of the mouth and the outer edge of the eye should align on a diagonal line. The ear should fit in the area between the top horizontal line and the lower horizontal line on or near the plumb line.

Step 6: Shaping the Head

Sketch a line from the chin toward the ear to create a feminine jawline. Using a square jawline tends to present a masculine appearance. The back of the head should be shaped mostly in the area between the two horizontal lines by bringing the line for the nape of the neck toward the ear.

Shaping the Features

Eyes

In order to properly shape the eyes, it is important to understand the view of the face with which you are working. Then, use the corresponding views of the eyes, nose, and mouth.

FULL FRONT VIEW OF THE EYE

Step 1. Begin with the shape shown and eliminate a diagonal portion from the left and right sides of the eye. The front (inside) portion of the eye changes; the back remains the same. In this case, a small area is eliminated from the front (inside), but the entire eye is visible; this allows some shape but no real distortion (areas eliminated are highlighted in the diagram).

Step 2. In the remaining area add the corner of the eye and the tear duct.

Step 3. Add the iris and pupil. Do not use a full circle for the iris. However, using a full circle is fine when drawing the pupil.

THREE-QUARTER VIEW OF THE EYE

Step 1. Draw the shape.

Step 2. Divide the shape one-quarter of the way back on a diagonal slant. This will make the front of the eye seem shorter and wider than the back, which is longer and narrower.

Step 3. Shape the eye; add the iris and the pupil.

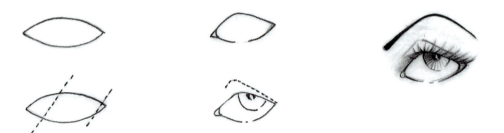

PROFILE VIEW OF THE EYE

Step 1. Draw the shape.

Step 2. Divide the shape directly in the center using a slightly arched line.

Step 3. Shape the eye and add the iris. When drawing the half (profile) view of the eye, it is helpful to create an eyelid.

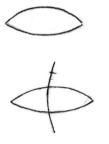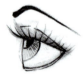

VARIATION ON EYES

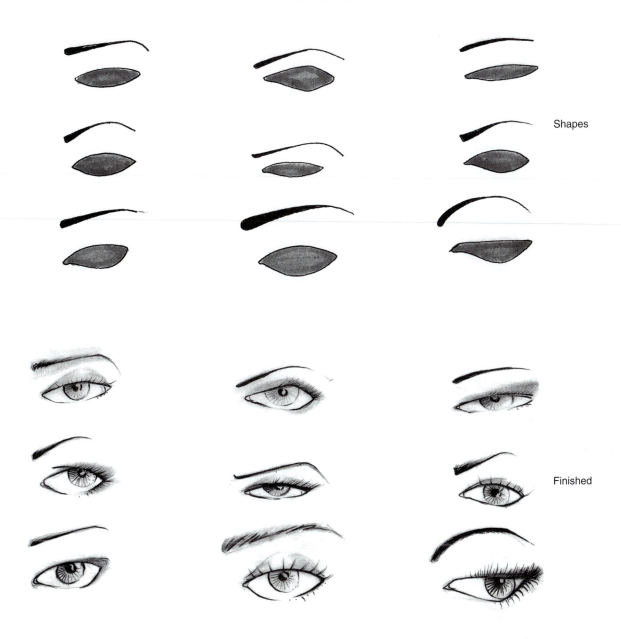

Shapes

Finished

Lips

Create the lips using a series of circles. The positioning of these circles on the lines used to divide the face will help you create the proper angle for each view (see diagrams).

FRONT VIEW OF THE LIPS

Step 1. Place the circles on either side of the center line of the face. The actual shape of the lips will be determined by the size and positioning of these circles.

Step 2. Use lines to enclose the circles as shown in the diagram. Shape may vary for different lips.

Step 3. Draw in the line to part the lips and shape.

THREE-QUARTER VIEW OF THE LIPS

Step 1. Position one of the top circles directly over the bottom one on the same side of the center line.

Step 2. Following the direction of the arrows, shape the lips by enclosing the circles.

Step 3. Part the lips and shape.

PROFILE VIEW OF THE LIPS

Step 1. Only two circles are needed for the profile view. It is best to keep the bottom lip slightly back from the top lip, so, when drawing the circles, remember to keep one in front of the other.

Step 2. Following the directions of the arrows, shape the lips by enclosing the circles.

Step 3. Part the lips and shape.

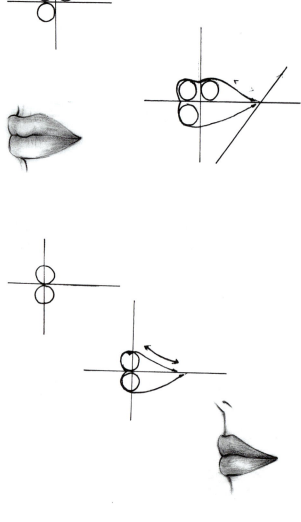

VARIATION OF LIPS

Finished

Shapes

NOSE

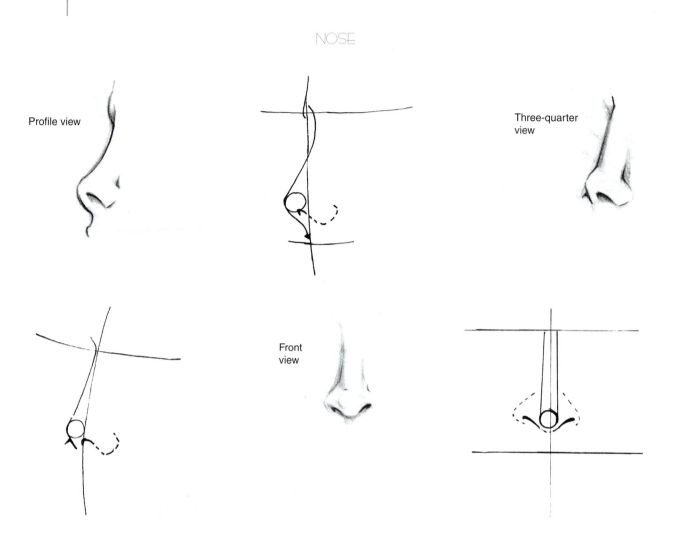

Profile view

Three-quarter view

Front view

Nose

To shape the nose, use one circle to establish the length or tip. The nostrils determine the width of the nose. The closer the nostrils, the thinner the nose; the further apart, the wider it will be. Shading and light help bring out the nose from the rest of the face. The accompanying diagrams show three views of the nose. Use them to guide you in drawing this simple feature.

Hands and Feet

Hands and feet are the most difficult parts of the body to master for most artists. This is because of the many positions and angles that are possible to use in drawing hands and feet. Also, the many bones and joints that play a part in the anatomy of the feet and hands make them challenging to master.

Many artists do not consider the feet or the hands to be important when illustrating clothes, particularly designers. However, a good designer must be capable in all areas of design, including illustration. A good idea can be lost in a bad sketch.

Good croquis are the foundations of effective sketches. Some designers choose to stylize their artwork, eliminating parts of the body. This may work for a while; however, in time, this limits the ability to create new artwork. It may also cause your work to look prematurely outdated in the ever-changing world of fashion.

HANDS—Following are important points to remember about drawing hands.

1. The palm and fingers are even in length.
2. The thumb extends halfway up the index finger.

3. Rarely are five complete fingers shown unless the hand is in a full frontal position. It is best to concentrate on the shape the hand makes and then divide that shape to form the fingers.

The accompanying diagrams show how to draw a variety of positions for hands. Carefully follow each step to achieve the best results.

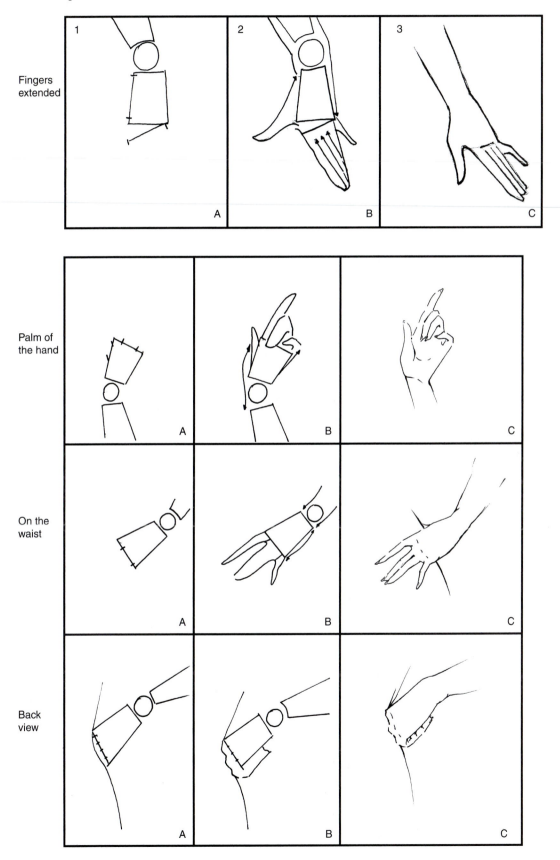

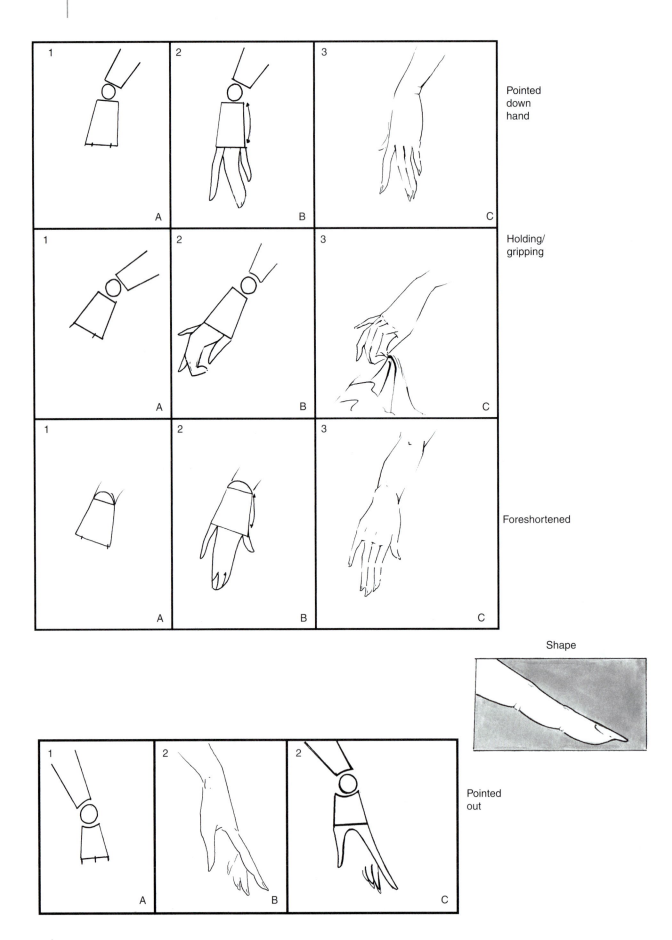

Pointed
down
hand

Holding/
gripping

Foreshortened

Shape

Pointed
out

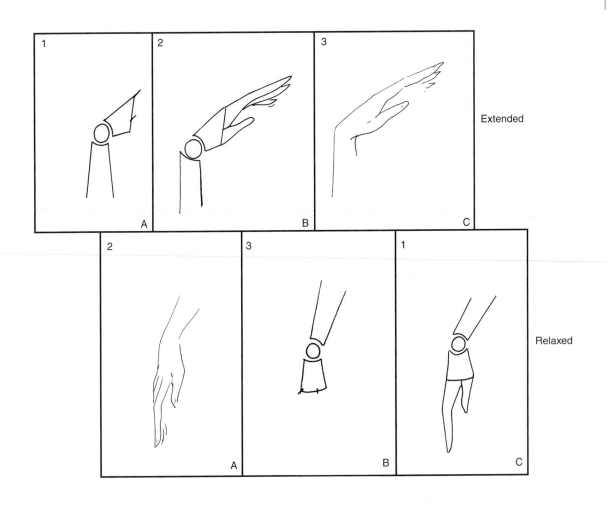

Extended

Relaxed

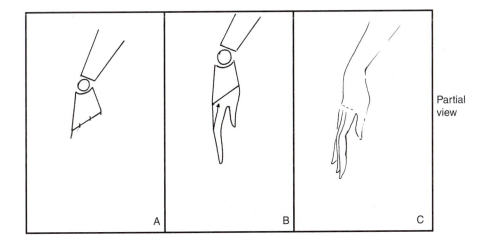

Partial
view

FEET—As with the hands, shapes are the easiest way to begin when drawing feet. First, examine the accompanying diagrams with the shapes. Follow the arrows to transform the foot as shown on the diagram of the clock. Notice that once you can achieve a full rotation of the foot, almost any pose is possible.

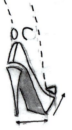

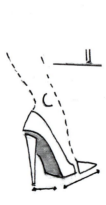

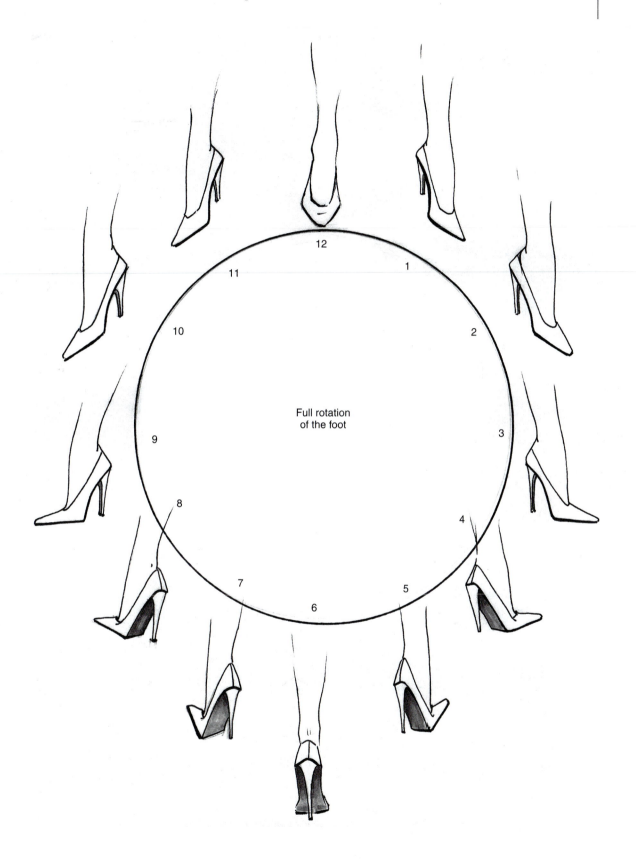

Full rotation
of the foot

BARE FEET

Drawing bare feet can become complex because of all the bones that make up the foot. Here are some angles that can prove to be helpful when drawing bare feet.

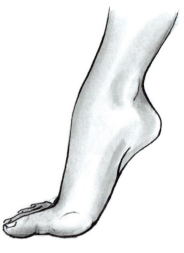
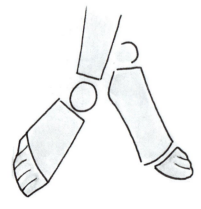
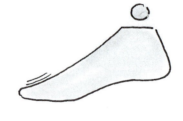
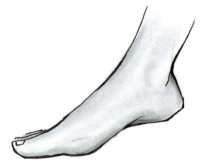
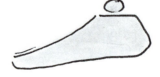
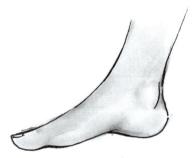

Hair

Hair styles change almost as quickly as fashion does and they certainly help complete a look. Some artists think hair is difficult to draw because they cannot separate what the eye sees from what the mind knows. The mind knows hair to be individual strands but looking from even the closest distance, a mass of hair is perceived by the eye as shape, color, and lights, and that is the premise of drawing good hair: Let your eye guide you.

1. *Establish shape.* What shape is the hair taking as a mass around the face?

2. *Present texture and light.* Is the outline, bumpy, wavy, and so on?

3. *Shape the strands.* Hair will always catch light in the center of a particular strand; the direction of light is irrelevant at this point.

COLOR—Always shade top to bottom and bottom to top as shown on the diagrams. Do not attempt to shade hair before it is shaped and separated into strands. Use color pencils or markers. Straight hair looks smoother but still should be separated into strands because it may change directions without causing the outline to change as in the case with layers. These strands are the very guide for adding light in the proper areas for the desired finished look.

HAIR SHADING

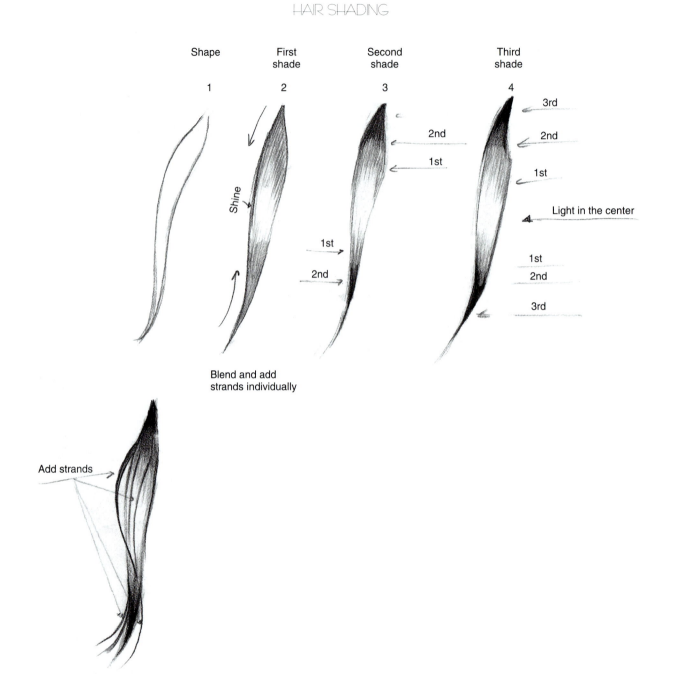

Shape
1

First
shade
2

Second
shade
3

Third
shade
4

Shine

3rd

2nd

1st

2nd

1st

Light in the center

1st

1st

2nd

2nd

3rd

3rd

Blend and add
strands individually

Add strands

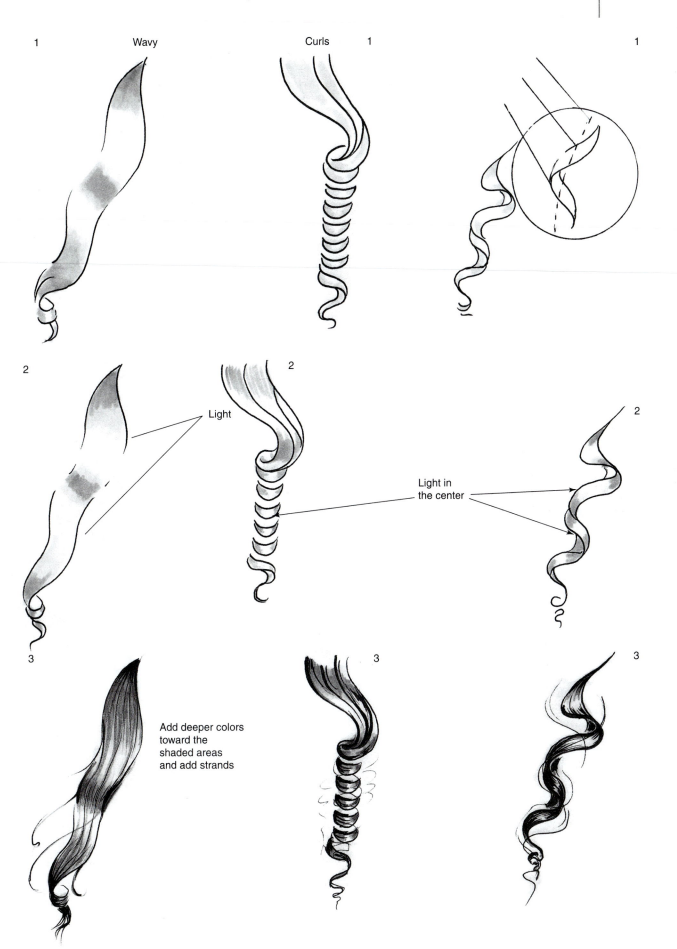

1 Wavy Curls 1 1

2 Light 2 2

Light in
the center

3 Add deeper colors
toward the
shaded areas
and add strands 3 3

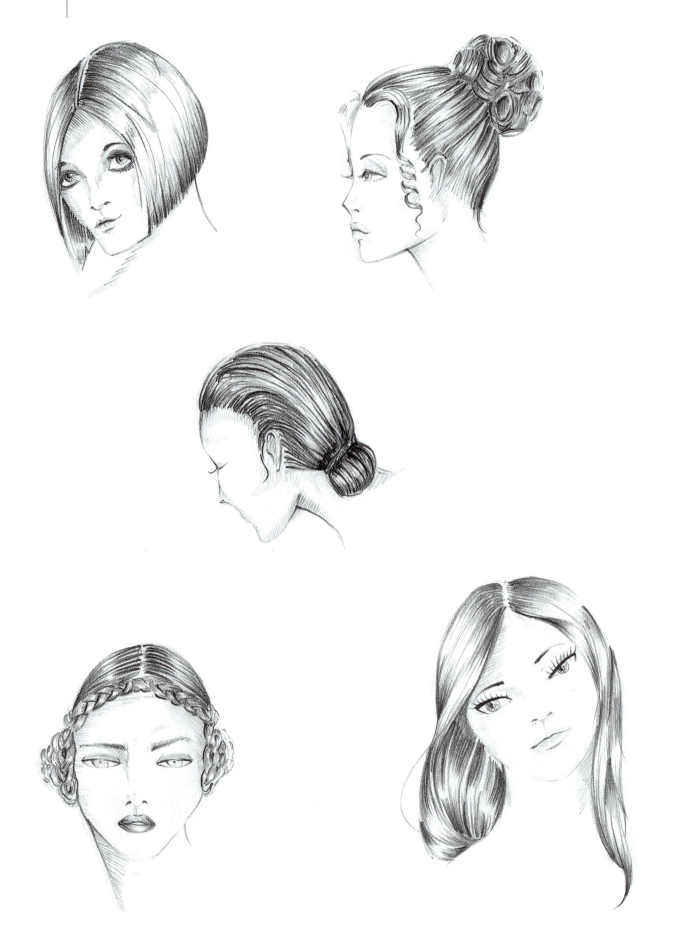

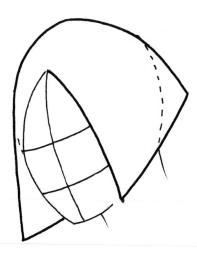

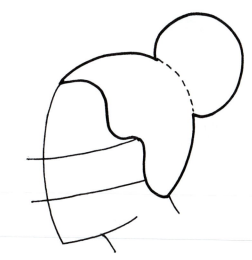

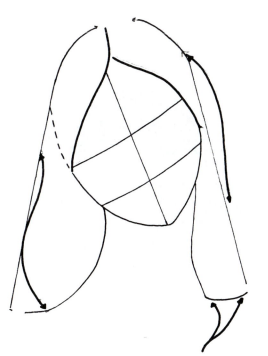

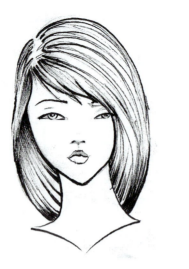
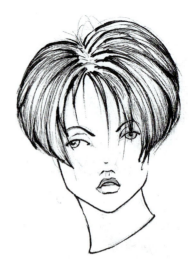

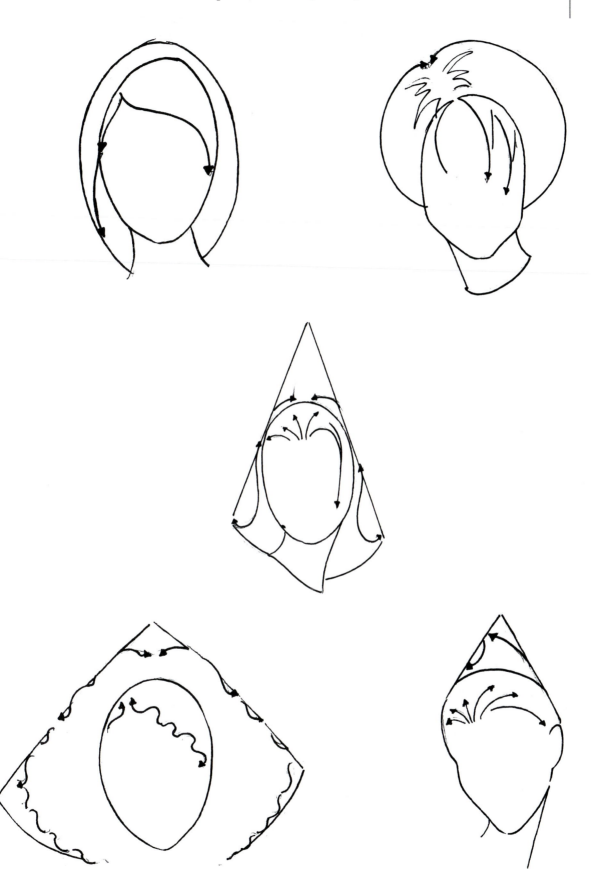

CHAPTER 3

Dressing the Female Figure

Conceiving a design that can be created and brought to fruition as close to its original sketch and concept as possible is a designer's most important task. Although all things are possible on paper, this is not so in real life. Garments that cannot be made or worn are merely whimsical. Just as an architect must never design a structure that cannot be built or is not user friendly, a fashion designer must never present his or her ideas if they cannot be made and worn.

Begin at the top when developing and creating a garment, much as you would any three-dimensional object, keeping in mind its structure and construction. The design must translate accurately in order to achieve its intended appeal. The design may change from inception through development based on patterns of construction.

When choosing the presentation model of a figure, choose the view that has the most to offer. Do not obscure important design details in areas behind the figure. Rotate the figure to ensure the best view. Study your design before picking a croquis. Exaggerate and emphasize any design details that are important or key to the garment.

Collars

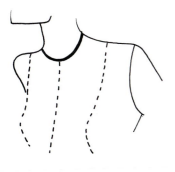

Collars with Stand and Roll

Collars may be flat or on a stand. Following are the basic steps for designing collars.

1. Establish the neckline.

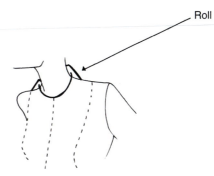

Roll

2. Determine the height and width; for example, consider collars with stands or rolls.

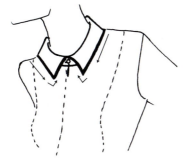

3. Shape the outer edge of the collar according to the design. The accompanying diagrams show a variety of basic collars in the three-quarter view. Follow the arrows to find the center front; this should originate, in most cases, at the pit of the neck.

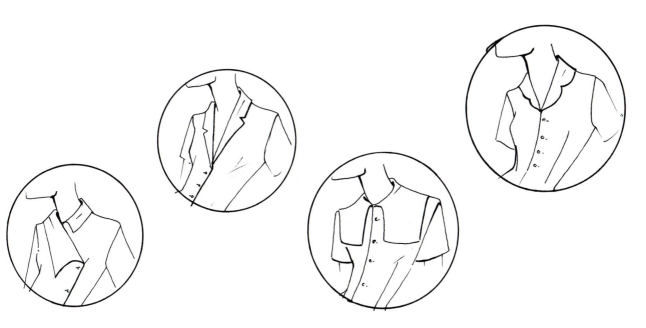

Collars with No Stand

1. Establish the neckline and depth.

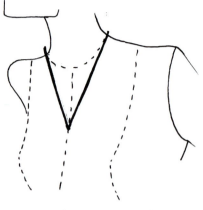

Stand collars: No roll

2. Draw the width flat on the shoulder and shape.

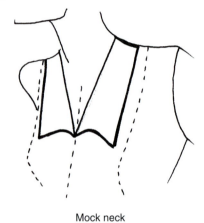

Mock neck

3. Sketch the neck width in an upward position

Stand and roll
turtle neck

Basic Darts

To place a simple waist dart, start at the apex of the bust, continue through the waist, and down to the hip line; some darts extend only to the waist, depending on the design of the garment. There are many alternatives for dart manipulation and the distribution of excess fabric. It is important to know the basics. Consider the accompanying diagrams that show darts continuing to the hip, as are used in many fitted tops and dresses, and darts that begin at the waist and extend to the apex of the bust.

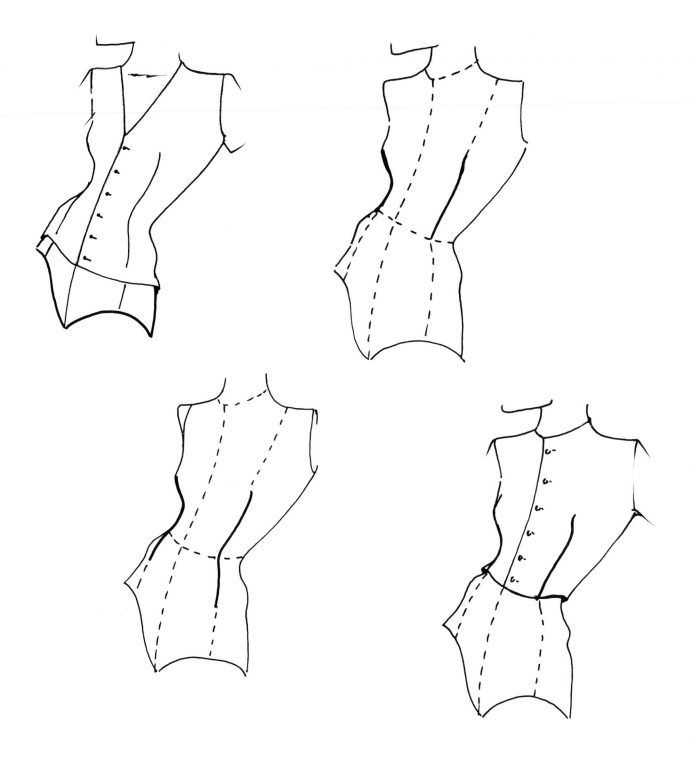

Dart and Placement

The accompanying diagrams show all of the basic darts on flats (technical sketches) with their corresponding three-quarter view. Note that, as the diagram is rotated, one side disappears from view; however, in most cases, both sides are mirror images of each other. For asymmetrical designs, turn the figure the other way.

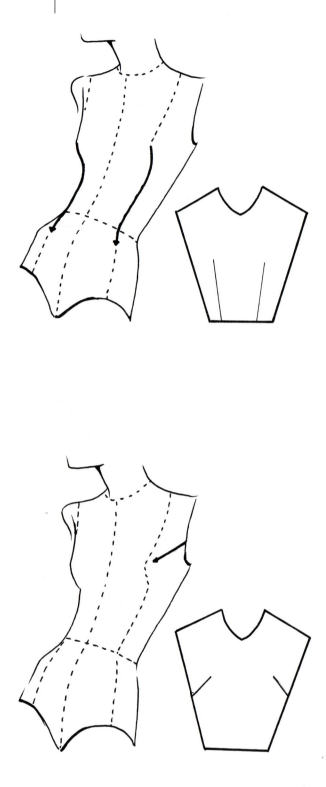

Dart Manipulation and Distribution

The accompanying diagrams show some examples of how the excess fabric under the bust may be distributed. The seams used in adjusting garments should not be seen as binding elements but rather as opportunities to create new and exciting designs.

Sleeves

Drawing sleeves need not be complicated. There are thousands of variations of sleeves. However, the rules remain the same for all. Remember, when using the three-quarter figure, the emphasis is on the front arm.

1. Use logic when considering sleeves. Fabric must adhere to the laws of physics. From a certain point, it will hang straight down if it is not interrupted by an outside object. This is known as the freefall side.

2. When the elbow is bent, the fabric will come to rest on some part of the arm. The side on which the fabric rests is called the contour side.

3. As the arm bends, the elbow will create a point of tension from which the fabric will slide down if there is no external interruption. A cuff would cause a wide sleeve to return back to the wrist, thus creating fullness.

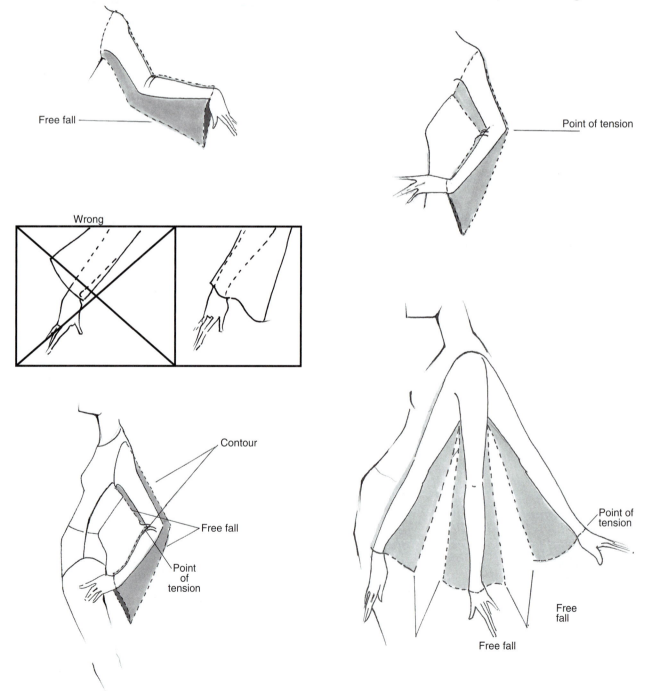

Remember, most sleeves begin at the armholes. Very few sleeves are possible without the existence of this seam. Two examples include the dolman sleeve and the princess kimono, but there are not many others. These sleeves will fluff and do not rest directly on any part of the arm. The excess fabric will create wrinkles and folds. The arrows in the accompanying diagrams indicate the movement of the fabric. Also, note that cuffs should always be drawn on a turn, never as a straight line. Sleeves may include only one shape, for example, that of a dolman, or many shapes, as seen on the stylized version and other variations shown here.

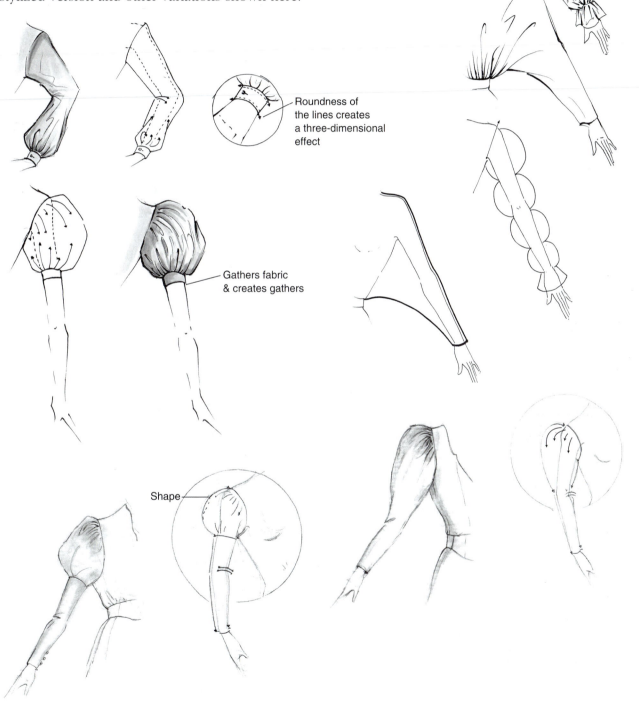

Roundness of the lines creates a three-dimensional effect

Gathers fabric & creates gathers

Shape

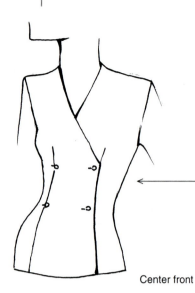
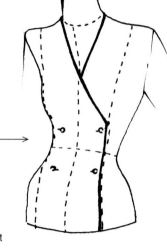
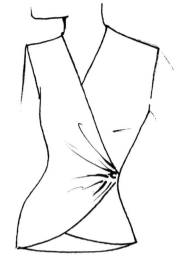

Center front

Wrapped

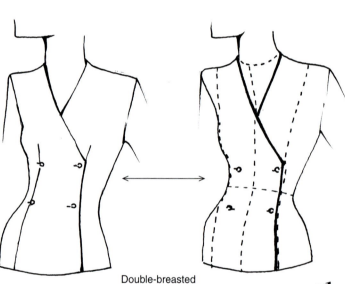

Double-breasted
tied and gathered

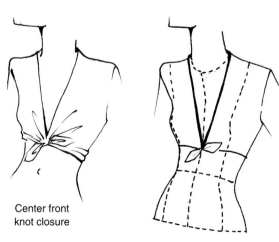

Center front
knot closure

Closures and Center Fronts

Some garments close in front, others in the back, but it is important to use the style lines, especially for closures on the front because they usually have very particular places. They can be hidden or displayed without looking awkward, and, in some cases, they can present a great opportunity for a designer's expression. However, do not compromise comfort, and never forget to consider putting on and taking off a garment. Forgetting closures is common at the beginning stages of design. However, the merger of beauty and practicality is the crown jewel of innovation.

Three commonly used front closures that are widely stylized by designers are the center front closure, the wrapped closure, and the double-breasted tied and gathered closure.

Drawing Tops

Whether creating original designs or interpreting existing styles, the proper way to begin is always the same: Start at the top and proceed to the bottom. Follow the three steps presented earlier in the chapter for designing collars. The collar should provide the beginning point for a great new creation.

The silhouette (outer edge of an object or the outline created by an object's shadow on a flat surface), is the next-important item and is one of the most defining features of a garment; it envelops the body. Whether it is full or fitted, it must lay correctly on the figure. Finally, to complete a top, add the sleeves.

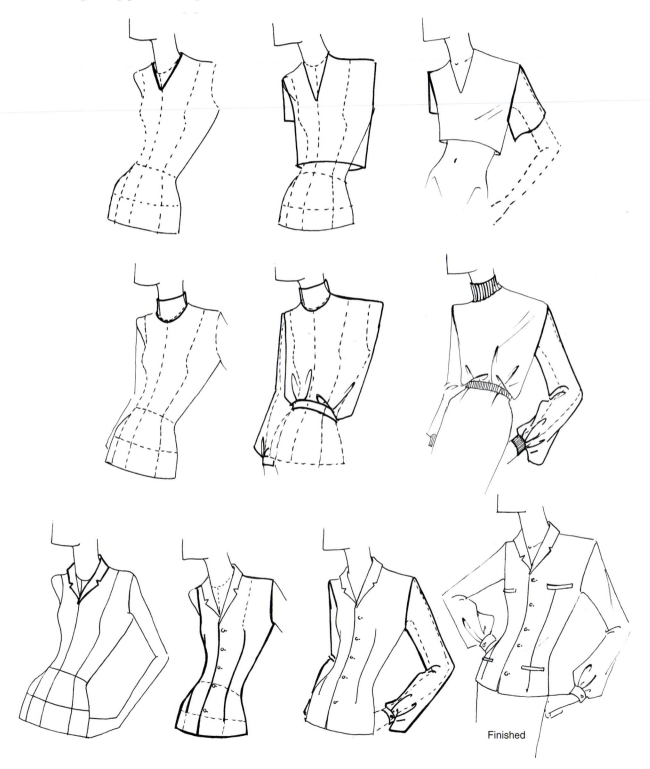

Finished

Drawing Skirts

The first thing to remember when designing a skirt is to establish a waistline. Anything at the waistline and above curves up. Anything below the waist curves down. For example, hip hugger pants would curve down at the waistband and empire shirts or pants would curve up.

When considering the width and shape of the skirt, remember to draw slits or other details on the front of your figure at the best angle, even if this means switching sides for the sake of a good drawing. The hemline must always align on a parallel with the waistline in any pose where the figure is standing. Apply the rules of freefall and contour when using the three-quarter view of the figure. The pelvic thrust allows for the hip to become a point of tension, and, when the back leg is at the plumb line, fabric will freefall from this point. Depending on the movement of the other leg, the fall of the fabric may vary, causing the hip again to be a key point of tension.

Narrow skirts taper in and, as the body moves underneath, the designer must find the movement in order to know where to shade later.

1 Anything that cuts horizontally across the body on the waist and above, curves up.

2 Anything that cuts horizontally across the body below the waistline, curves down.

Narrow Skirt

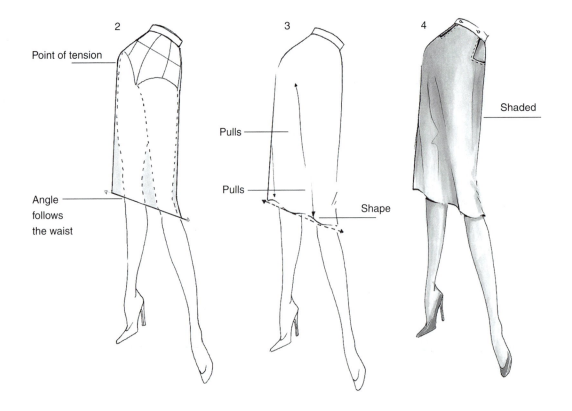

2 Point of tension

Angle follows the waist

3 Pulls

Pulls

Shape

4 Shaded

Flair Skirt

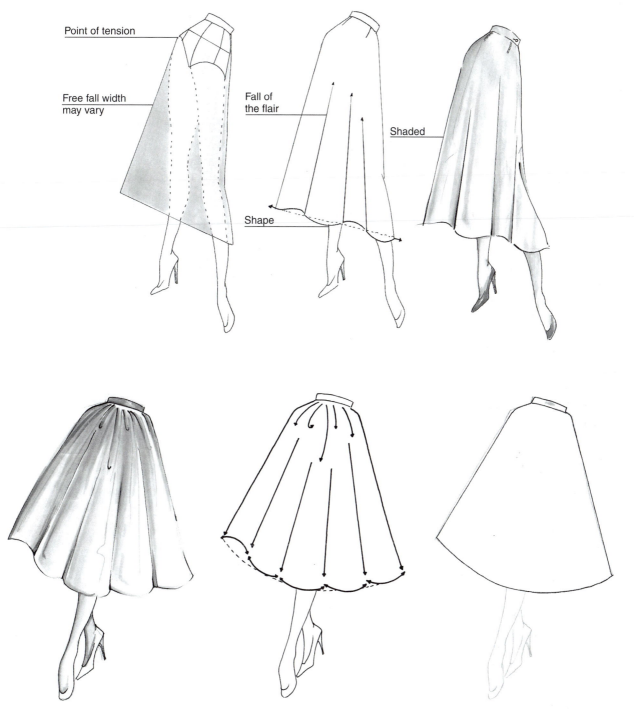

With flair skirts, depending on the fabric, there may or may not be a well-defined contour side. Fullness at the waist may be a key factor in the fall of a flair skirt. However, if the leg is extended underneath, fabric will fall until it comes to rest on something.

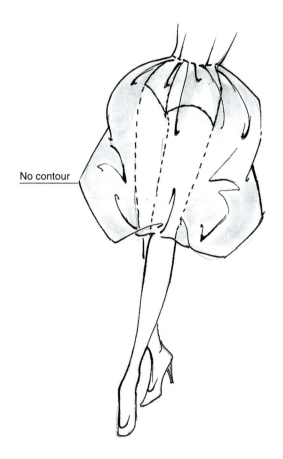

No contour

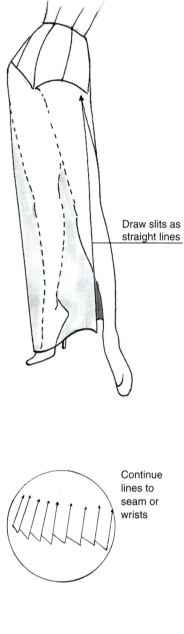

Draw slits as straight lines

Continue lines to seam or wrists

Pleated Skirt

Once the skirt is silhouetted, add the pleats.

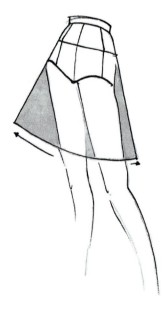

Use a series of touching check marks

CHOOSING THE RIGHT POSE

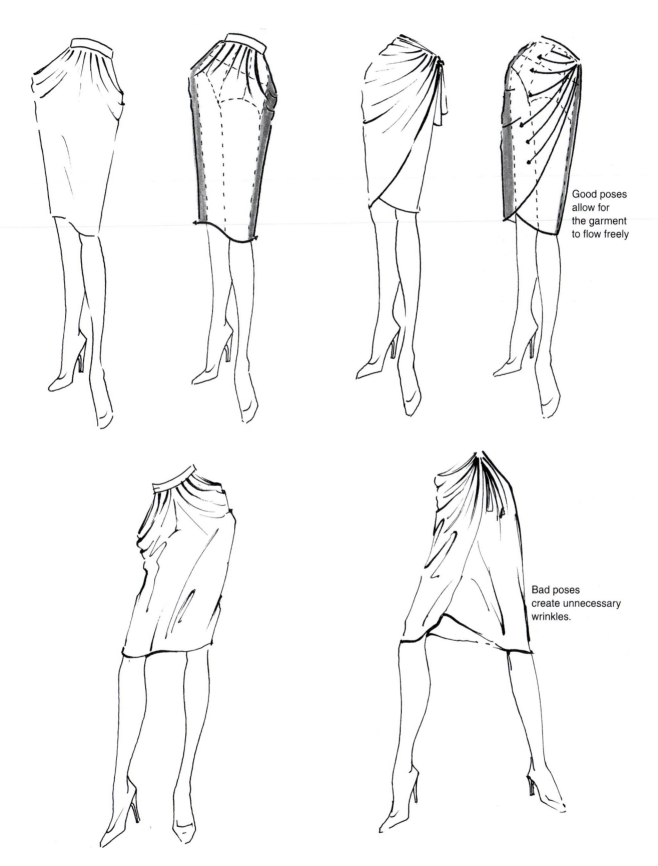

Good poses
allow for
the garment
to flow freely

Bad poses
create unnecessary
wrinkles.

Short Skirts

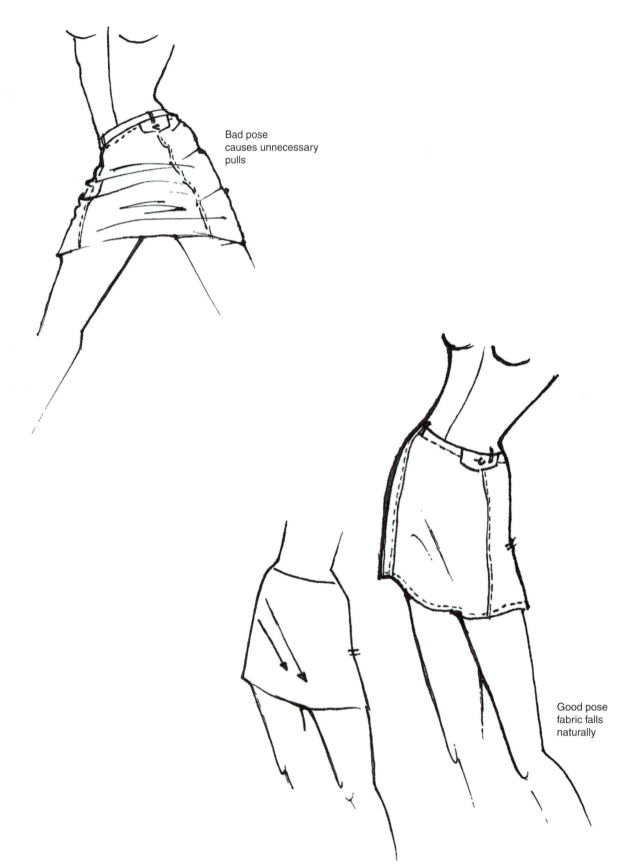

Bad pose
causes unnecessary
pulls

Good pose
fabric falls
naturally

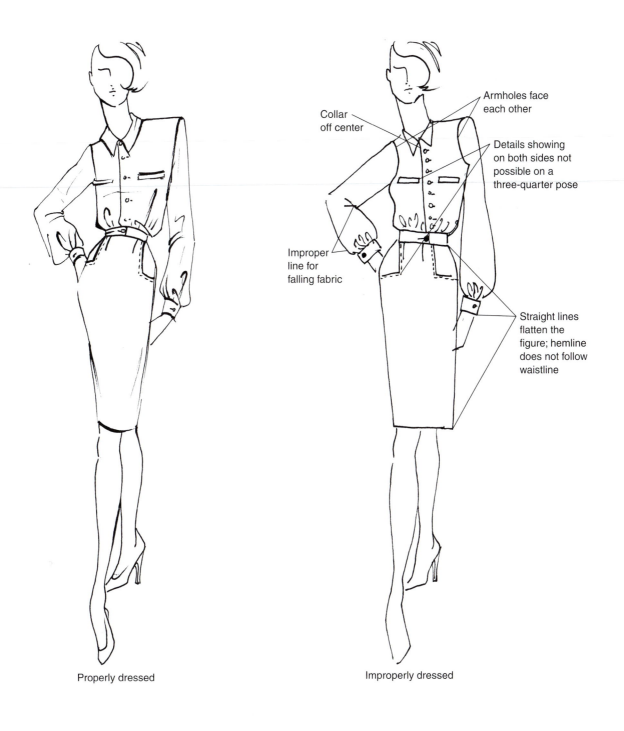

Collar
off center

Armholes face
each other

Details showing
on both sides not
possible on a
three-quarter pose

Improper
line for
falling fabric

Straight lines
flatten the
figure; hemline
does not follow
waistline

Properly dressed

Improperly dressed

Drawing Pants

Pant legs and sleeves are designed in much the same way, which is not surprising because our arms and legs function in a similar manner. So, again, build from the top to the bottom establishing the design point by point. The waistband width is a matter of taste; if it is at the waist or above, curve it up; below the waistline, curve it down. A seam, usually where a zipper is found, either in front or back joins the legs. Go down past the pelvic box of the figure to give the pants ease. The point of tension establishes which side will fall straight down and which side will rest on the leg to take its shape or be manipulated by the

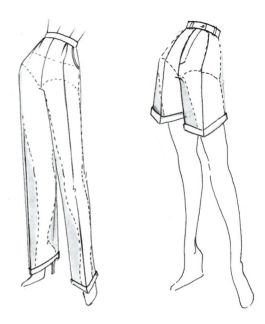

body. Check the hem line. Do not leave these as straight lines; they form part of a circular opening, which is the pant leg; therefore, fabric will curve over the front and around to the back.

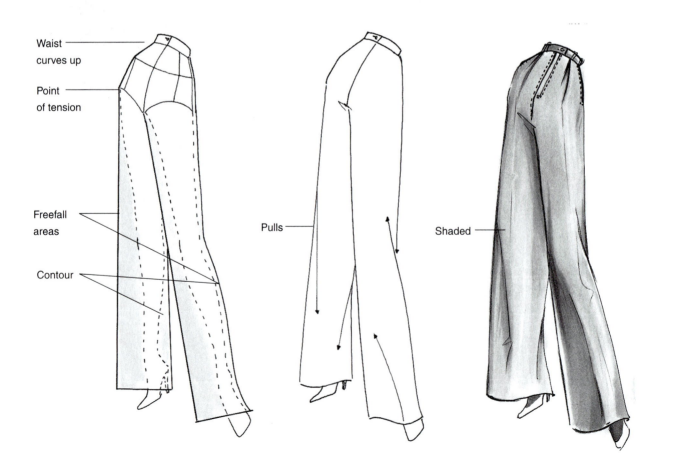

Waist curves up

Point of tension

Freefall areas

Contour

Pulls

Shaded

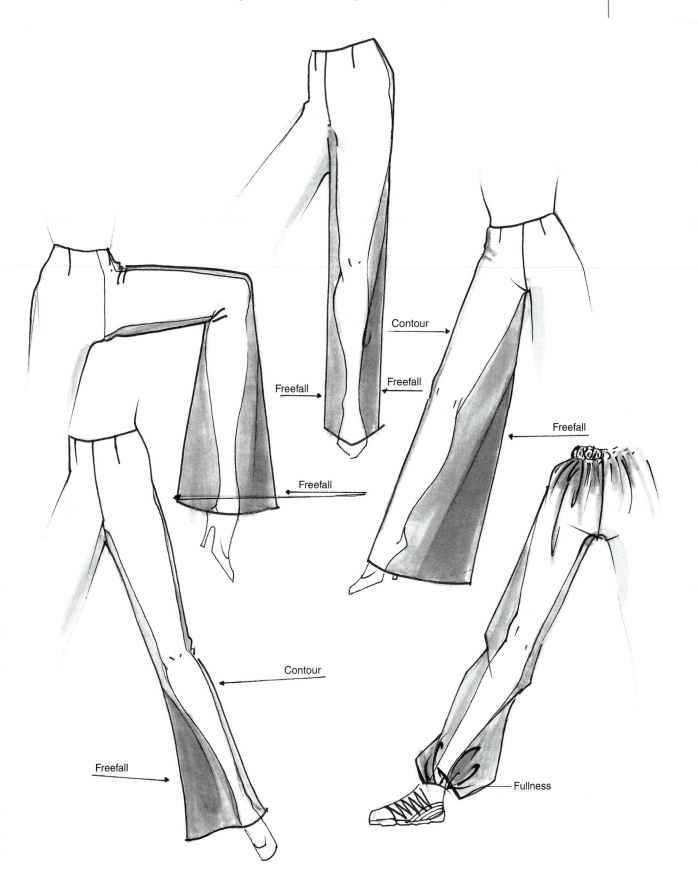

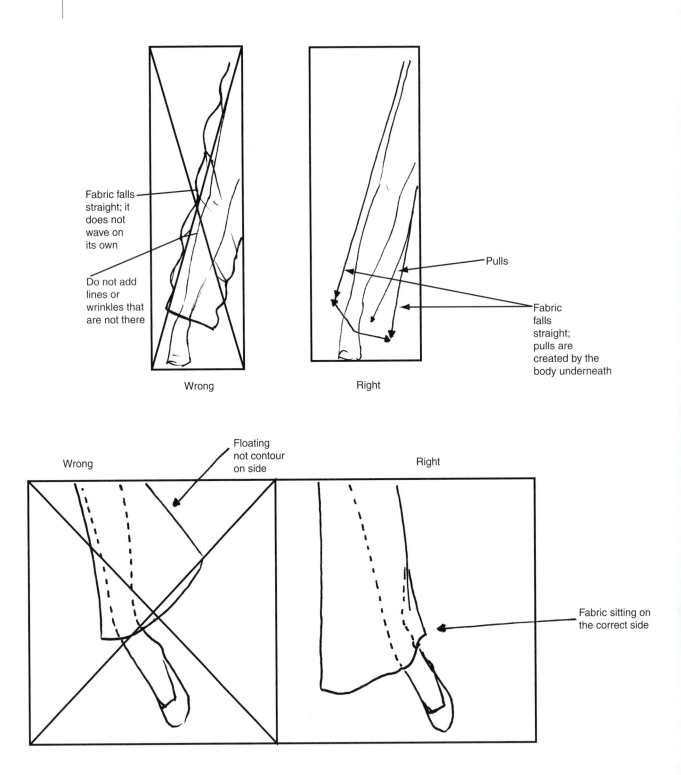

Fabric falls straight; it does not wave on its own

Do not add lines or wrinkles that are not there

Pulls

Fabric falls straight; pulls are created by the body underneath

Wrong

Right

Floating not contour on side

Wrong

Right

Fabric sitting on the correct side

Drawing Jackets

Jackets are garments that usually work with other articles of clothing; therefore, they need to be roomy. Armholes are usually more open at the bottom and become straighter. Designers must follow the style lines closely without making the garment look too small for the figure.

The accompanying diagrams show some basic jacket styles. Arrows represent the folds and directions of the fabric, and shaded areas represent the loose areas a jacket may require.

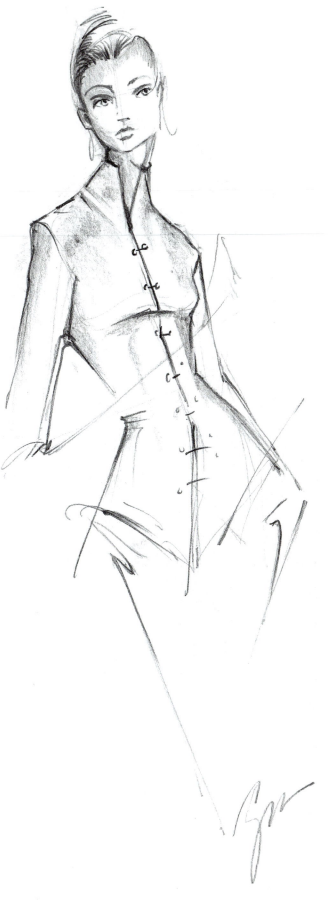

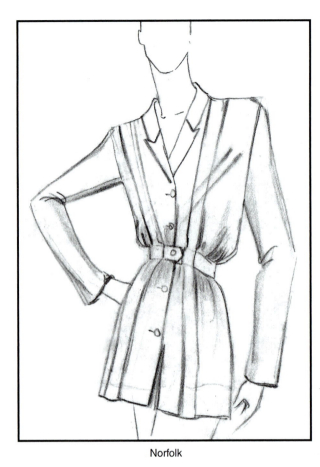

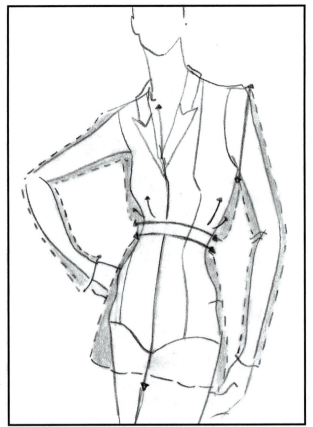

Norfolk

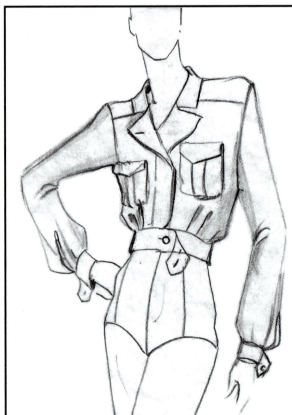

Eisenhower

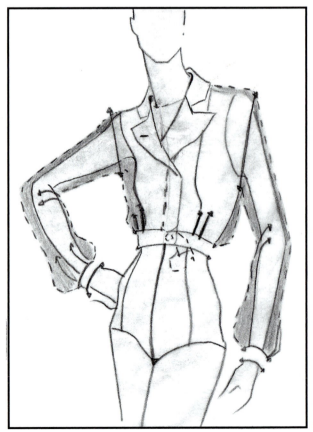

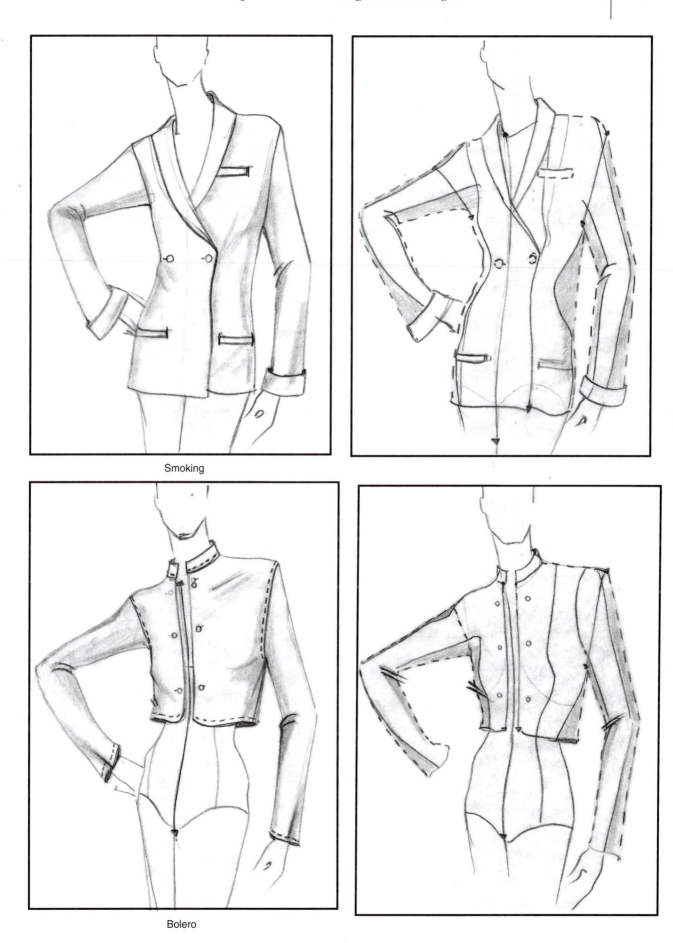

Smoking

Bolero

CHAPTER 4

Menswear: The Figure

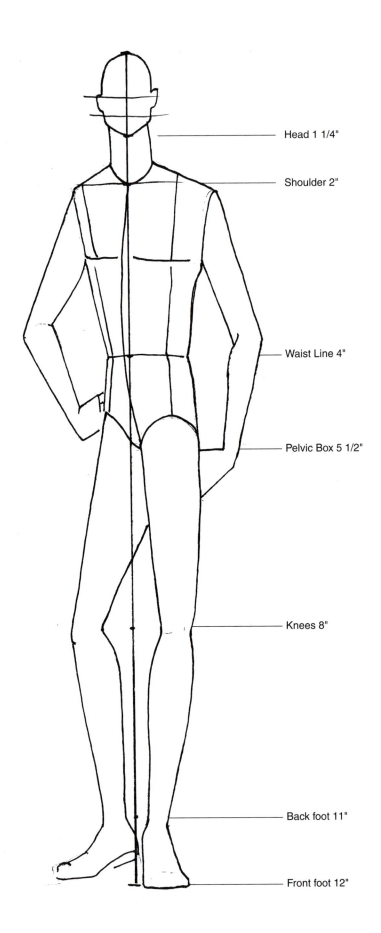

Head 1 1/4"

Shoulder 2"

Waist Line 4"

Pelvic Box 5 1/2"

Knees 8"

Back foot 11"

Front foot 12"

The 12 Steps

Step 1: Plumb Line

Draw a straight line by which to build around and establish proper posture. This line is referred to as the plumb line for both men and women figures. The plumb line helps you achieve good positioning of the figure and helps ensure that the figure is accurately supported in its stance. The line works for drafting all figures because it is used to help establish balance rather than being concerned with gender differences.

Step 2: Reference Points/Measurements

Establish reference points on the plumb line. Mark the very top and the very bottom of the line; then mark the reference points for the head, shoulder line, waistline, pelvic area, and knees. You may use the measurements provided in the accompanying diagram or create your own proportions.

Step 3: The Head

To draw the face and head, begin by drawing an oval in the space allowed from the top of the line to your first measurement. In order to make the face look more masculine, it is customary to emphasize the jawline as a dominant feature rather than the cheeks, which tend to suggest a more feminine figure.

Step 4: Shoulders and Waist (2-part step)

PART 1: SHOULDER LINE—Draw a straight, not angled, line across the plumb line. Place the line one-quarter of the way to one side of the plumb line and three-quarters of the way to the other. This line has no particular length; however, it is important to point out that the emphasis for the male figure is on the shoulders. Musculature or volume is directly related to the length of this line.

PART 2: WAISTLINE—Place a parallel line at the waistline reference point measuring approximately three-quarters of the length of the shoulder line. Draw this line proportionately with the shoulder line, one-quarter of the way to one side of the plumb line on the same side as the shorter portion of the shoulder line and three-quarters to the other.

Step 5: Center Line

The center line is important because the body of the figure will be built around this line. Begin by drawing a slightly arched line from the pit of the neck (the intersection of the shoulder line and plumb line) to the pelvic box reference point.

Step 6: Closing the Neck and Torso

To complete the outline for the neck, simply draw the lines from the sides of the head straight down to the shoulders. Add the trapezoid muscles by drawing lines from the center of the sides of the neck to the ends of the shoulders.

To complete the sketch of the torso, begin at the front, which also happens to be the area with the most shape. Go to the side of your figure where the line is shortest past the plumb line and close that area (see diagram). The more muscle on your figure, the more shape it will require.

To complete the sketch of the back, draw a line straight from the end of the shoulder line that ends in a hook. The hook shape begins to establish the opening for the arm; therefore, it must not extend beyond the middle of the chest (see diagram). At this point, join the hook shape to the waist by simply connecting the two points with a diagonally inclined line.

Remember, proportion is important; therefore, check that the shoulders and waist are appropriate and proportionate in width. Some type of shape is necessary; the waist should be narrower than the shoulders. A waist any smaller than three-quarters the width of the shoulder line may appear too thin and could distort the drawing.

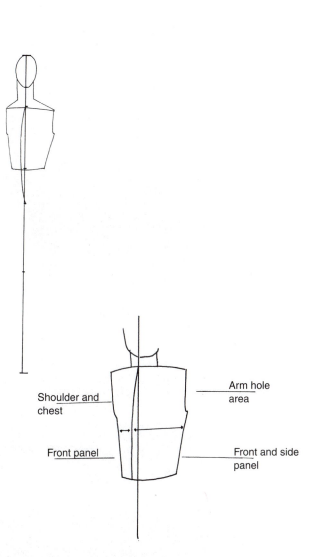

Shoulder and chest

Arm hole area

Front panel

Front and side panel

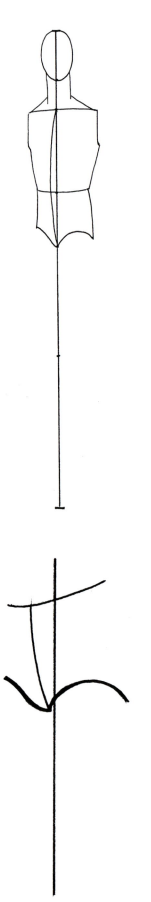

Step 7: Closing the Pelvic Box (2-part step)

PART 1—Create an area for the legs by using the shape shown in the diagram. This whole shape must be smaller in width than that of the shoulders and waist. If this area becomes disproportionately large, it will create emphasis on the hips, which is only used for female shapes. On the male figure, the emphasis is on the shoulders.

PART 2—Shape the contour of the hip bone on the front side. Note that the front side must be adjusted depending on the position of the back leg (see diagram). Adjust the front leg by moving it away from the plumb line. Never position both legs on one side of the plumb line, unless the figure is leaning on something. However, as long as the figure is standing freely, the center of gravity is on the plumb line or on one foot, leaving the other foot to move freely.

Shape

Step 8: Legs

After the torso is completed, use straight lines to properly position the legs. Begin at the top of the leg in the designated area. Because the front leg is used as the weight-bearing leg in this particular pose, it is best to start with that leg. Draw a straight line from the center of the shape; add a dot for the knee at the next reference point on the plumb line as a guide.

For the back leg, which is the one that will appear to have the most freedom to move, draw a line from the side of the figure, which is also the center of the leg, to the knee mark. Add a dot for the knee and continue the leg line down to the foot. The back foot may end at the 11″ or 12″ reference point, depending on the position of the figure (see diagram).

Step 9: Shaping the Leg

Examine the shape shown in the accompanying diagram. To form the legs, draw contour lines around them using arrows to achieve an appropriate shape.

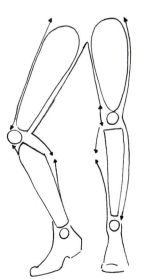

Step 10: Positioning Arms

Using straight lines, as was done for the legs, begin by drawing in the center of the designated area and, keeping in mind that the elbow is parallel to the waist, continue down to the wrist, which is parallel to the bottom of the pelvic box, and dot it (see diagram).

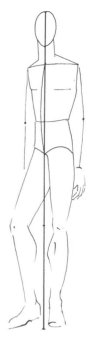

Step 11: Arm Shape and Contour

The upper body is a focal point on the male figure. This is partially because of the shoulders, which form the upper arm. Therefore, shape is crucial. Vary the shape of your figure to suit your design and adjust for body mass.

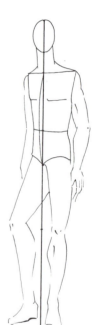

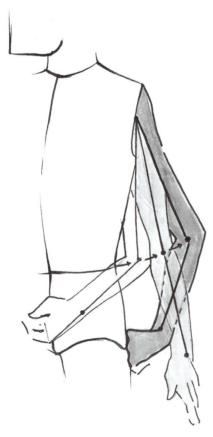

Step 12: Hands and Feet

For hands, focus on the shape the hand forms and not on the position of each finger. The foot angle will vary according to the position of the leg. However, keep in mind that the foot will not be elevated as is the case in the female figure when high heels are present. Keep the foot flat and firmly on the floor.

Men's Faces

When drawing men, keep the features rugged. Emphasize the jaw line and make the eyebrow wider and closer to the eye. Do not enclose the entire eye or lips with a solid line, because this will make it look like they are wearing make-up. Widen the nose and nostrils. These tips will keep the face looking masculine and differentiate men from women.

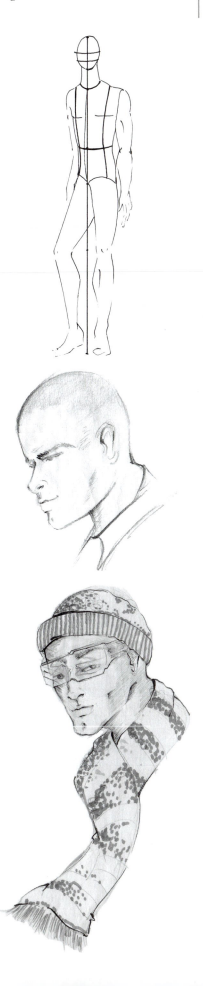

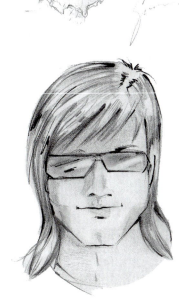

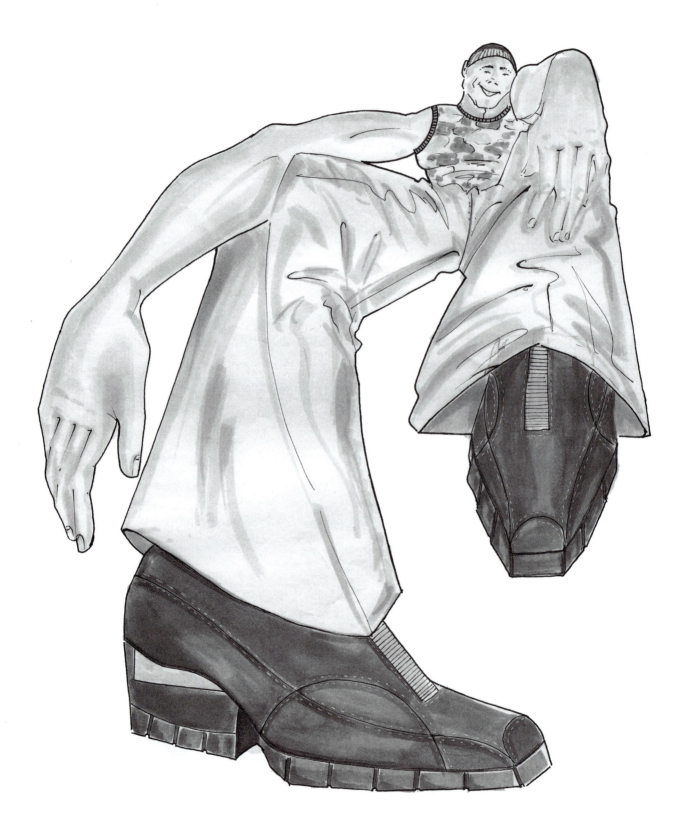

Front View

Step 1: Shape

For the male head, begin by drawing an oval shape. Use a wider shape than that used to draw the female face. This increase in volume ultimately will help the end result of the figure look more masculine; it is also more appropriate for the wider frame used for the male figure.

Step 2: Dividing the Shape

Divide the head down the center horizontally, then again vertically. Divide the lower portion in half again, thus dividing the bottom into quarters.

Step 3: Eyes and Eyebrows

Draw in the eyes. Remember, the measurement between the eyes is about one eye's distance and from the outer edges of the eyes to the side of the head is one-half an eye distance. Note the shape of the eye is not as wide as that used for female figures. Men do not usually have the benefit of makeup to draw attention to the eyes. Therefore, a narrower shape is used with a considerably thinner line. For more on eyes and other facial features refer to later sections in this chapter.

The eyebrows should be positioned very close to the eyes. Use a heavier or wider shape for the eyebrow. The eyebrows and the jawline are defining characteristics of the male face.

Step 4: Nose

Placement and width of the nose should be defined. The actual shape is revealed through shading; place the nostrils on either side of the vertical dividing line.

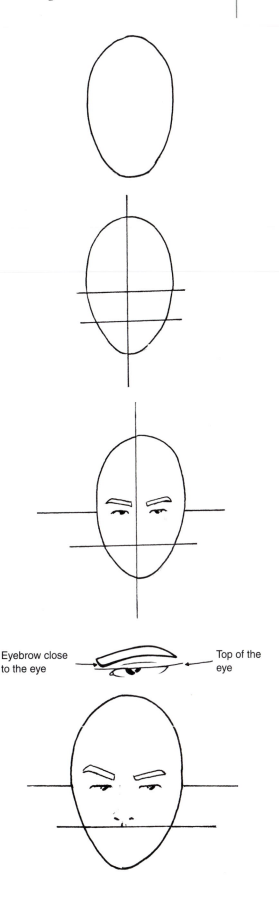

Eyebrow close to the eye

Top of the eye

Dotted areas indicate areas of shadows

Step 5: Mouth

The mouth is positioned directly under the nose. The width of the mouth is determined by drawing a line diagonally from the outer edges of the eyes to the tip of the chin. The depth is up to each individual's features. Do not outline the entire mouth.

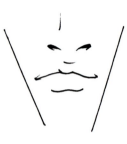

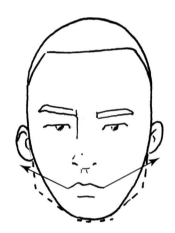

Step 6: Shaping the Face

Draw the ears on both sides of the head. Begin at the eye lines and end near the corners slightly above the mouth.

After all the facial features have been drawn in, shape the jawline. Remember that, along with the brow, the jaw is one of the defining features of the male figure. A prominent jaw is desirable in models and actors primarily because of its photogenic appeal.

Profile View

It is important to distinguish what features are most prominent on the face so that we may emphasize these. It is common that if you are used to drawing women, the features can become feminine. On the profile, the bridge of the nose and forehead are frequently very pronounced.

The lips are frequently less pouty on men. Therefore, use small circles when using this method. The chin and jawline are very dominant characteristics and should be emphasized to create a masculine face. You may want to keep the eyebrows larger and thicker; using a square jawline, you can ensure the face does not become feminine.

Step 1: Shape

The shape used to begin the profile view of the head is similar to that of a flower petal or a guitar pick. If this shape is difficult to draw, try drawing a circle first and then adding a corner. The area forming the corner should have a straight angle.

Step 2: Dividing the Shape

Divide the profile view shape first vertically three-quarters of the way back from the front. Then divide it in the center horizontally and again divide the lower portion in half, breaking it into approximate quarters.

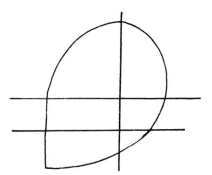

Step 3: Finding the Features

Using a series of circles, position reference points for the nose, lips, and chin. Draw the first one in the section of the face allotted for the nose, then add the lips reference point circles below the lower horizontal line dividing the lower face. At the corner of the profile view shape, place a circle for the chin.

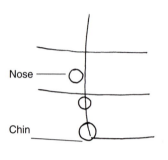

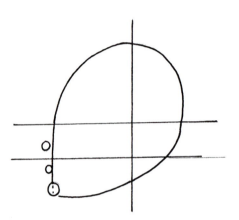

Step 4: Shaping the Profile

The profile view of the face offers the most interesting contour. Once your reference points have been added, begin applying the contours. Above the upper horizontal line draw an indentation for the bridge of the nose, then extend the line back out and around your first circle to form the nose.

Continue the contour on the third section to shape the lips. Finish by forming the chin around the lowermost circle (see diagram).

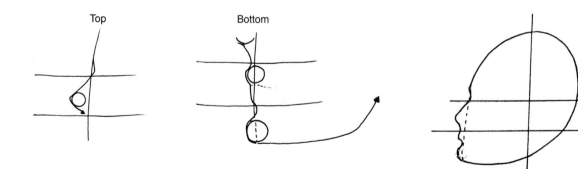

Step 5: Adding the Features

Use the side views of the eye, ear, nose, and mouth, placing them appropriately (see diagram).

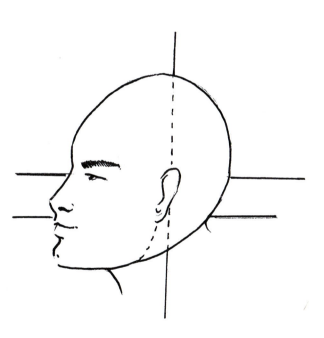

Step 6: Shaping the Head

Before shaping the face, draw the ear along the vertical line. Next, begin at the chin and add shape around the jaw and to the ear. This facial shape will vary for each figure.

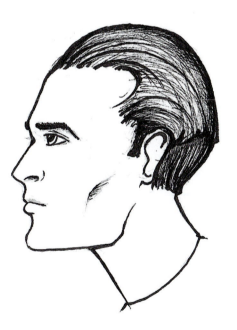

Three-Quarter View

Although this view to the face may be the most challenging, remember to also use a three-quarter view with the features. This helps keep the face from becoming distorted. Emphasize the brow, chin, and jaw, being careful that they are in proportion to each other. You may need to practice this a few times before getting it perfect.

Step 1: Shape

Use the same shape as that used for the profile view.

However we will use a different series of lines to divide it.

Step 2: Dividing the Shape

Divide the shape horizontally twice: Draw a line through the center and add another line to divide the lower section in half, thus creating approximate quarters as was done for the profile view. Then, draw two vertical lines, the first three-quarters of the way to the back and the second toward the front, establishing a center line for the face somewhere between the edge of the shape and the vertical dividing line (see diagram). *Note:* There are many angles for this view; the placement of the center line directly affects the shape of the outer edge of the face, as well as the eyes, nose, and mouth.

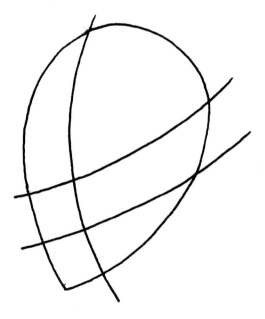

Step 3: Facial Contouring

Eliminate any unnecessary areas in the three-quarter view by properly shaping the outer edge of the face. Begin above the top horizontal line, add an indentation at the upper horizontal line to establish the brow. Continue down toward the center line without touching at the bottom.

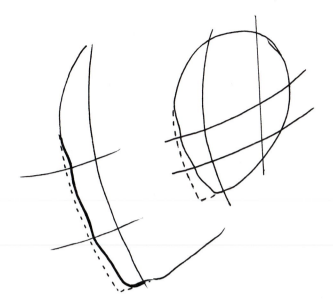

Step 4: Adding the Features

Use the appropriate angles for the eyes, placing them at the eye line. Use the three-quarter view of the nose and mouth, placing those appropriately.

Note: The outer eye will change according to how close the center of the face is to the edge.

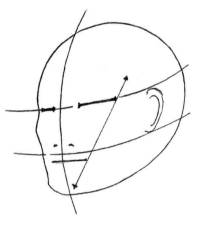

Step 5: Shaping the Face

Begin shaping the face by first placing the eyes along the left vertical line. Shape the remaining features from the chin to the jaw and up toward the ear.

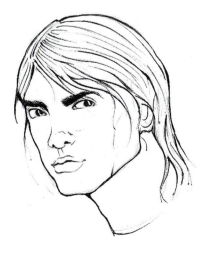

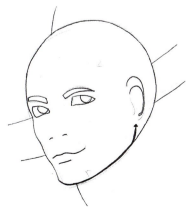

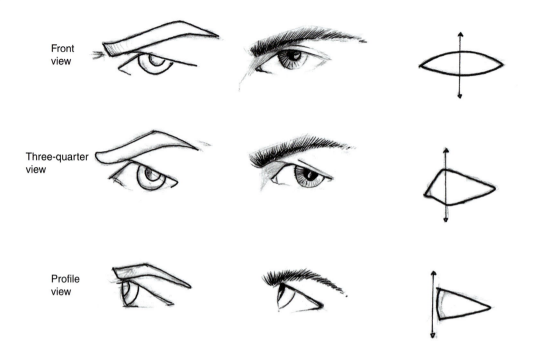

Front
view

Three-quarter
view

Profile
view

The Brow—Position the brow low on the head, adding definition and emphasis. It should be close to the eye.

The Eye—Emphasis for the eye should be at the top and on the path of vision, specifically, the pupil and iris.

The mouth—The lower lip and the actual opening of the lips are the areas usually emphasized, giving a clear masculine look.

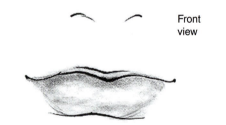

Front
view

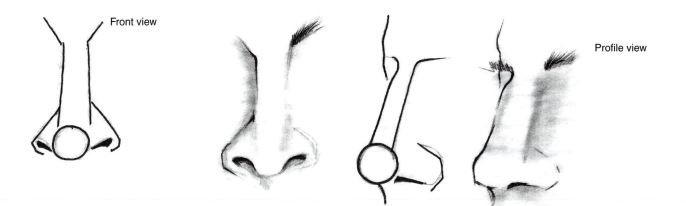

Front view

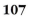

Profile view

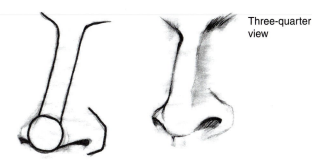

Three-quarter view

The nose—The nose should be wider at the tip and narrower at the base. This feature varies from face to face.

Chin and jaw—The chin and jaw are the most prominent features on the face, followed by the brow. A wide chin and square jaw line will facilitate an unmistakably masculine shape.

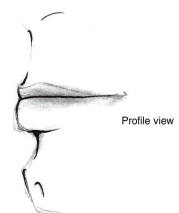

Profile view

Three-quarter view

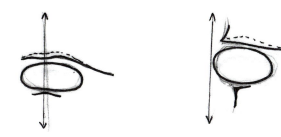

Men's Hairstyles

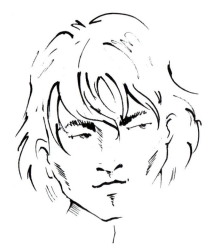

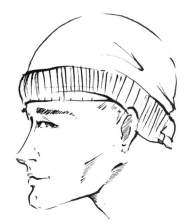

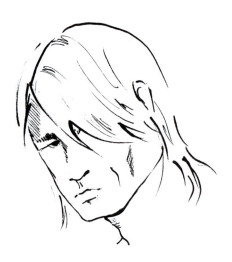

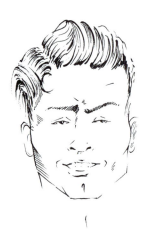

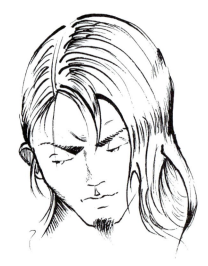

Hair Shapes and Styles

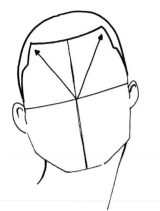
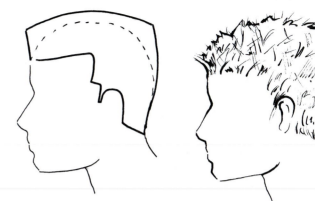

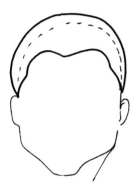
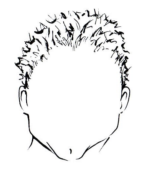
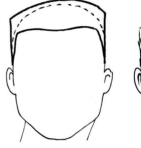
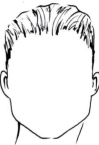

Hairline—In men, the hairline tends to be further back, leaving a more ample area for the forehead.

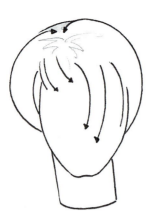

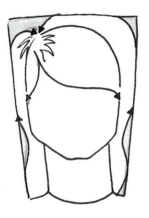

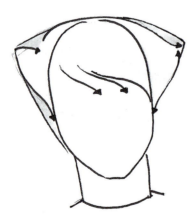

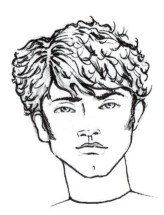

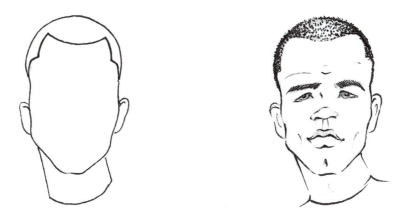

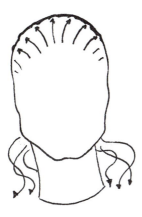

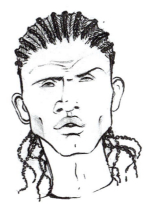

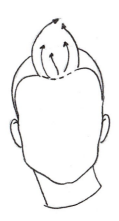

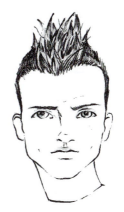

Style Lines

The body is divided into quarters all around, thus creating crucial lines for the placement of basic design elements.

Neckline—The neckline ensures that the garment's collar is properly positioned on the figure regardless of the figure's movement.

Center Line—The center line ensures that elements such as center front closures, for example, button or zipper fronts, align on the center of the body.

Waistline—The waistline must be placed at the thinnest point where the upper body meets the lower body, or the pelvic area. It is important to note that the majority of men will not wear pants that extend to the waistline. They prefer waistlines slightly below the waist that extend only to the hip area.

Identify and mark the areas leading to the arms and legs for proportion and to use as guidelines for armholes, undergarments, and swimwear.

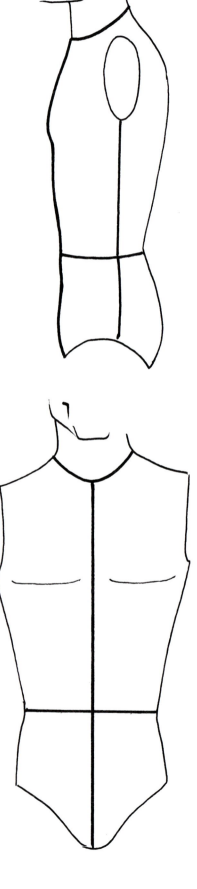

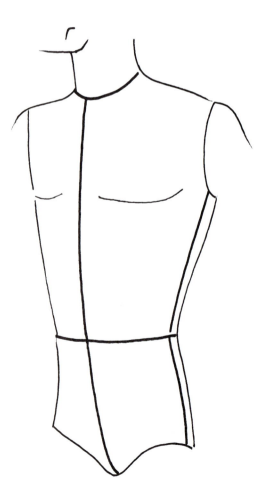

Hands

When drawing hands on the male figure, re-member that the distinguishing characteristic of the male hand compared to its female counter-part is the thickness. The bone structure beneath the muscles is frequently heavier on men. Do not separate the fingers; keep the overall hand one single shape. There are considerably fewer hand gestures in male illustrations than are found in il-lustrations of females. Follow the step-by-step approach as shown in the accompanying dia-grams to drawing these hand positions, which are the most commonly used for illustrating men's fashion.

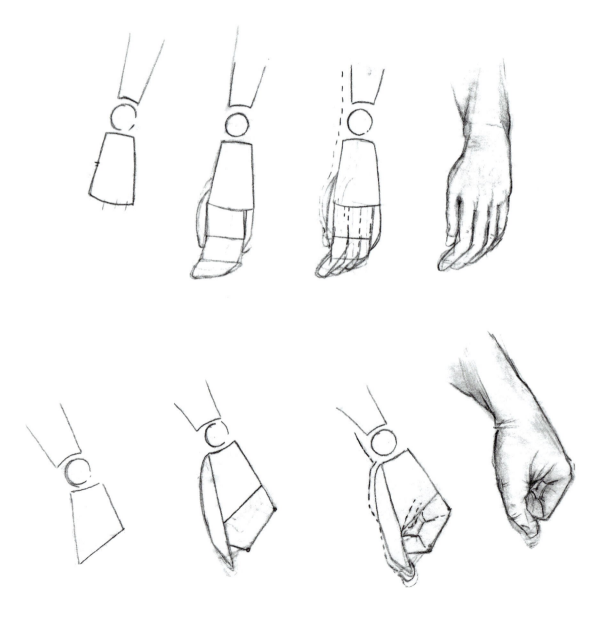

Feet

The male figure uses a flat position for the foot regardless of the angle in which it is seen. Most men's shoes have what is known as a common sense heel, and all shoes will elevate the foot.

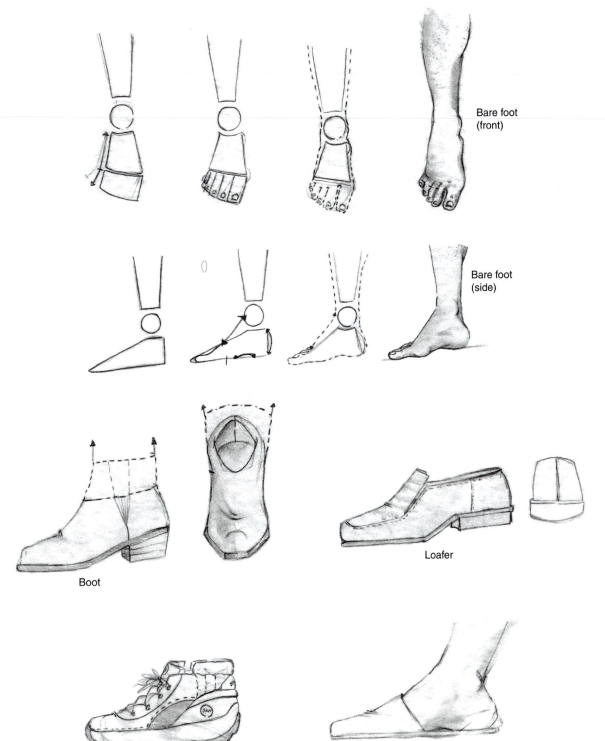

Bare foot
(front)

Bare foot
(side)

Boot

Loafer

Sneaker

Slipper

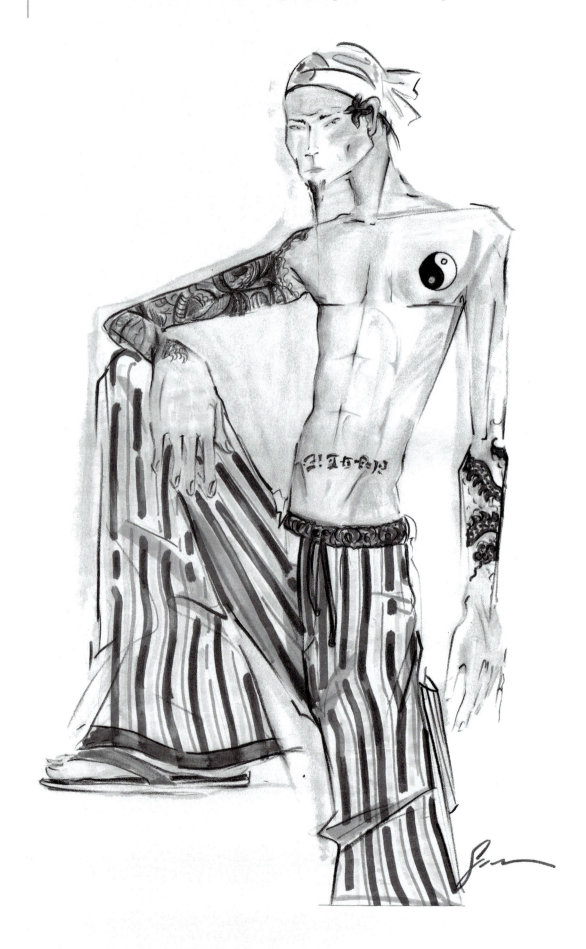

Shaping the Arms

To shape muscular arms, use a series of arches and circles to achieve the desired contours without making an in-depth study of the human body.

STEP 1—Begin by establishing a line for gesture. This line begins at the shoulder or slightly below it and extends to the waist; add the dot for the elbow and continue the line to a point near the end of the pelvic area. At that point, mark the position of the wrist. The full length of the arm must include the hand, which should extend to the middle of the thigh area.

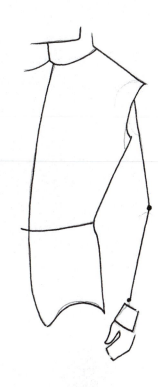

STEP 2—Draw a circle for the shoulder at the very top of the arm. Directly below it draw an oval that ends at the elbow. Finally, draw another oval from the elbow mark to the wrist.

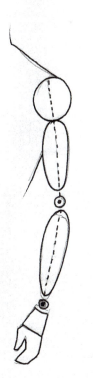

STEP 3—Using a series of arches, develop a contour suitable to your taste. If a very muscular physique is desired, the arches must be deliberate and clear. If a less muscular look is desired, use less definition between the circles. Follow the arrows for proper shape.

STEP 4—Review your sketch and take time to shape any areas that do not look quite right. If something looks "off," it probably is. If these areas are to be exposed, shade around the muscles to achieve the look of a sculpted body. Erase any unwanted marks or trace over your own work.

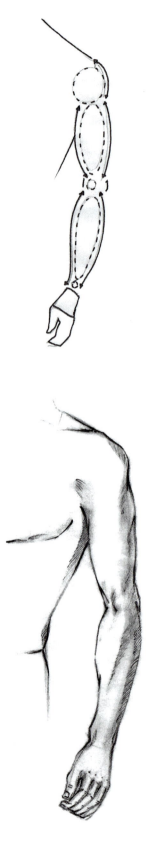

Shaping the Legs

When drawing men's legs, remember to strongly emphasize the muscles. The upper calf muscle and thighs or hamstrings are bulky and may require steep angles when being drawn. The joints such as the knee and ankle should be thick, yet they should remain the narrowest part of the leg. Keep them in proportion with the rest of the leg. Avoid using long, fluid lines around the contour because this will make the leg look feminine. You may want to keep the foot large and bulky, especially when drawing today's fashion.

STEP 1—As is the case with the arms, the drawing of all extremities should begin with a gesture line. Begin this line at the bottom of the pelvic area and draw the line down what will become the center of the leg; add a dot for the knee. Remember that in most poses one knee is lower than the other, depending on which leg is the front leg. Continue the leg line, straight or slightly arched, toward the ankle and add a dot for the ankle. The foot extends beyond that point.

STEP 2—Continue sketching the leg by enclosing the line with designated shapes in appropriate areas. Use an oval for the upper leg or thigh and a long triangular shape for the lower leg.

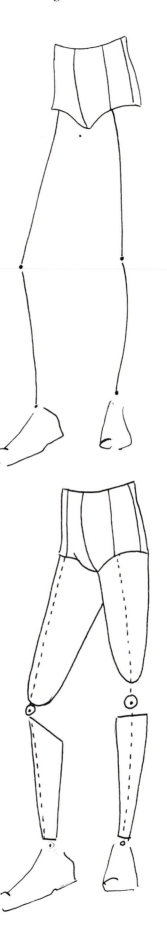

STEP 3—Following the arrows and using your newly formed shapes as guidelines, sketch the refining contours for the legs (remember that musculature depends on the exaggeration of these lines).

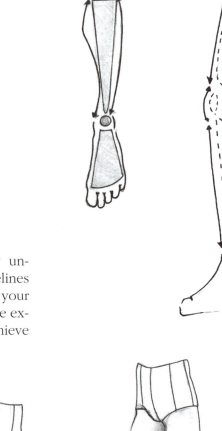

STEP 4—Review the contours; erase any unwanted marks, such as the circles and guidelines between the newly formed lines. Check your work and consider whether the legs are to be exposed or emphasized. Add shading to achieve the desired muscle tone.

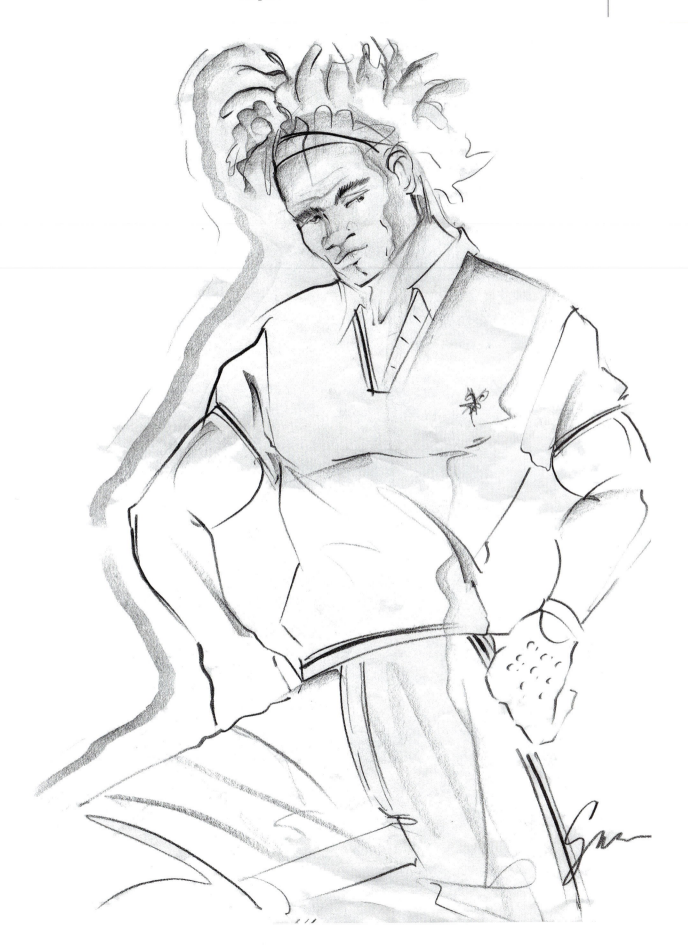

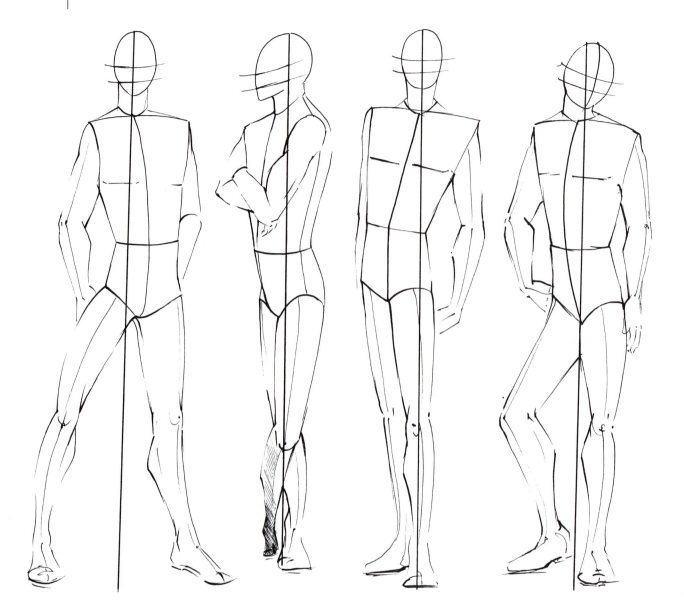

Manipulating the Figure

When striving to present appropriate and appealing compositions in your work, figure manipulation is inevitable. In fact, a good designer conceives designs balanced from all angles and displays them in a manner worthy of exhibition. New artists following the step-by-step method as a first-time attempt at drawing should always begin with the plumb line and reference points in order to maintain proportion.

Dressing the Male Figure

Men's clothing fashions do not change at the quick pace that women's fashion designs tend to. Rather, they rely more on traditional styles that are readily accepted by society. The kilt, for example, is one of the only deviations from the traditional, most-frequently-opted-for trousers. However, men's fashions are unparalleled when it comes to construction and sheer attention to detail and comfort. A master tailor must cater to the needs of individual bodies and artfully sculpt from the most unassuming of figures. In this section we begin to explore sketching the dress of the male figure, considering particularly some of the nuances that make men's attire so unique.

Drawing Men's Tops

Men's clothes have traditionally been roomier than women's, and this facilitates less negative space between the arms and legs in the figure. Sometimes it is helpful to concentrate on the full silhouette. The negative spaces determine how tightly the garment fits.

The accompanying diagrams show examples ranging from tight-fitting tops to a looser layered style. Note the silhouettes and the negative space areas shaded in black that help reveal how the garment should fit and how much space to leave.

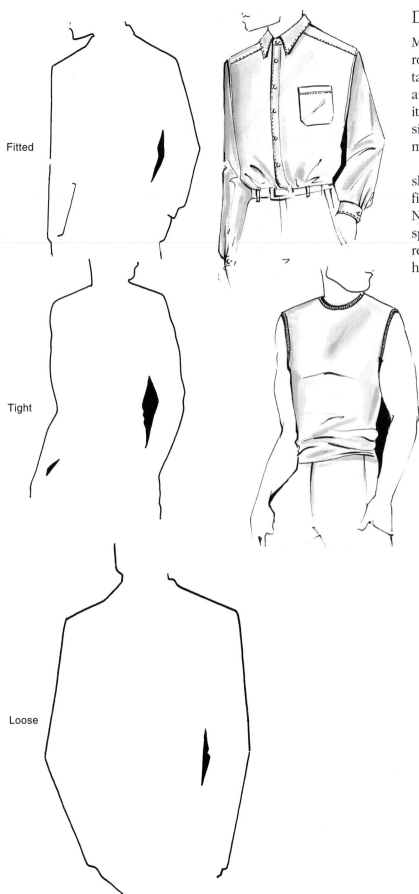

Fitted

Tight

Loose

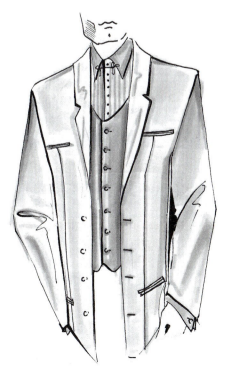

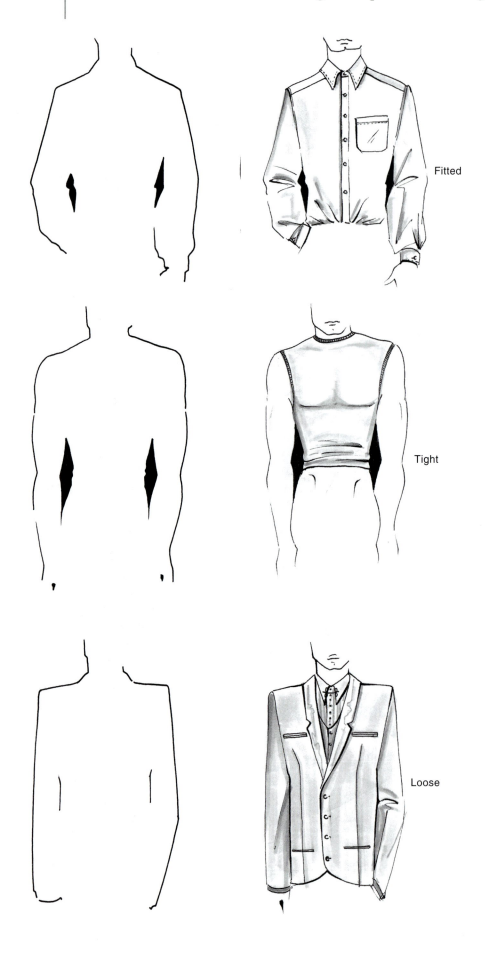

Fitted

Tight

Loose

Drawing Men's Pants

Most men's slacks or trousers are designed to rest on the hips, rather than on the waist as is the customary style in women's apparel. Therefore, the waistband curves down on most poses showing men's slacks. Keep the width of the leg proportionate with the rest of the figure, even when a tight fit is desired. Always include all the details, such as pleats and belt loops, common on men's clothes. Finally, focus on the areas of concern to the consumer; pockets, for example, are a subtle, but important, element in men's apparel.

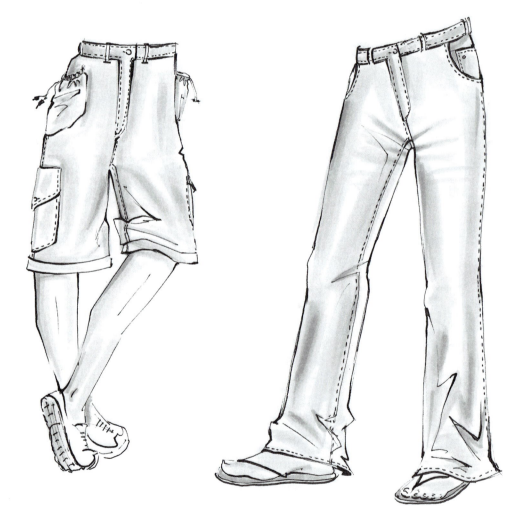

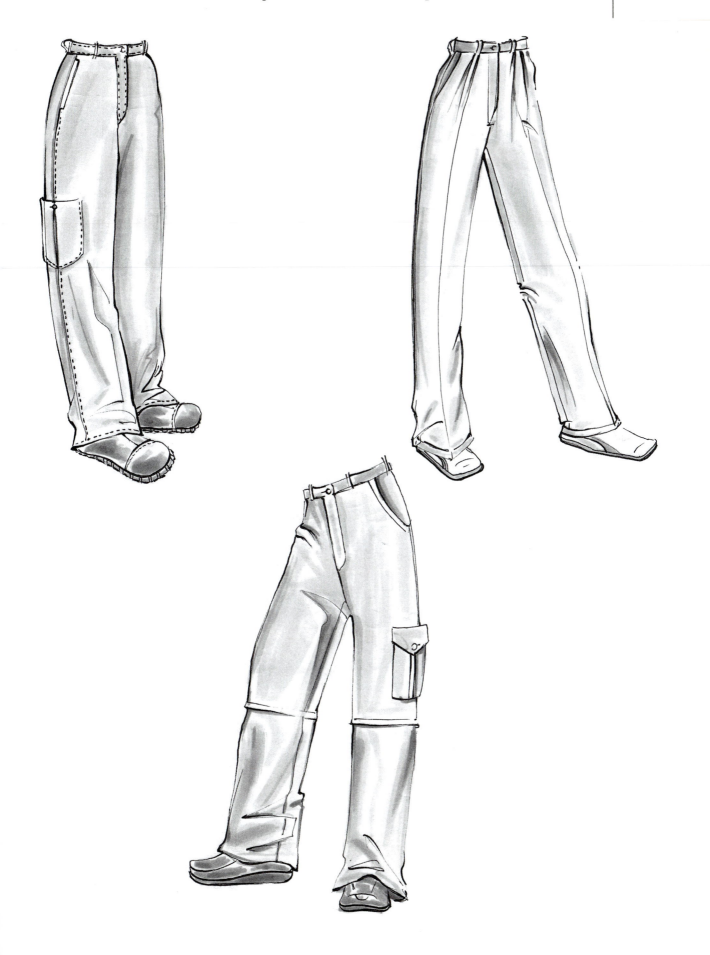

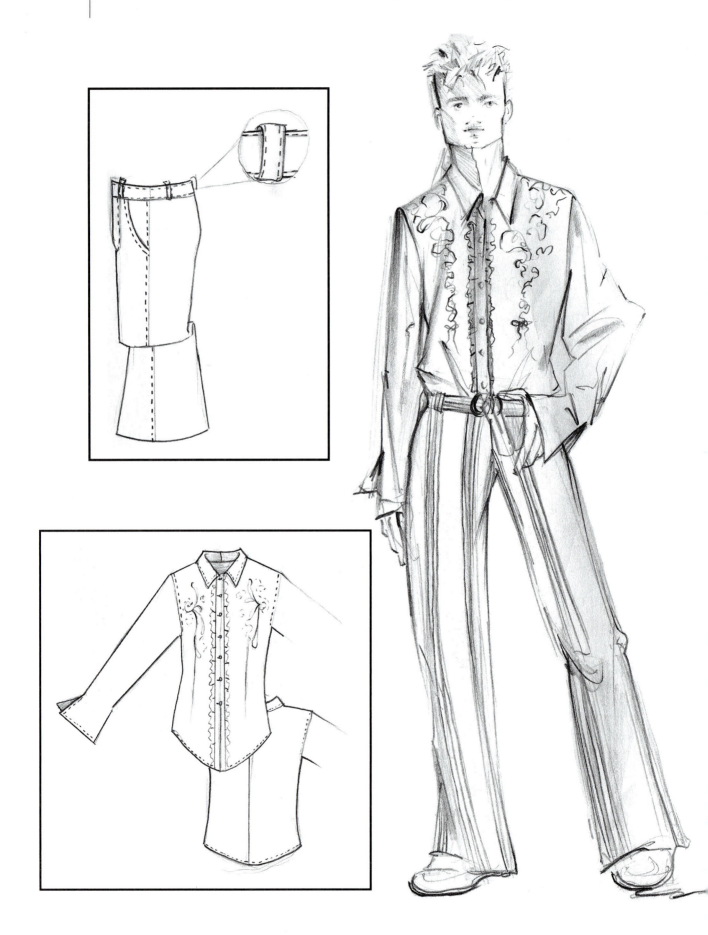

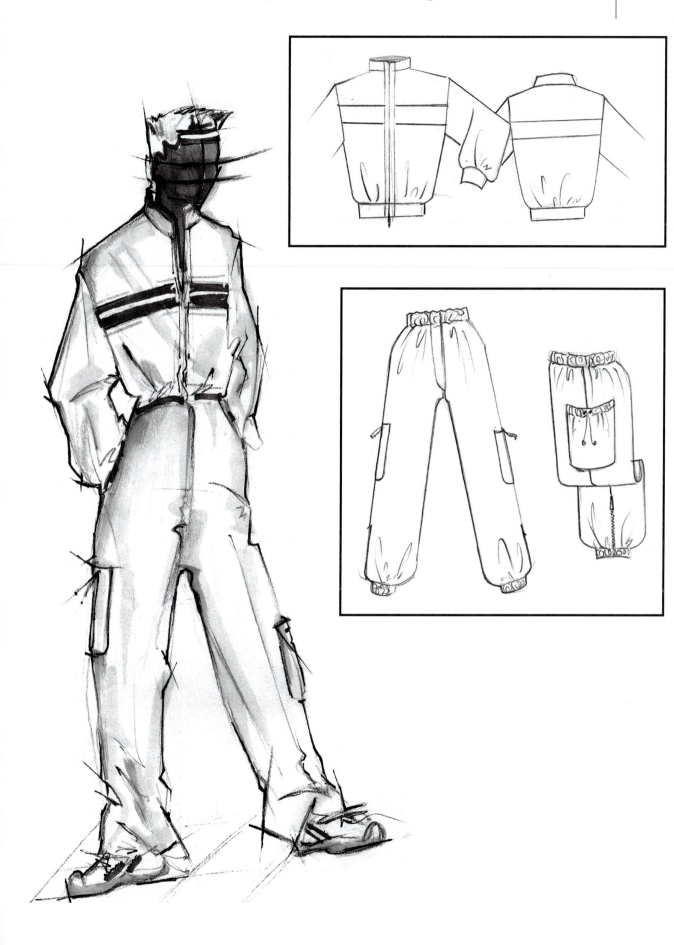

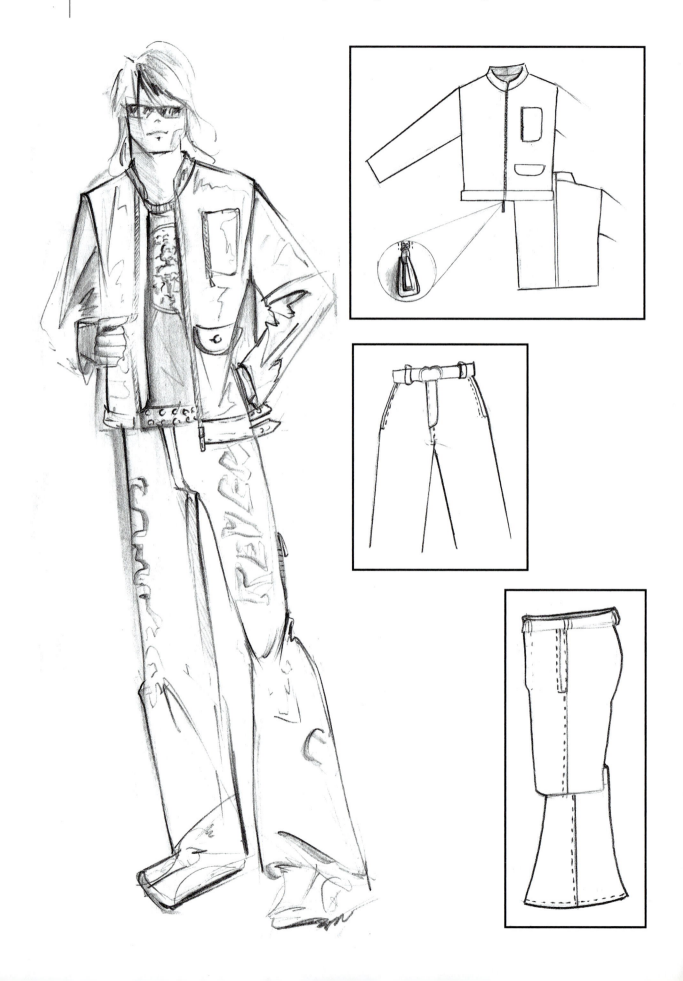

CHAPTER 5

Color in Design

In illustration, if the line drawing is the framework, light is what infuses life on the art. The use of both shadows and light adds depth and dimension to a design.

Colors evoke feelings. Red, for example, frequently symbolizes passion. It is no coincidence that the most popular lipstick colors are shades of red. Green is symbolic of abundance and wealth in some cultures. Black, the absence of all color, triggers fears of the unknown. Yellow and blue, frequently equated with sun, water, and the elements, are popular in summer. A designer first begins to attract customers by choosing colors that convey a desired mood. A good sense of color is as important to a designer's career as water is to life.

In fashion, color changes frequently yet very little. As much as designers would like to believe that color schemes for the seasons are a thing of the past, time and again retail sales prove that in the bright days of summer, wardrobes brighten up. In the fall, as the leaves change from yellow to orange and brown, the clothing people wear follows suit. Spring is synonymous with rebirth and purity. Thus, pastels flourish in wardrobes in that season. Old man winter seems to prefer black and gray, and not only for notoriety. Dark colors attract light thus keeping people wearing the darker colors in winter warmer. Finally, the use of color in garments may also provide people with protection from the elements as added safety features. For example, skiers wear bright-colored suits that make them more visible in the snow. Reflective colors keep joggers safer in traffic. In almost all team sports, color helps spectators and players recognize friends and foes.

Colors affect a person's work, life, and environment. The importance of color is integral in all areas of design. Colors should be studied carefully, combined masterfully, and reviewed as much as vision will allow in order to appreciate and take advantage of their infinite spectrum.

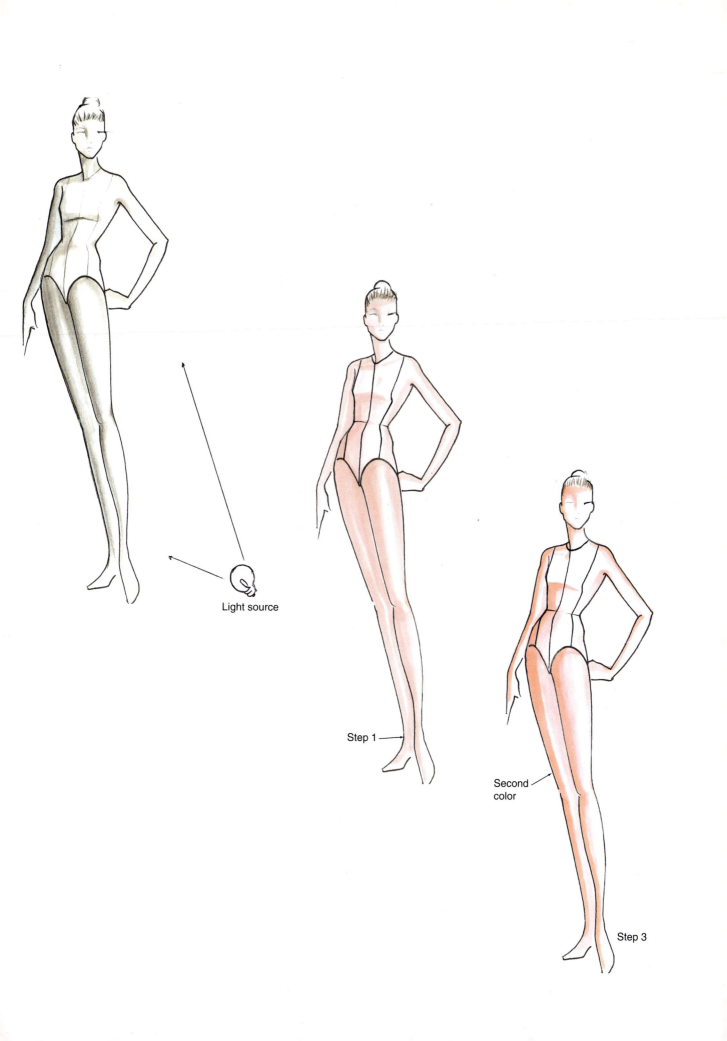

Light source

Step 1

Second
color

Step 3

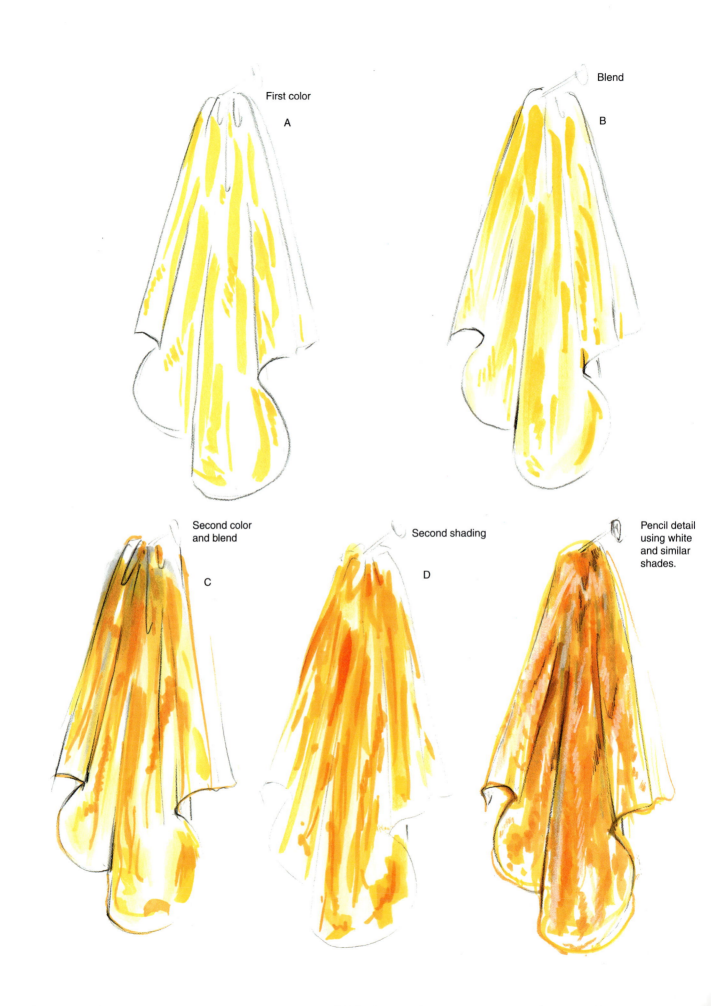

First color

A

Blend

B

Second color
and blend

C

Second shading

D

Pencil detail
using white
and similar
shades.

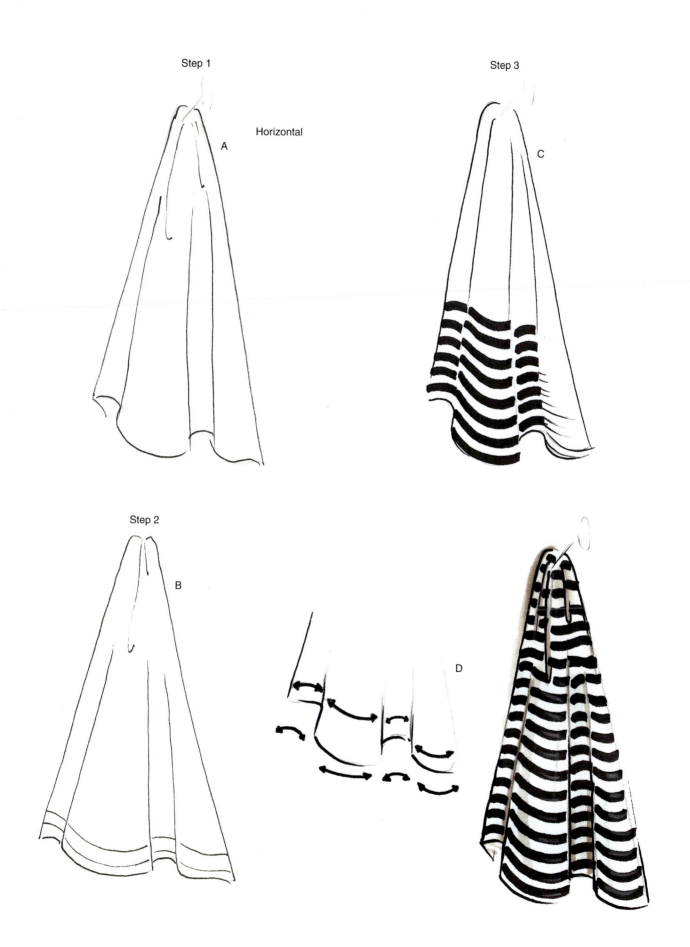

Step 1

Horizontal

A

Step 3

C

Step 2

B

D

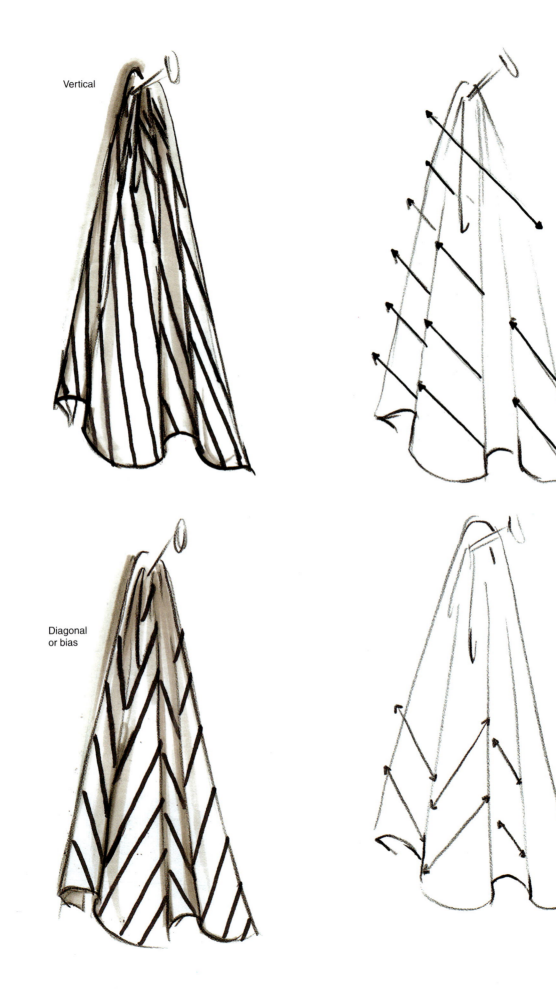

Vertical

Diagonal
or bias

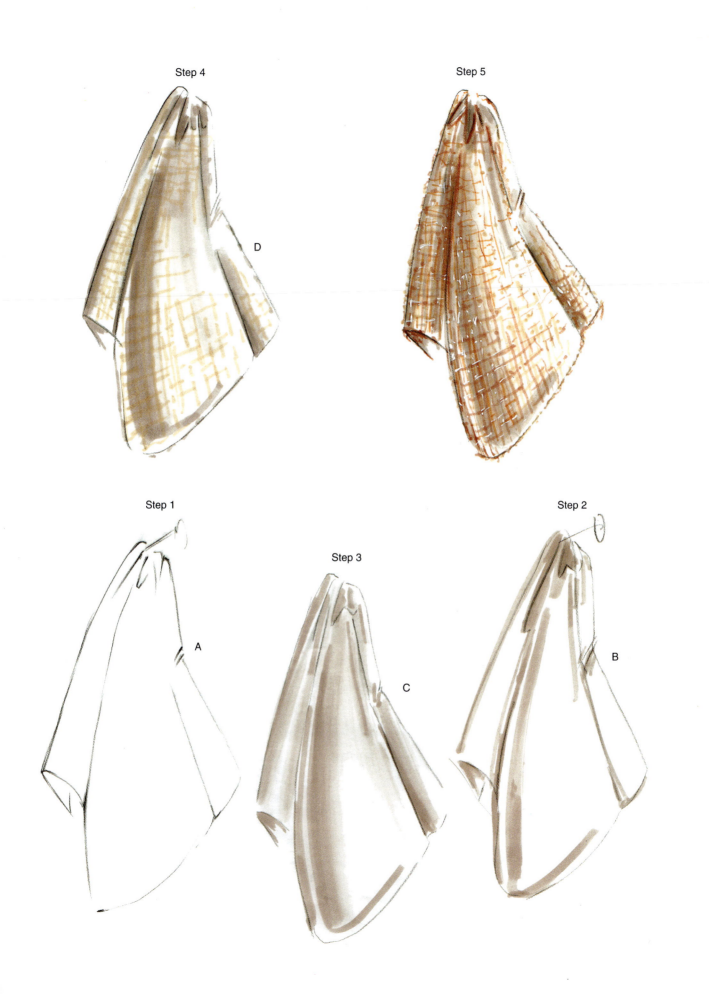

Step 4

D

Step 5

Step 1

A

Step 3

C

Step 2

B

A

B

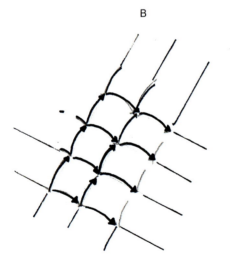

D

C

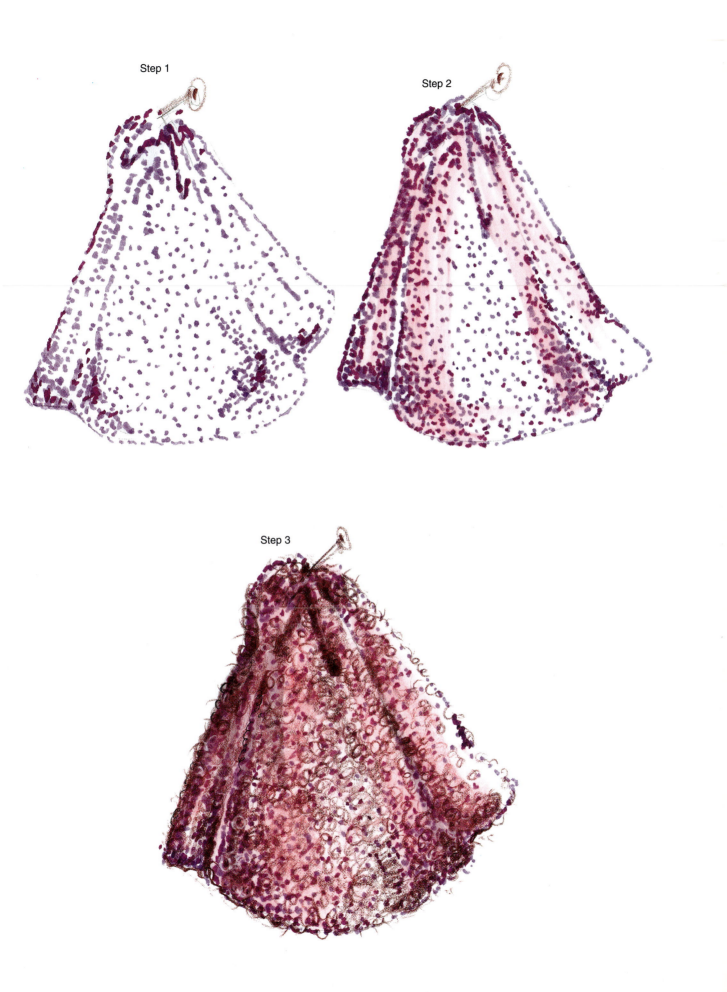

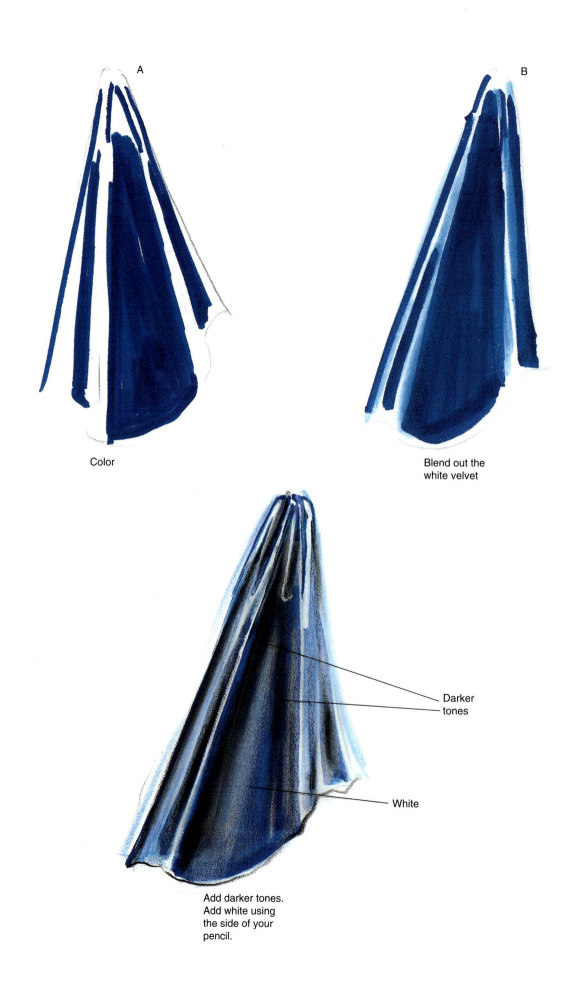

A

Color

B

Blend out the
white velvet

Darker
tones

White

Add darker tones.
Add white using
the side of your
pencil.

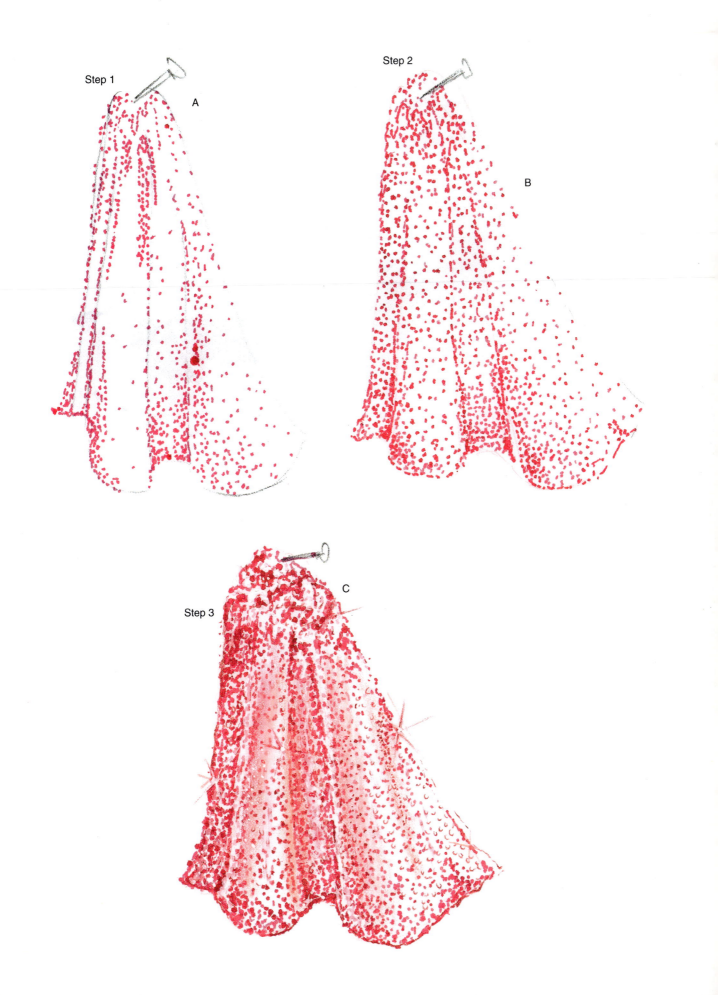

Step 1
A

Step 2
B

Step 3
C

Print

1

2

3

1 2 3 4 5

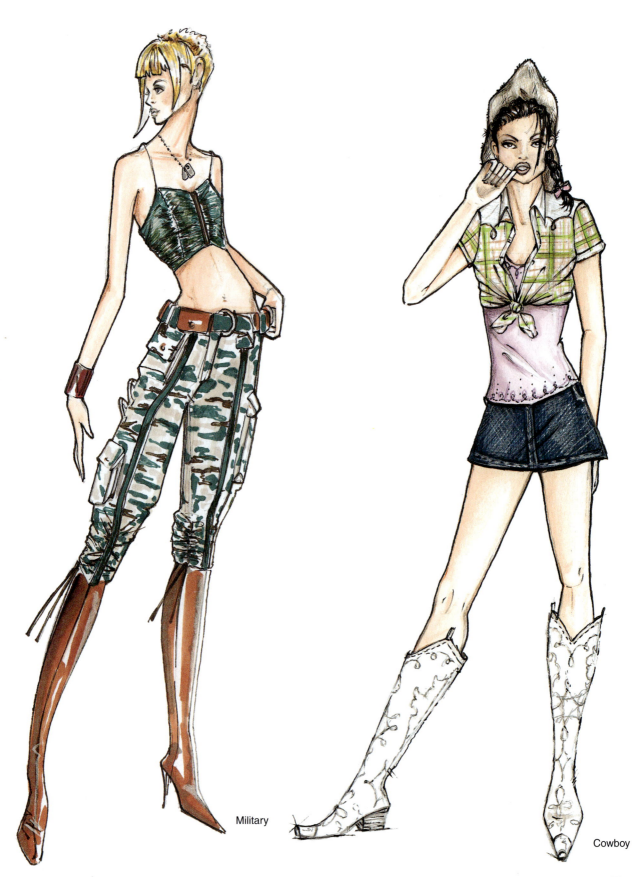

Military

Cowboy

With its heavy use of camouflage, the military look, like the rock star look, falls in and out of grace with fashion aficionados. Yet it seems to surge in popularity in times of national strife and war.

The western look is an adaptation from the pioneering cowboys. This early American look is associated with the wild west frontier days and relies heavily on the use of plaids and denims.

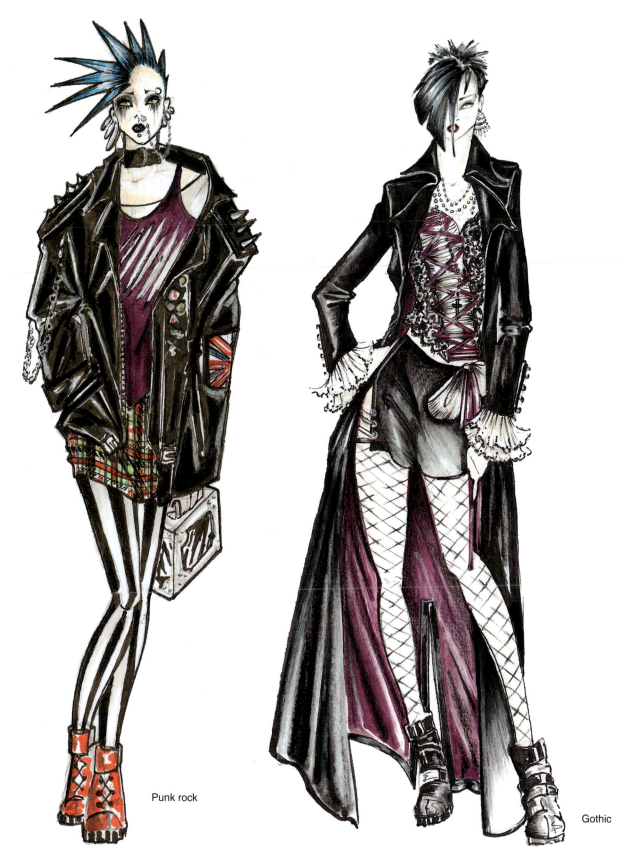

Punk rock

Gothic

The punk rock look takes its roots in the anti-establishment music by the same name. This alternative movement has been around since the 1970s when it was born in the streets of London.

Gothic or goth was born in the early 1990s club scene. This heavily accessorized look plays on the legend of vampires and considers itself a revival of the Gothic period.

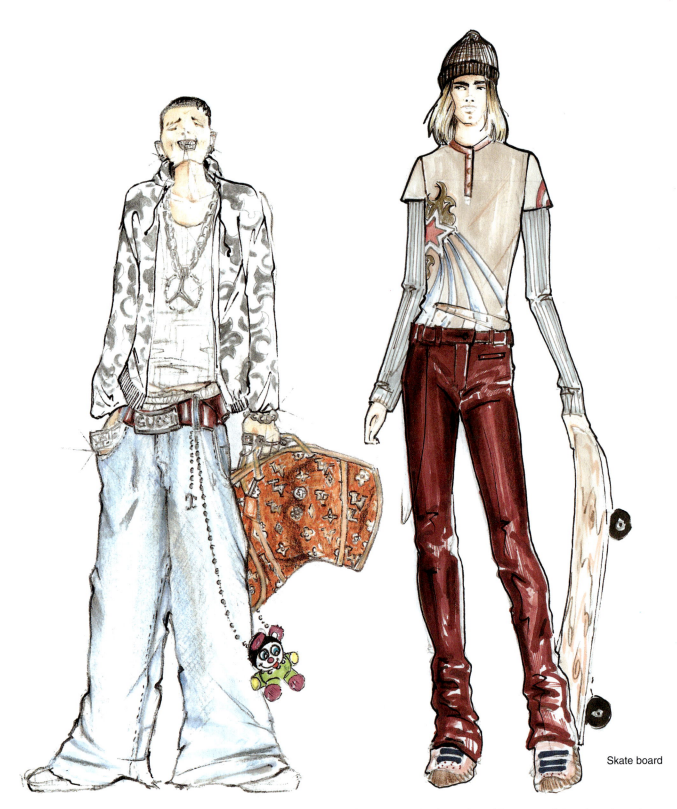

Skate board

The urban/hip-hop look takes its roots in rap music and has been evolving since the 1970s. Born in the inner cities of the United States, this frequently controversial movement and its music have revolutionized the fashion and music industries.

The skater look has been adapted from sport of skate boarding and is very popular with the younger generation.

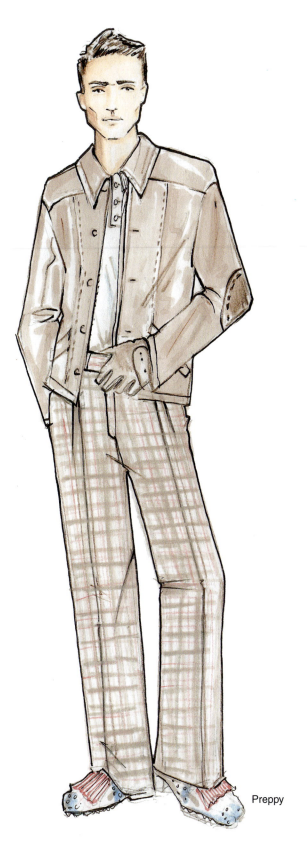

Preppy

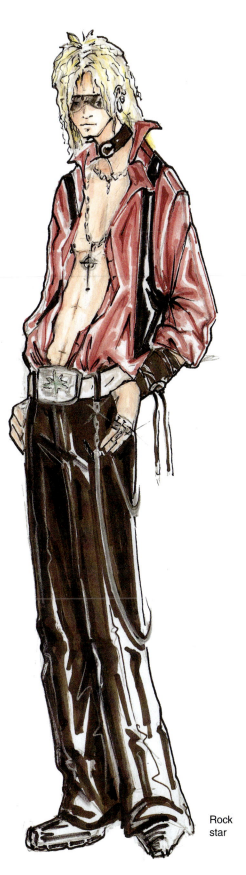

Rock
star

The preppy look is based on the clean cut all-American look, polarized in the 1960s by the Kennedy family and is rooted in the northeastern US.

The rock star look has been around since the 1960s and comes in and out of main stream fashion. But it always has a home in the world of rock and roll from which it was derived.

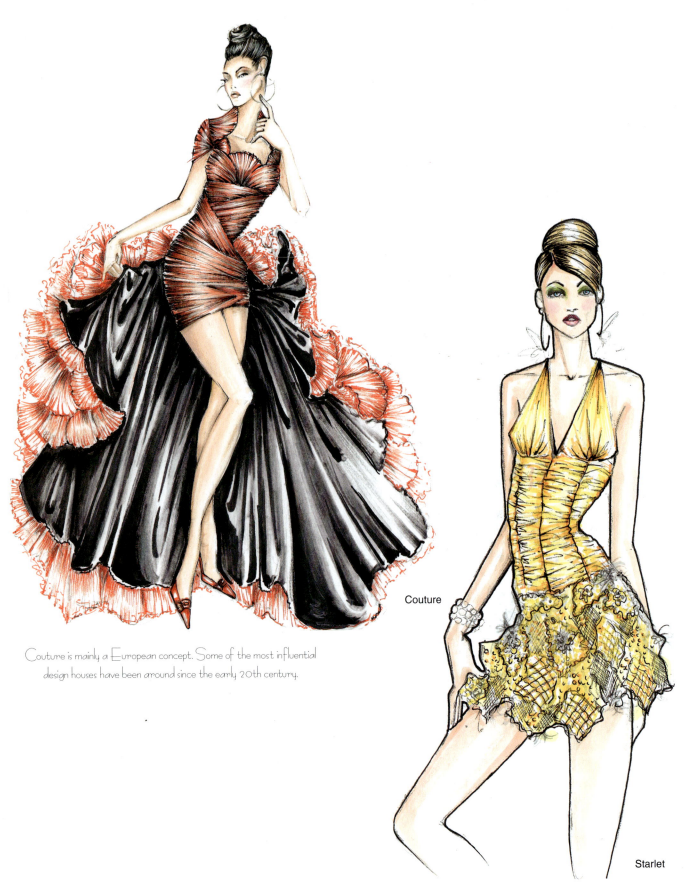

Couture

Couture is mainly a European concept. Some of the most influential design houses have been around since the early 20th century.

Starlet

The starlet look is a relatively new movement with an old name. The concept was born at the turn of the 21 century and glamorizes all things young. These skimpy outfits with usually hefty price tags strive to show off the body as much as the clothes themselves.

Using Markers

Today, markers are the first choice of designers for applying color. Markers provide a quick and reliable source of color, and there is a large pre-existing selection of them. Recently, the choices available for markers have been expanded to include colorless blenders as well as a myriad of tips and attachments that offer the ability to draw everything from graphic lines to airbrush effects. The method discussed in this section is geared toward creating a water color effect using blenders and color pencils.

Light source

Step 1

To begin creating the design figure, first choose a tip that is appropriate for the desired area. For example, on the pantone markers there are three tips—a large broad tip for large areas to minimize streaks, a medium tip for smaller areas such as the face and hands, and a very thin tip good for outlining and small details such as the eyes and lips. It is important to color an area quickly in order to avoid streaks. Therefore, a pre-existing knowledge of how light and dark color works is helpful; however, for beginning artists, a preliminary black and white shaded version is useful as a guide. When choosing a light source (where the light comes from), it is best to use a light source which comes either from the lower left or right hand side of your figure.

Step 2

Color the areas that will appear darkest first. Use the lightest color on the largest space. Leave the light areas colorless. Do not color the entire space. With your first shade of color, shade in down one side of your figure, keeping in mind that if your light is coming from the right, then all of the left side of your figure will be the darkest. Cover most of the area with this shade, leaving some of the space closest to the light colorless.

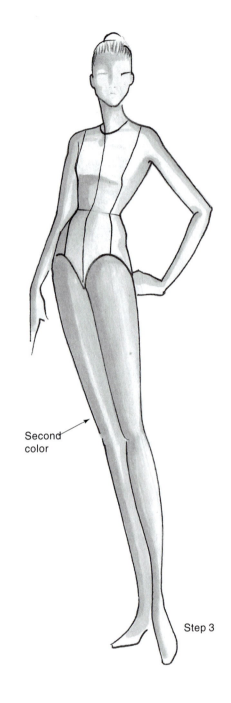

Second color

Step 3

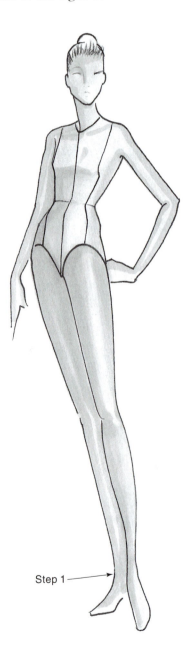

Step 1

Step 3

Once step 2 is complete, the colors and white spaces will need to be blended. Apply color from the marker to the blender by rubbing the marker tip over the blender. *Note:* If you place the blender tip over the color, it will not work.

Begin at the edge of the color that has been applied to the figure and blend the edge that separates the white of the paper from the marker color. *Note:* It is a good idea to test the blender first to make sure that the desired tone can be obtained. The more you use the blender, the more the color will fade.

Step 4

Next, choose a marker with a slightly darker tone and repeat the process. However, do not cover as much of the area as was done for the first rendition. The darker the color is, the smaller the colored area should be. Blend color and white areas by applying color to the previously blended areas; add blending where the two shades meet. Do not blend the entire area; this will make the figure appear flat. It may also cause the color to become muddy or spotty as the paper saturates.

Step 3

Third
color

Step 4

Finished
fully blended
3-tone

Shine

When rendering shine, it is important to leave a lot of white areas and a sharp contrast between the light and dark areas, with very little color progression in between. This process may be repeated many times. The more tones of one color used in succinct progression, the more three-dimensional the illustration becomes.

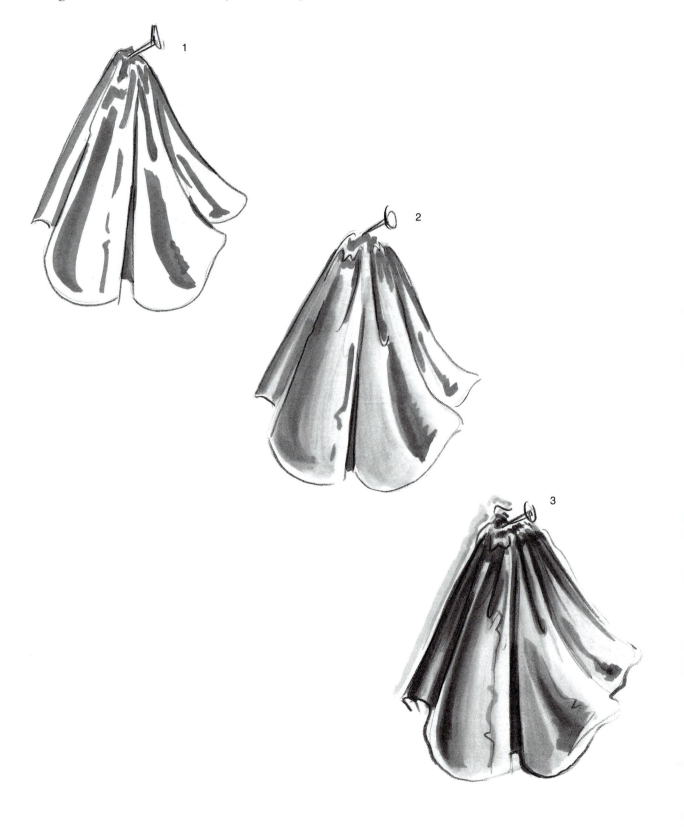

Color Pencils

Using pencils is important because they can help return definition to a sketch. They also provide a cheaper and sometimes more complete color source. However, using pencils is time consuming, and, depending on how heavily you rely on them, they may need to be replaced more often. They should be used to enhance a drawing; however, it is not desirable to use them to color large areas. Most color pencils are oil based, which restricts how much color can be applied before the surface becomes slick and will not accept any other medium.

Rendering

Rendering is a term used in art that refers to mimicking any surface on canvas. The following examples present the differences among basic groups of fabrics and prints. Each fabric must be handled in a unique way using these easy-to-follow steps.

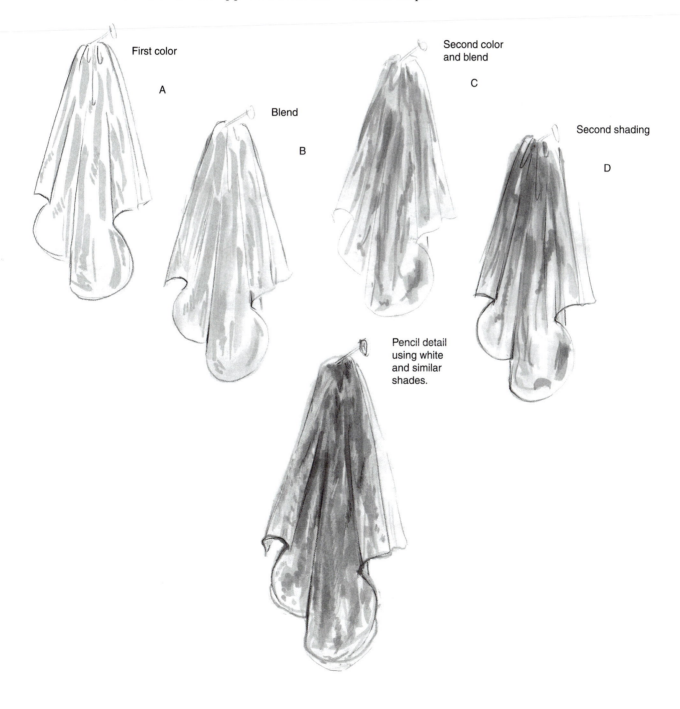

First color

A

Blend

B

Second color
and blend

C

Second shading

D

Pencil detail
using white
and similar
shades.

Regular Prints

Regular prints are fabrics with motif designs that are equally spaced one from the other, such as a polka dot or checkered pattern. In order to make it look realistic, one must scale down the actual print to match the scaled-down drawing of your garment. Unless the garment is drawn life-size, the print will have to be adjusted.

For example, if your drawing is smaller than the actual garment, then the print must be reduced. If the drawing is larger than the actual garment, the print must be enlarged. If you are drawing the garment to scale or actual size, then you must copy the fabric as in B. Note: Most of the time, the print will need to be reduced to fit your drawings.

1. *Fabric:* Draw in the shape of your fabric or garment, and include all wrinkles and folds.

2. *Graph:* Using a grid, map out where each motif will go. These will land at the intersection of each line to ensure equal spaces. *Note:* Use a pencil as these lines will need to be erased.

3. *Fill in design:* Using your marker, fill in the pattern of your print.

4. Erase the graph and shadows to the area. Keep in mind your light source when shading.

Stripes

Map out your stripe by placing a thin line going across your drawing, using the bottom edge of your area as a guide.

Draw in the lines using a width that will represent a smaller scaled-down version of the actual print.

Add shading to your fabric. Remember to choose a light source and place your shadows accordingly.

When adding stripes, follow the bottom shape of the fabric.

1. Background
2. Graph
3. Fill in design
4. Shading

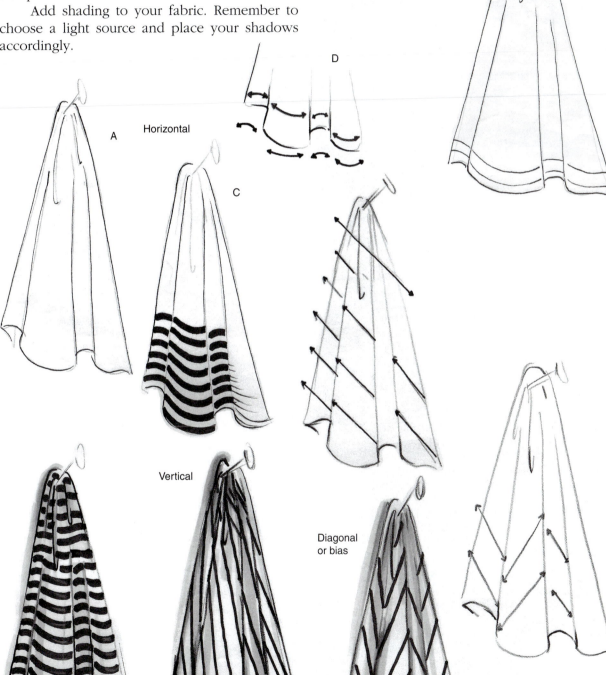

A Horizontal

B

C

D

Vertical

Diagonal
or bias

Textures

When working with textures, such as knits, quilting, or fur, keep the following key points in mind.

1. There should be no straight lines or edges around textured fabrics.

2. Choose at least three shades of each tone to provide high and low color contrast and add shadows to the darkest areas.

3. Mimic with your hand the surface of the fabric. For example, on flat colors, you want to glide the marker smoothly over the surface of the paper. For textures, you want to use a series of blotches or spots one over the other to create highs and lows of the same color. Light does not travel evenly over a textured surface as it does on a flat surface.

4. Continue to zero in on the most visible or notable fibers and add details such as patterns and fibers.

5. Bring back your folds and wrinkles as these may disappear under the colors.

Knits

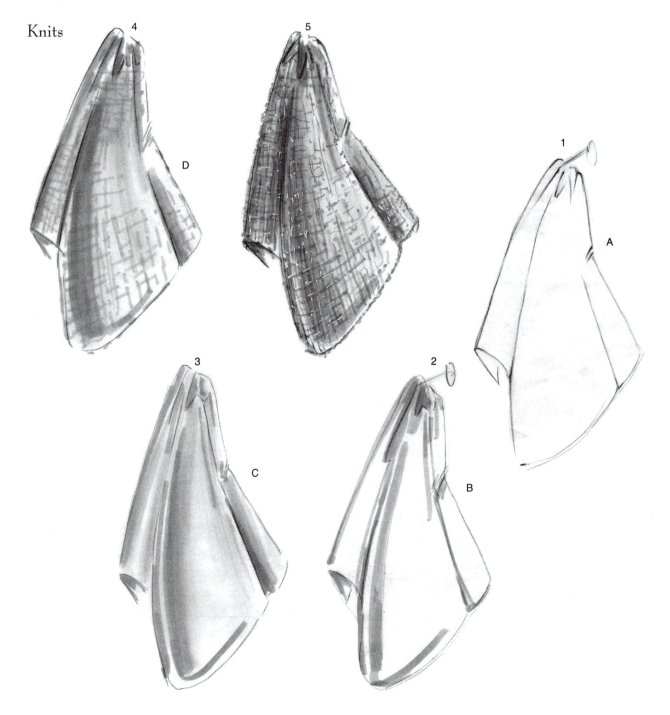

Quilting

Quilting is a good example of adding texture to a flat fabric. Although any fabric may be quilted, frequently the actual stitching over a thick filler will create a secondary pattern and texture to any fabric.

1. Create a graph.
2. Curve the lines on the graph.

3. Shade all of the remaining shapes on the same side. The light will not skip around so make sure you color each area on the same side.
4. Create stitch lines by redrawing or breaking the existing line. Then add pull lines and shadows at the cross points.

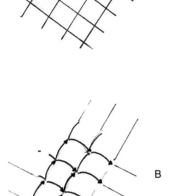

A

B

C

D

Boucle is an example of an extremely textured fabric.

1. Begin with your lightest color and fill in the area with a series of color blotches or spots. with a denser concentration on the folds or wrinkles where the darkest areas should be.

2. Repeat the process with a darker color. It may be necessary to use two different shades for this step.

3. Using a color pencil, add the nap and yarn using a circular motion over the entire area of your fabric.

Fur

Fur is a textured surface that is acheived by using a series of thin straight lines to achieve an area of dense hair or hair-like fibers.

1. Establish your darkest areas.
2. With a lighter color, add the actual color of the fur.
3. Blend the edges of these colors together.
4. With a color pencil, add the individual hair to create textures. It is also necessary to cover in with an opaque white pen or pencil to add the shine of the fur.

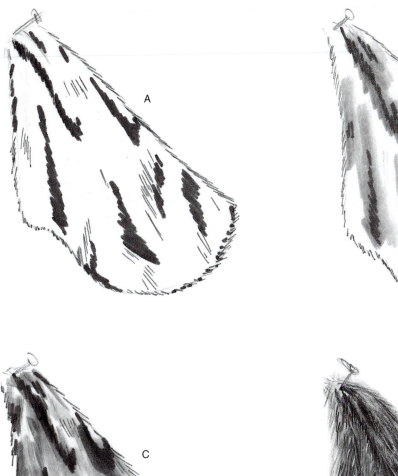

Sequined Fabric

1. Using very small dots in your lightest color, begin to fill in your garment or shape. Keeping a denser concentration over the darkest areas such as folds and wrinkles.

2. Using a darker tone of the same color and a larger tip if necessary, repeat the same process.

3. Once the entire area is covered, bring back lines which may have disappeared beneath your color. With a white opaque pen or pencil (using the same method) dot in your lightest sequins and add sparkles.

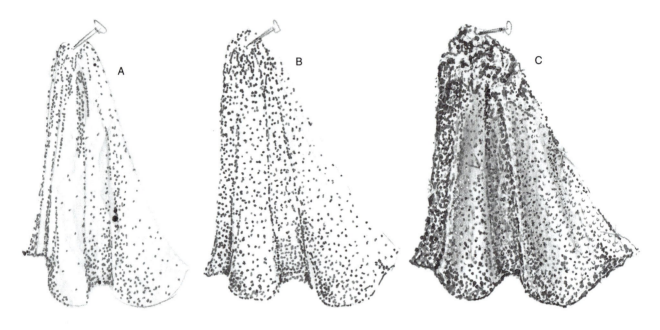

Solid Fabrics

1. Fill in your area using a smooth stroke. Start at the darkest parts.

2. Blend out the edges of your color keeping the lightest parts closest to your light source.

3. Add a darker color over the existing dark areas to create a dramatic contrast. Note: The shinier the fabric the greater the contrast from the darkest color to the lightest in rapid succession.

Color

Blend out the
white velvette

Add darker tones.
Add white using the
side of your pencil.

Darker
tones

White

Sheers

Sheer fabric is see-through, thus creating the appearance of various layers in different tones as the layers overlap. Apply color, leaving the most white in the center as the fabric appears to separate.

Gathered or Layered Sheers

On sheer fabric, the darkest areas will occur even when there are many layers that overlap. Where the fabric is overlapped, such as the hem of a skirt, the darkest color concentration will be at the bottom where the fabric will fold over itself.

On a gathered piece of sheer fabric such as on an elasticized waist band, the darkest color will appear at the top when the fabric is pushed together and the bottom will separate and become lighter. Note: On most garments, there will be multiple hems or at least two, because the back will also show through the front unless the garment is lined.

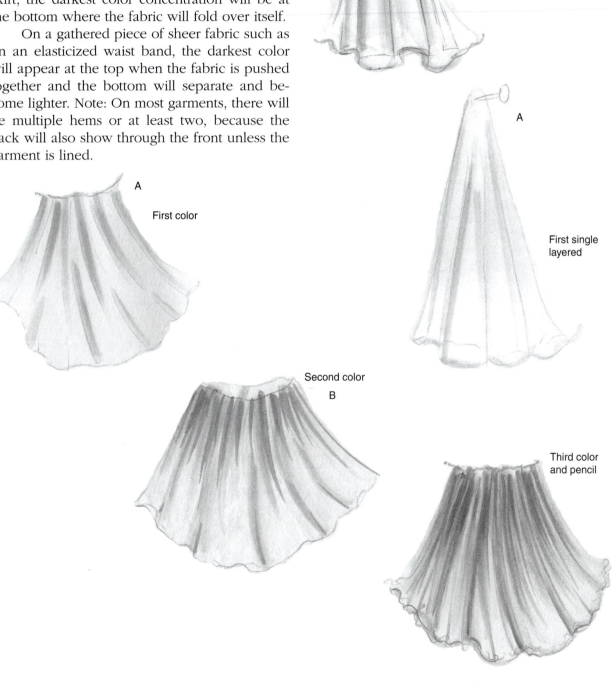

A

First color

A

First single layered

Second color

B

Third color and pencil

Tulle and Lace

Tulle and lace are basically the same thing. Tulle is a net-like fabric which most people recognize from wedding veils for which it is used.

Lace is tulle which has been embroidered on top to create a pattern. Most laces are created this way and have a finished edge, usually scalloped.

The one shown here also has feather tuff appliques.

1. Create shadows according to your light source. Concentrate most of the color on the darkest parts.

2. Create the netting by creating a very light grid. As the fabric overlaps there may be multiple grids showing through. Add more lines to obscure the areas where the layers overlap. A color pencil works best on this step.

3. Map out a pattern of choice or according to your fabric.

4. Use a marker or darker pencil so that it may be visible on the background and fill in your pattern.

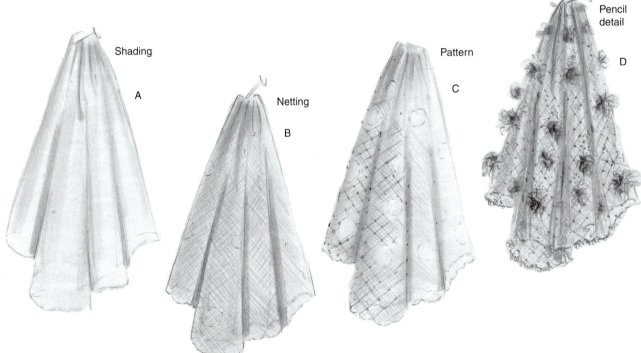

Shading

A

Netting

B

Pattern

C

Pencil detail

D

All-Over Prints

There are three important things to remember when using all-over prints, or fabrics whose repeat patterns are not apparent.

1. *Shape.* What will be the shape of the design? To eliminate detail in order to concentrate on the shape, squint your eyes and focus only on the configurations of the design.

2. *Color.* Be sure to use all of the colors that appear on the print.

3. *Scale.* Choose an appropriate size for your print in proportion to the figure. Your print will need to be reduced according to your sketch. Drawing your pattern the size which it is will give the appearance on a small drawing of being bigger than it would actually be on the garment. This is very important or you could misrepresent your fabric if you are not careful.

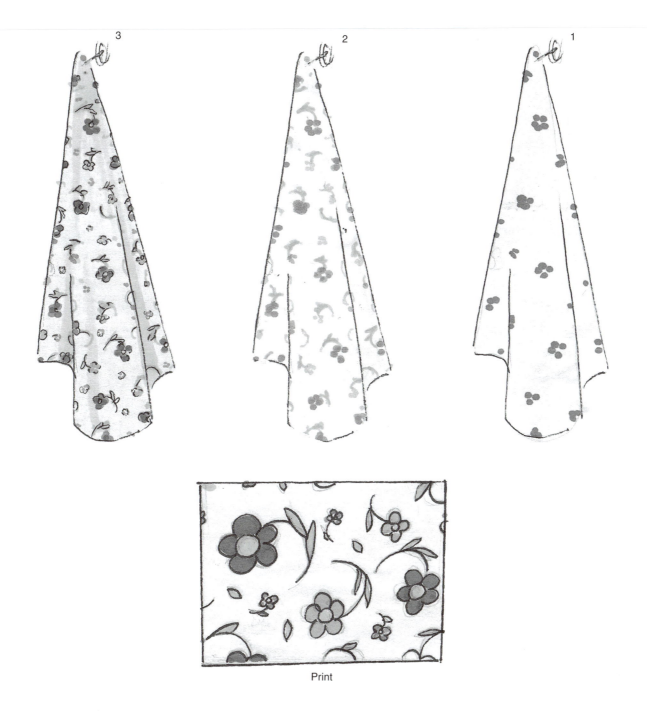

Print

Here are some examples of garments and how light affects them. The light on these examples is coming from the front lower left hand side and is traveling up, highlighting the body underneath.

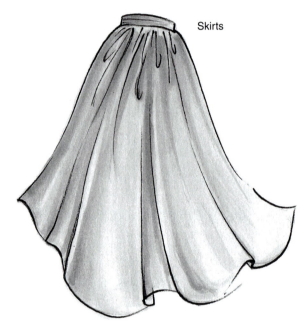

Skirts

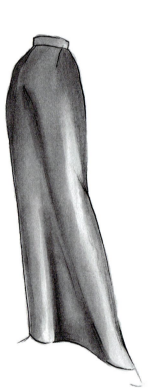

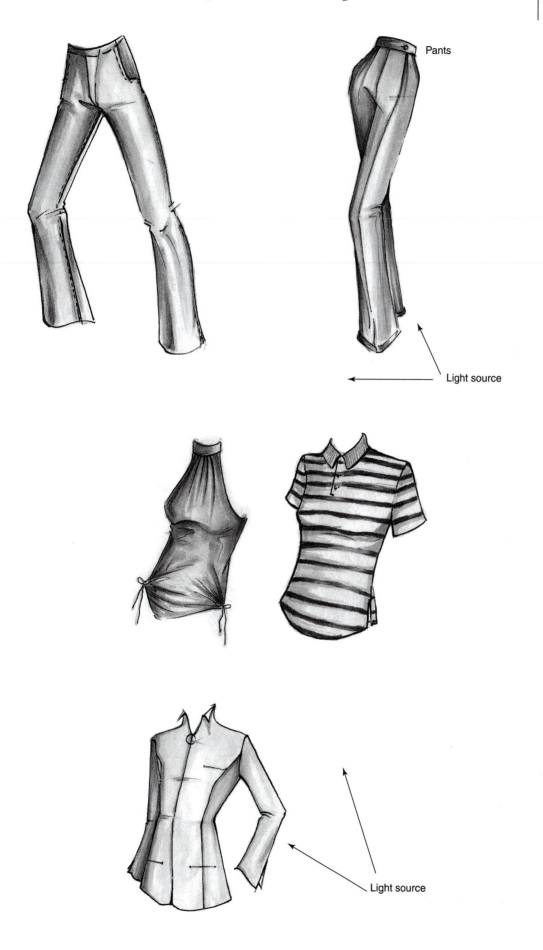

Pants

Light source

Light source

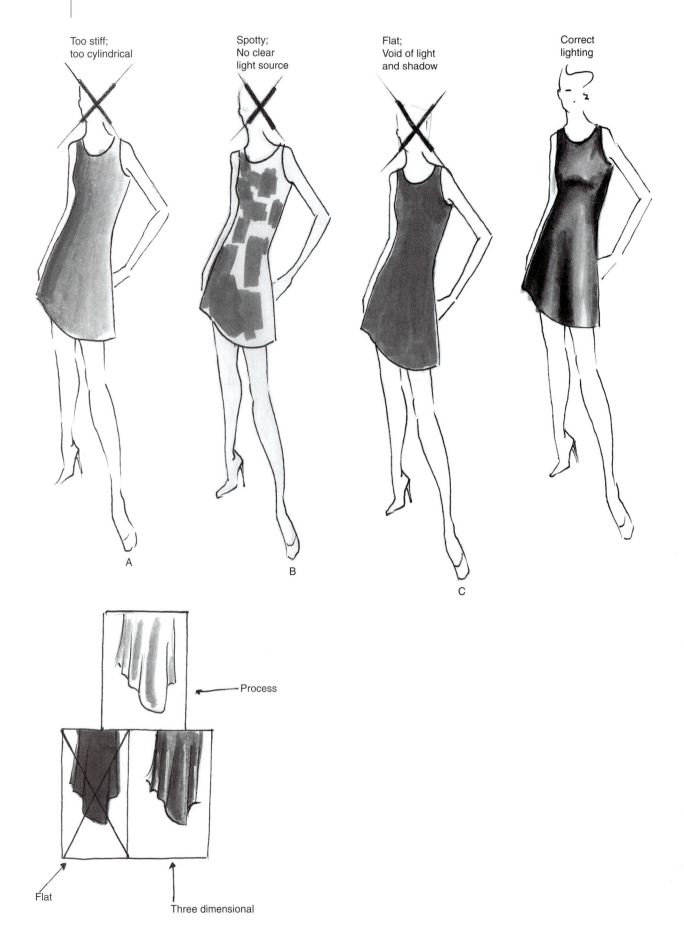

Too stiff;
too cylindrical

Spotty;
No clear
light source

Flat;
Void of light
and shadow

Correct
lighting

A

B

C

Process

Flat

Three dimensional

CHAPTER 6

Figures and Fashions for Children

Drawing children poses an exciting challenge for the fashion illustrator. There are no preconceived poses or stances as dictated by fashion. Instead you must capture youth itself through the movement of the figure and the mood of your artwork. The art itself must be fun, energetic, and fresh.

Because the years' from childhood to adolescence bring rapid change to the body, there are a different set of proportions according to the age group you are trying to illustrate.

In this chapter, you will learn to use simple shapes to achieve overall form and line to develop further detail to your art. It is important to simplify what you know about the human body for drawing children and round off the shapes to create a rounder figure less structurally defined by the skeletal frame of the body.

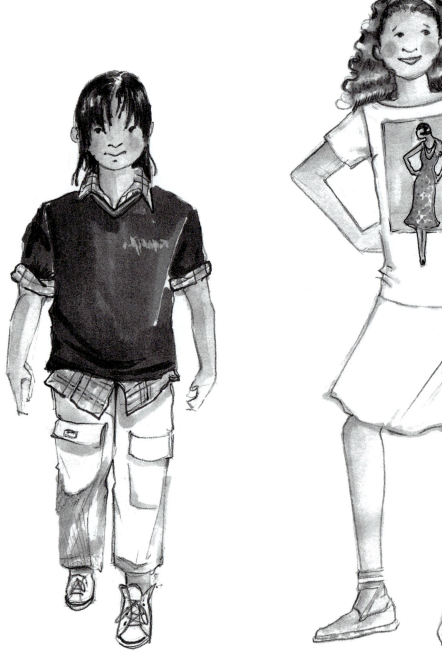
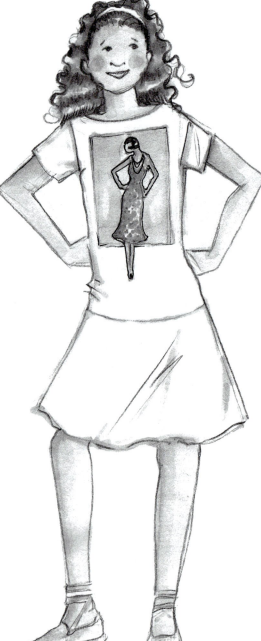

Drawing Infants

Children do not begin to show discernable gender characteristics for at least 6 to 12 months after birth. Their clothes often distinguish boys from girls. The most frequently used identifier for children is color; pink for girls and blue for boys.

The general shape of the body and face for male and female infants remain the same at this early age. Because infants cannot stand, and most of their extremities are foreshortened, designers must establish shapes for these children.

Step 1

Draw the head. Infants' heads are large and somewhat disproportionate to the body. However, be careful not to overexaggerate proportions, which will cause distortions. Then extend a line 2 times the length of the head for the body.

Step 2

Draw the body. Using the shape shown in the accompanying diagram draw the body; leave little space for the neck, making sure that the widest point of this shape does not exceed the width of the head at its greatest width (in this case usually the shoulder line).

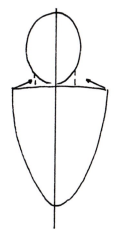

Step 3

Using the shapes shown in the accompanying diagram, draw the legs, beginning at the center of the torso shape which makes up the body.

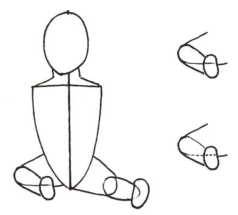

Step 4

The arms and legs of infants usually are not positioned in completely straight poses, and the fingers usually are gripping rather than extended.

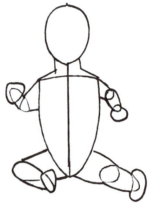

Step 5

Draw the facial details and hair. Do not draw excessive hair; this will also distort the drawing. Add the details to your garments and review your sketch. See later sections in this chapter for more information on drawing faces.

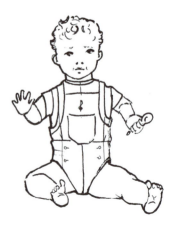

Drawing Toddlers

The proportions used to draw infants are much more realistic than those used to draw men or women. The head appears larger and the torso is about two heads in length. The legs are then added in a sitting position to depict an infant or extended in a standing position for a toddler who has just begun to walk. The body stays the same; it is the pose that changes.

Foreshortening of the limbs is much more common in children. Foreshortening is the appearance of a full limb in a bent position without appearing smaller than it would in its extended position. This is achieved by drawing overlapping shapes and eliminating the lines. We would not see were these shapes solid.

Step 1

Draw a circle for the head.

Step 2

Extend a line 3 1/2 to 4 times the length of the head down from your shape.

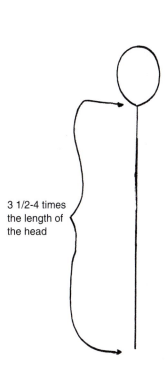

3 1/2-4 times the length of the head

Step 3

Find a waistline by placing a mark on your plumb line. To find this area, measure all the way from the top of the head down to the bottom of your line and place a mark at the half-way point for the waistline. From this point down, place a mark 1/2 the size of the head. This serves as the end of the pelvic box.

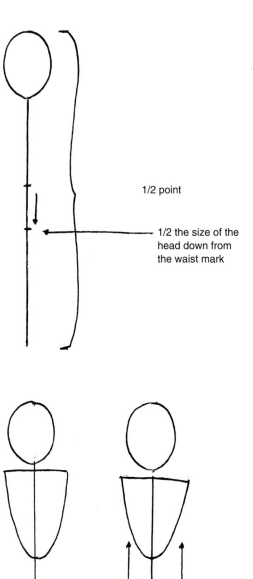

1/2 point

1/2 the size of the head down from the waist mark

Step 4

Place the shape shown directly under the head and extend it below the waist mark to the mark done for the waistline.

Note: The width of this shape at the shoulders or the widest point should be the same size as the head or slightly larger. Two heads in width is too much.

Step 5

Extend a curved line out to either side of this shape at the bottom to create the end of the pelvic box.

Note: Full length of both curved lines together must be less than that of the shoulder width. Draw a line up from either side of this shape to connect it to the top shape. This closes off the pelvic box.

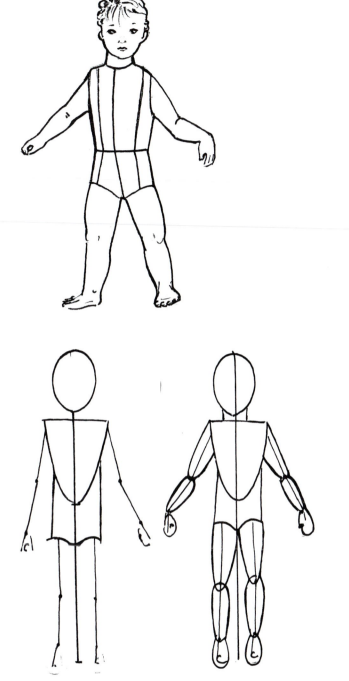

Step 6

Using gesture lines and dots for the joints, establish the gesture of the limbs.

Using rounded shapes, enclose the gesture lines and shape the arms and legs.

Note: The feet may drop past the end of the line to allow for shoes, however, keep the feet and hands to a minimal size.

Drawing Boys Ages 5 to 10

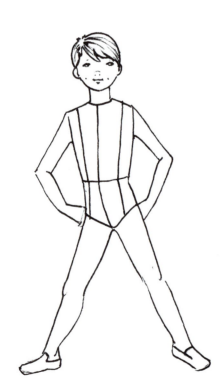

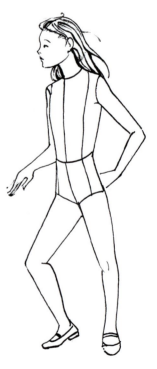

Drawing Girls Ages 5 to 10

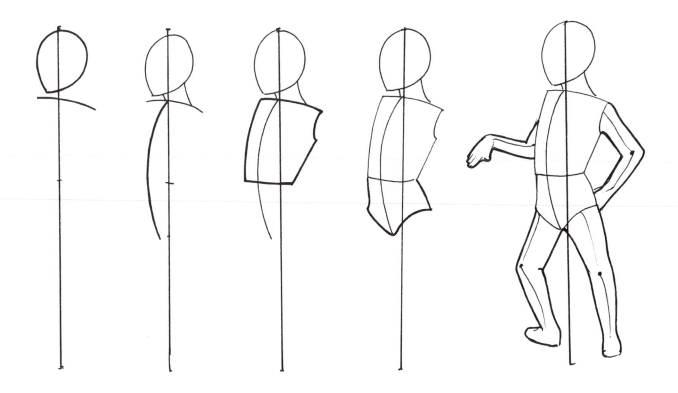

Dressing the Figure

Step 1

To begin drawing a clothed figure, first draw a vertical line the length of the desired figure. Mark off the top, bottom, and center. The center mark will serve as the indicator for the waistline.

Step 2

Draw the head and shoulders. The neck of a young child is longer and more apparent than that of an infant. At this point, also draw in the angle of the waist.

Step 3

From the pit of the neck on the intersection of the center line and plumb line, sketch a gesture drawing for the body and legs. Note that the gesture drawing should include the center line of the body, which usually is different from the plumb line.

Step 4

Sketch in the general shape of the garments.

Step 5

Add shape in the areas not covered by the clothes. Girls may have shapelier legs and smaller waists.

Step 6

Add faces, hands, and feet. For girls use longer, pointy fingers. Use less character in boy's hands. It is also best to position boys' feet firmly on the ground. Remember, extend the feet slightly below the bottom of the center line.

Note: The general gestures and character exhibited in girl figures is more animated than that usually used for boys. The body mass may also be different, as may the shape of the legs and arms.

Boy Figures

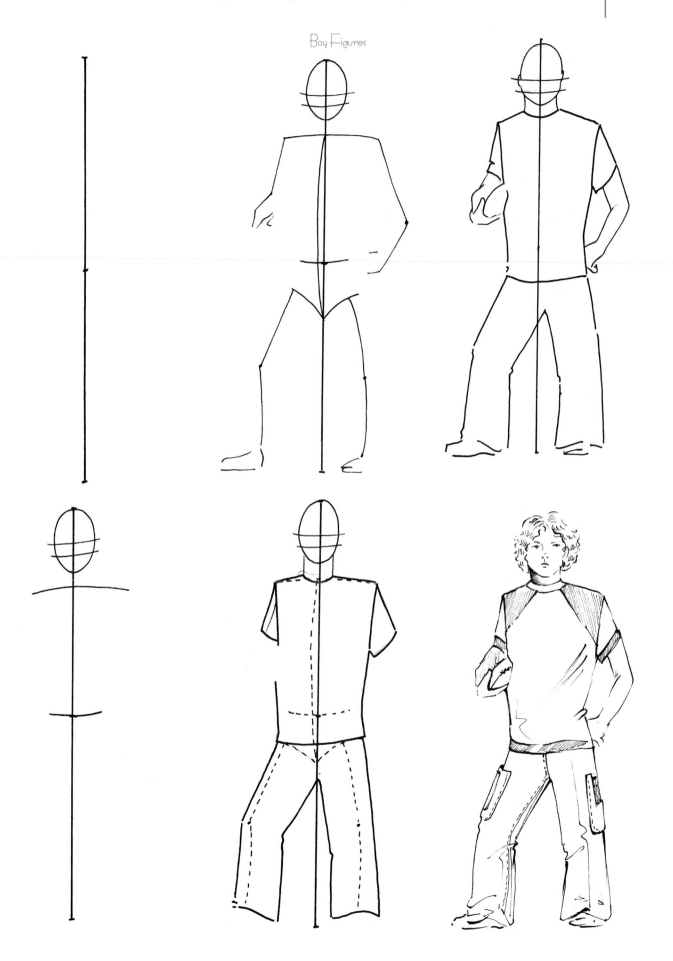

Girl Figures

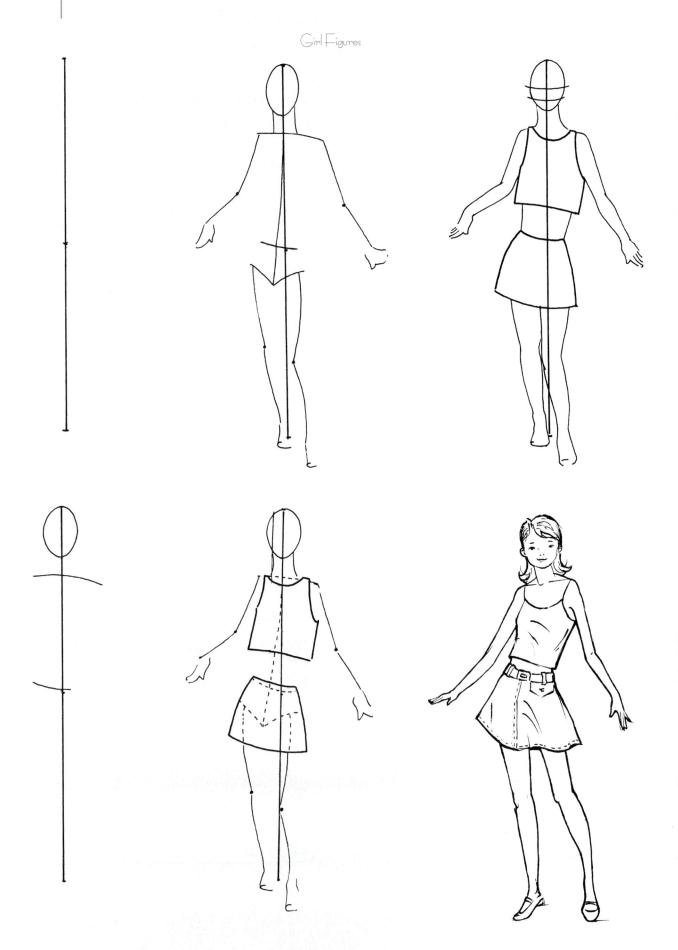

Gestures for Girls

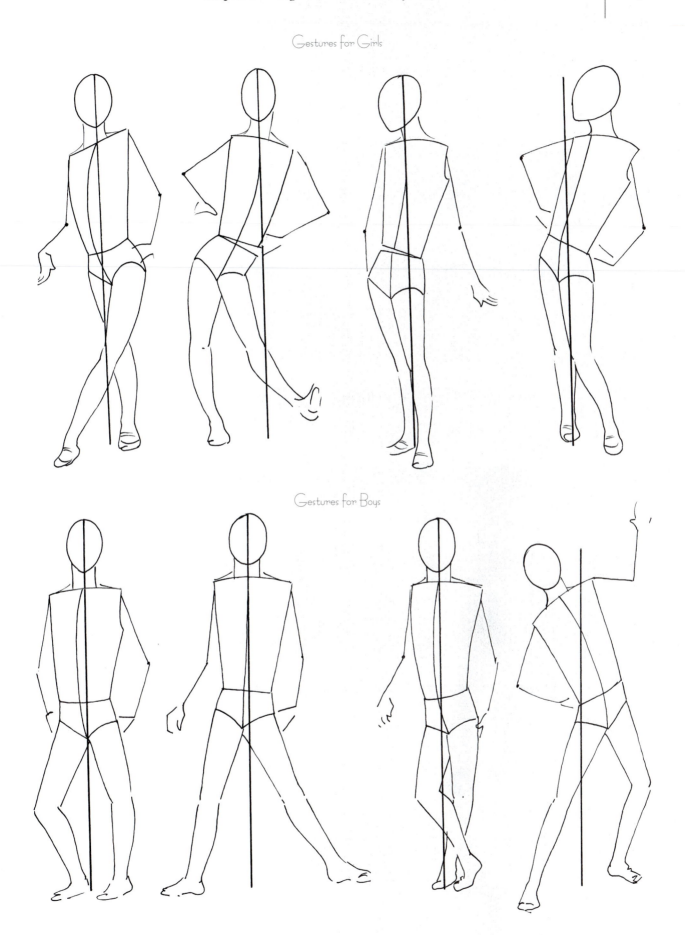

Gestures for Boys

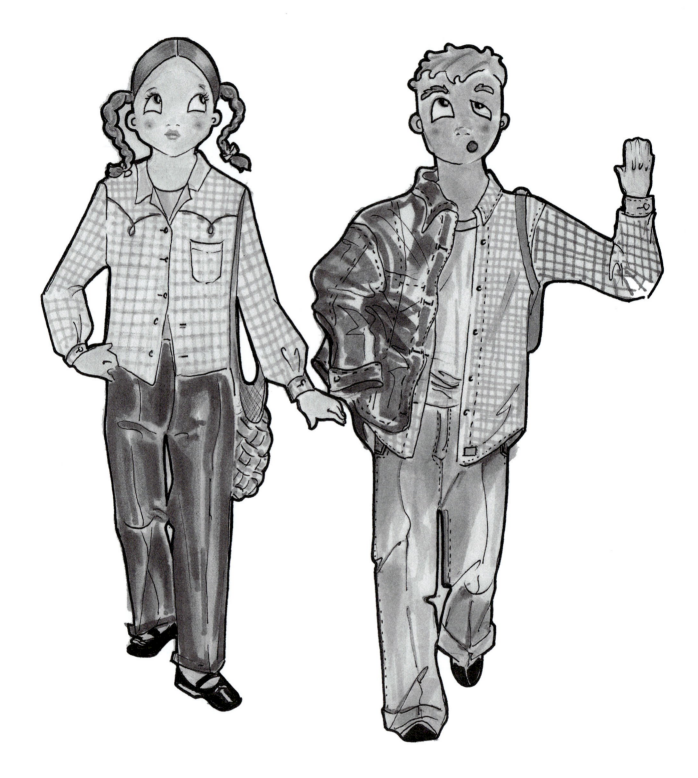

Faces

Step 1

Draw a round or oval shape for the head. Note when drawing infants, it is best to use a round shape, because the bone structure is not visible at such an early age.

B. Divide the shape in the middle vertically and horizontally and divide the bottom portion in half as well.

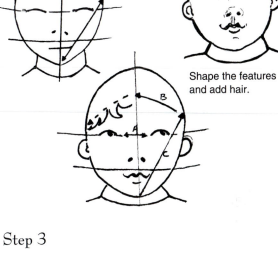

Shape the features and add hair.

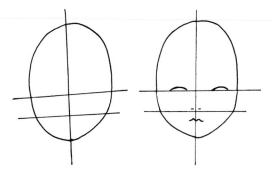

Step 2

Establish the placement of the features by darkening in the part of the line where they will be placed.

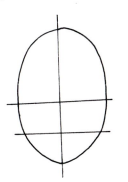

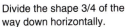

Divide the shape 3/4 of the way down horizontally.

Step 3

Shape in the features. Keep 1 eye's distance between each eye—making them wide and visible. The nose or nostrils should be placed right above the second horizontal line. Place the mouth beneath the second horizontal line under the nostrils. The width can be established by measuring diagonally from the corner of the mouth.

Step 4

Establish a hairline by using the corner of the eyes as a guide and shape the features.

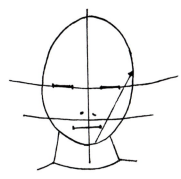

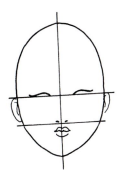

3/4 View

1. Draw the shape shown and divide it by placing a vertical line which will define the center of the face. In this case, it is off toward the right. Then divide in the center twice horizontally—once in the center and again to divide the bottom part in half.

2. Shape in the contour of the face. Start at the top of your shape. Come down the side to the first horizontal line and dip in for the eyes. Continue by coming out for the cheek and dip back away from the side until you pass the second horizontal line and back out to detect the outside line. For the chin, erase the outer edge and shape the contour of the face.

3. Establish the placement of the features by darkening in the appropriate space.

4. Draw in the appropriate view of each feature over the lines drawn you have darkened.

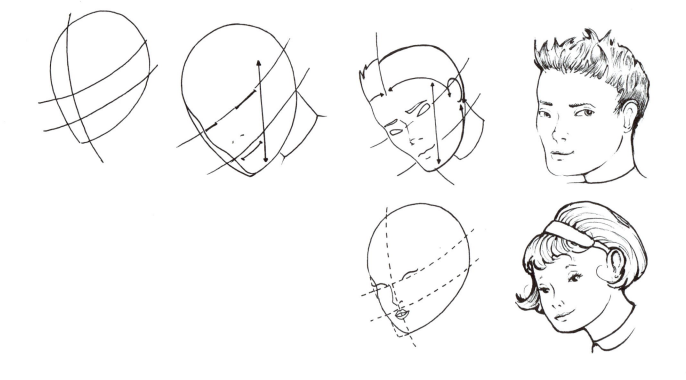

Eyes, Nose, and Lips

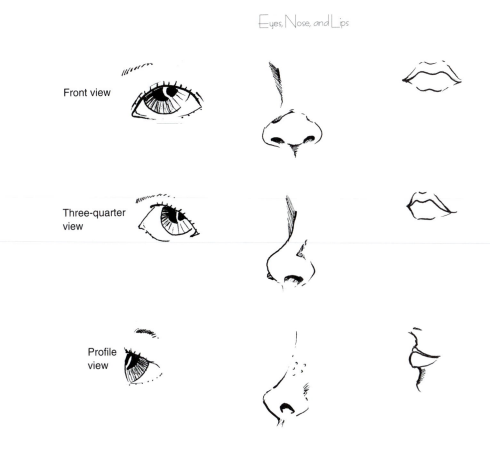

Front view

Three-quarter view

Profile view

Hair

Step 1

Begin the figure by establishing the desired facial shape.

Step 2

Curve and add the shape to achieve a natural look.

Step 3

Divide into sections and shade.

Refer to the accompanying diagrams for some ideas on different hair styles with various textures.

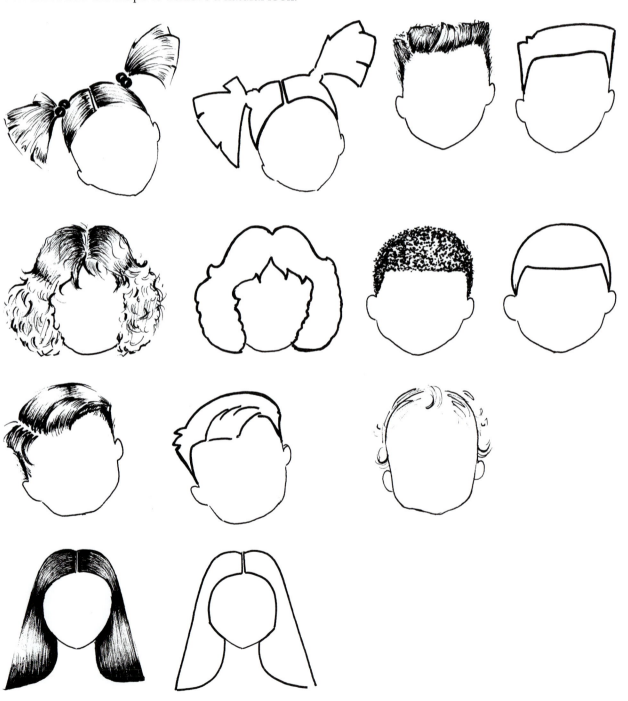

Facial Shapes

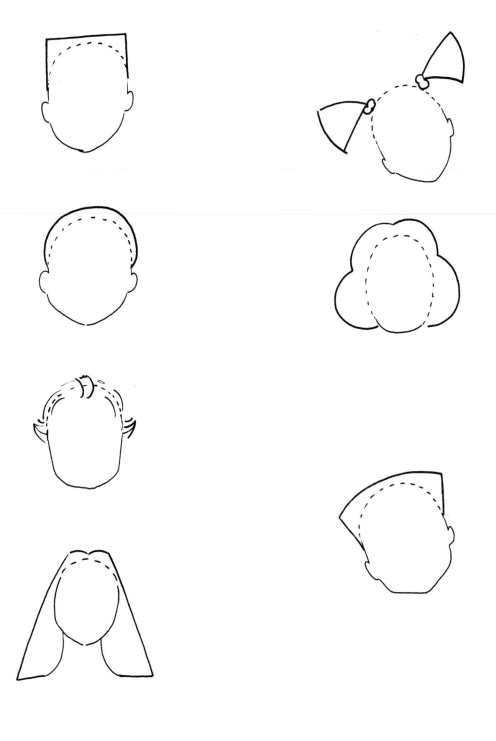

Hands

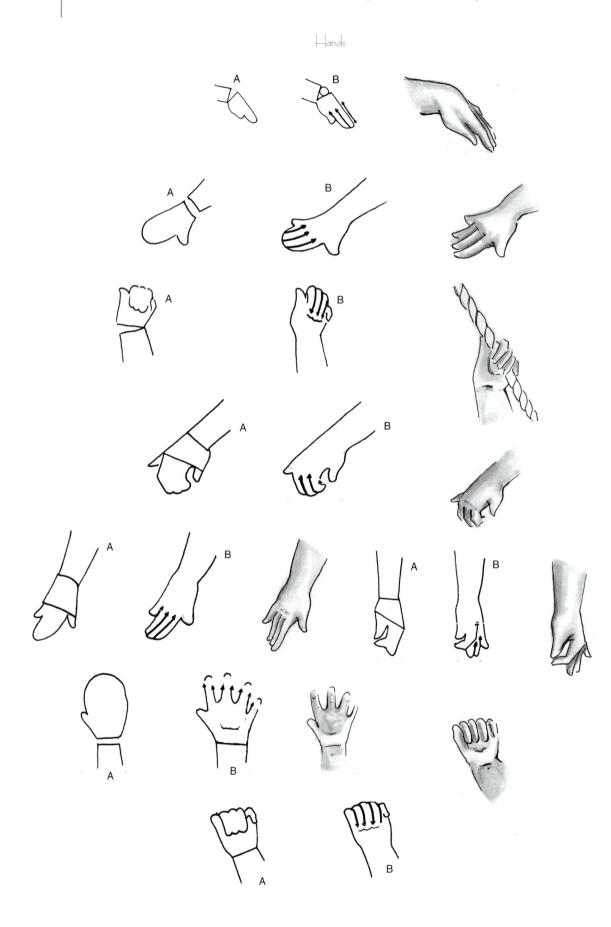

Children's Arms

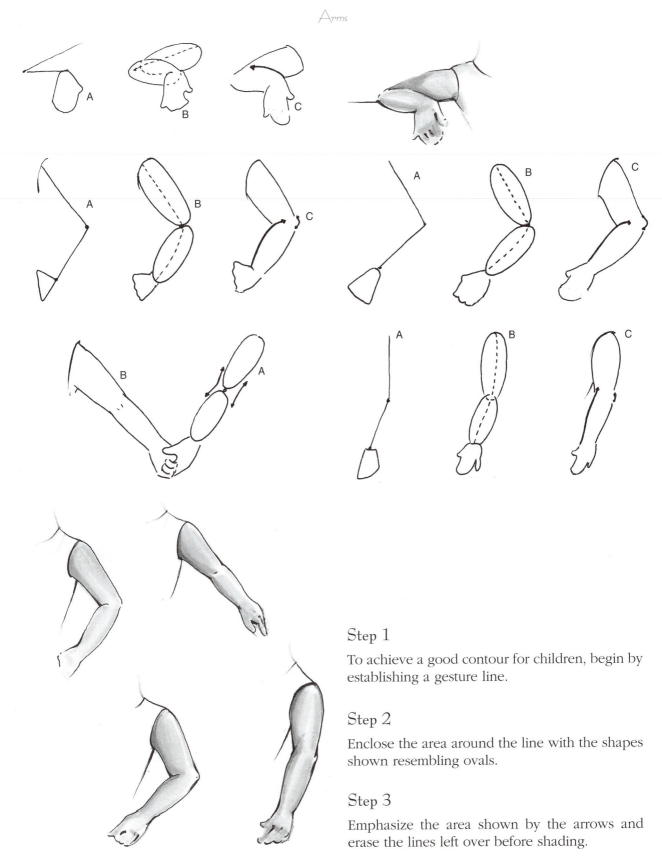

Step 1

To achieve a good contour for children, begin by establishing a gesture line.

Step 2

Enclose the area around the line with the shapes shown resembling ovals.

Step 3

Emphasize the area shown by the arrows and erase the lines left over before shading.

Children's Legs and Feet

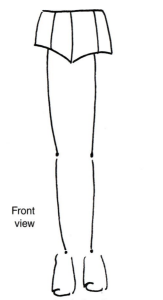
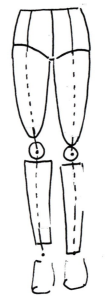
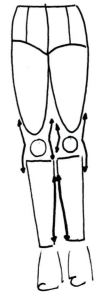

Front
view

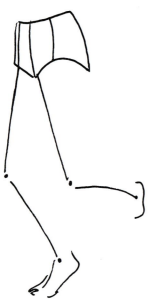
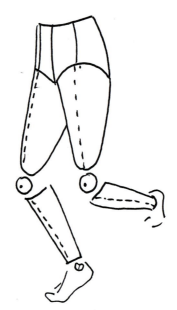
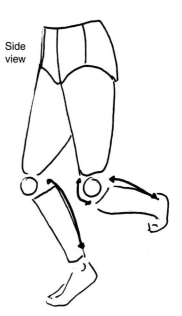

Side
view

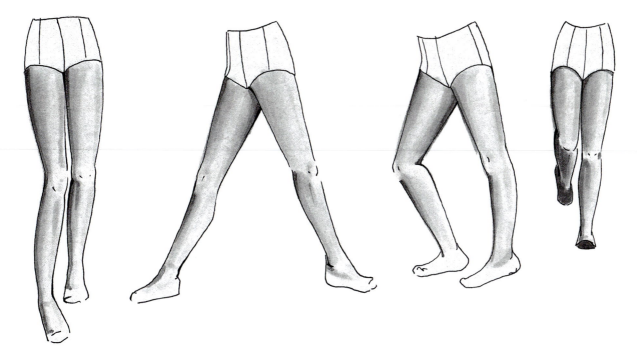

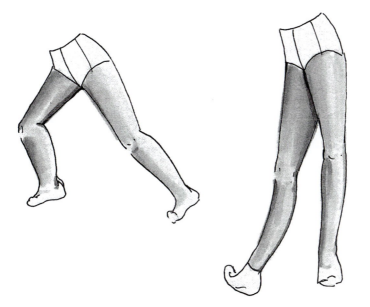

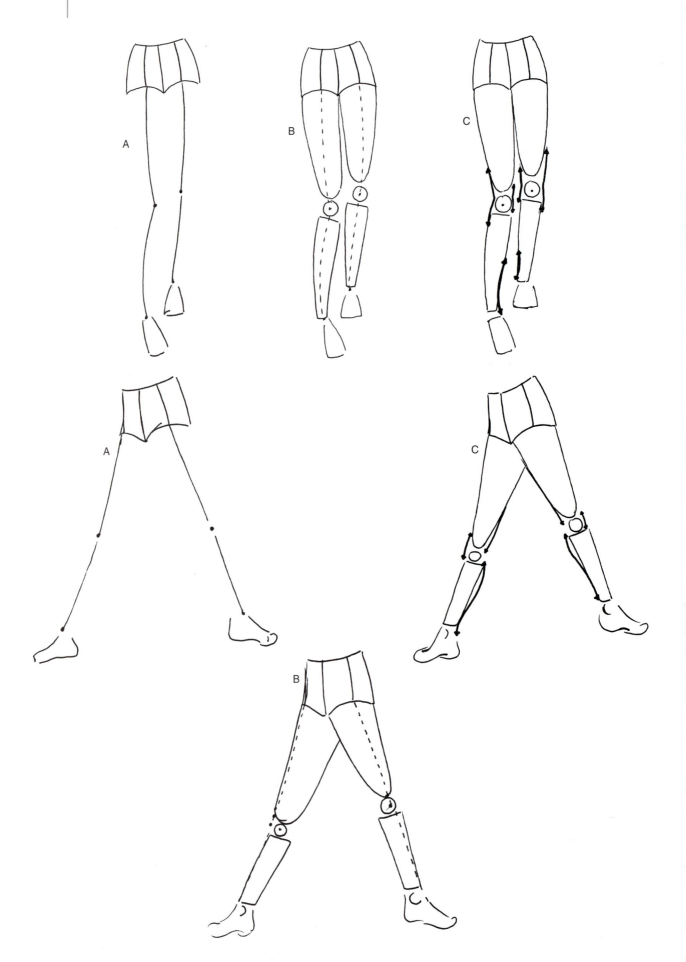

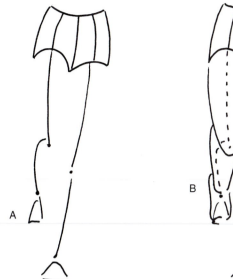

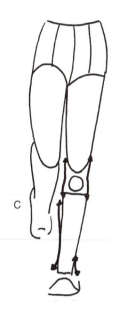

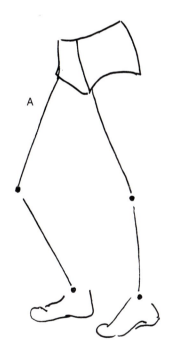
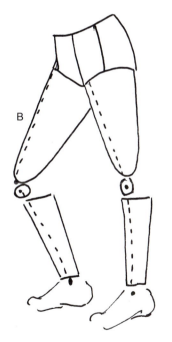
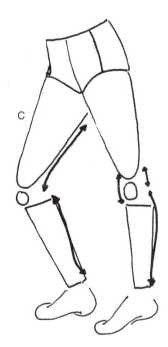

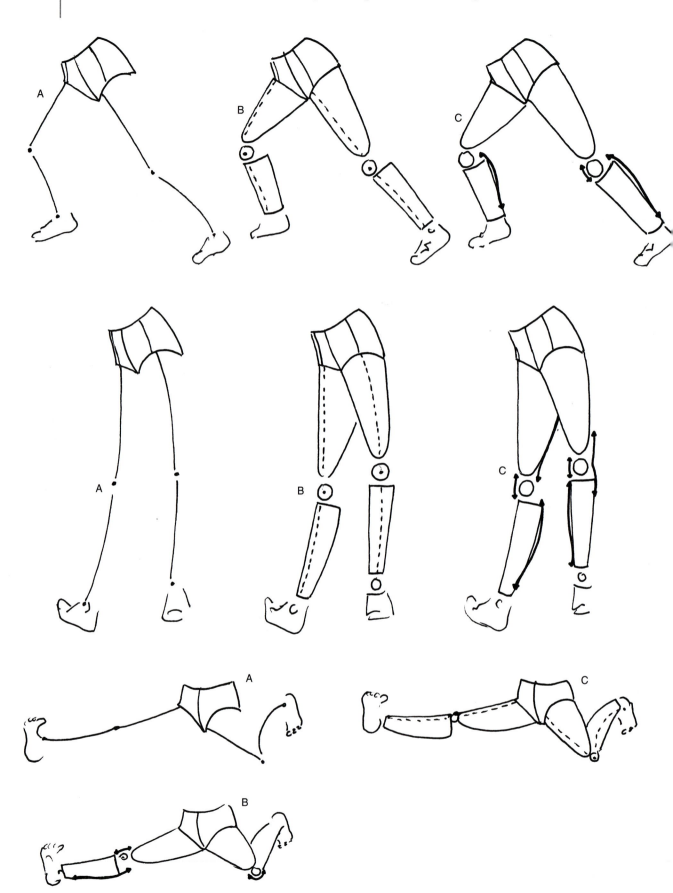

Feet

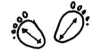
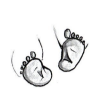
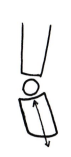
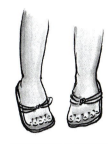

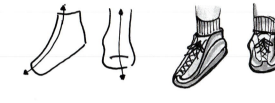
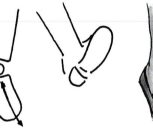
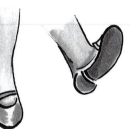

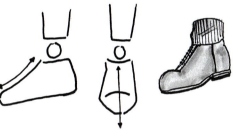

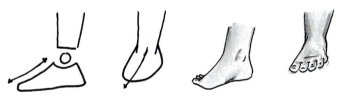

Drawing Tops

Step 1

Select a silhouette and place around the center of the body.

Step 2

Add the opening for the neck-line. Make sure the deepest point is at the base or pit of the neck.

Step 3

Add the opening of the arm.

Step 4

Hole and add sleeves.

Step 5

Add movement and design elements.

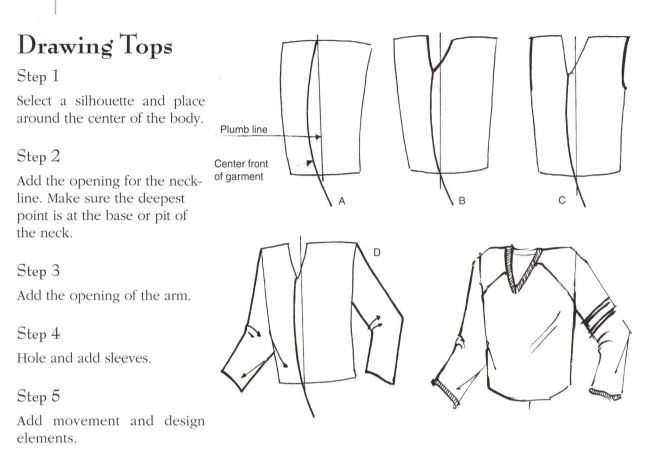

Dressing Children

To draw dressed children, begin by using the basic silhouette of the garment. Because children's wear should be comfortable for their active lifestyles, clothes tend to be roomier than those for adults. Another contributing factor to looser children's clothes is the fact that children's bodies have less curves, which further reduces the need for a close fit.

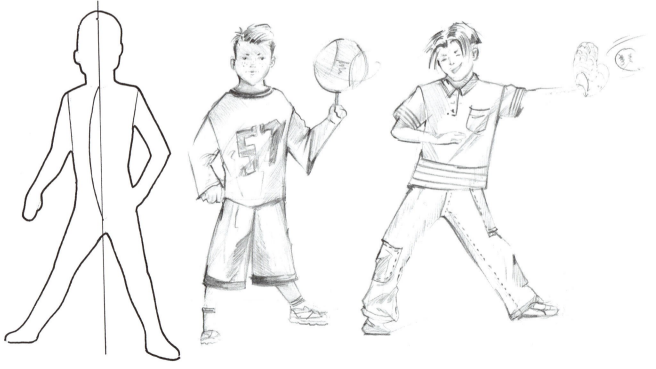

Popular Silhouettes

Tops

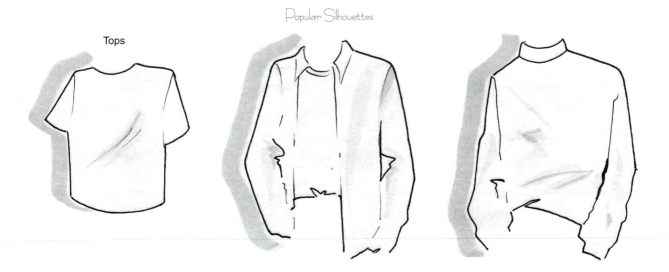

Bottoms

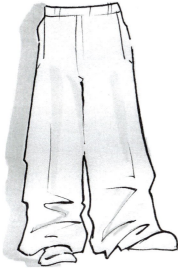

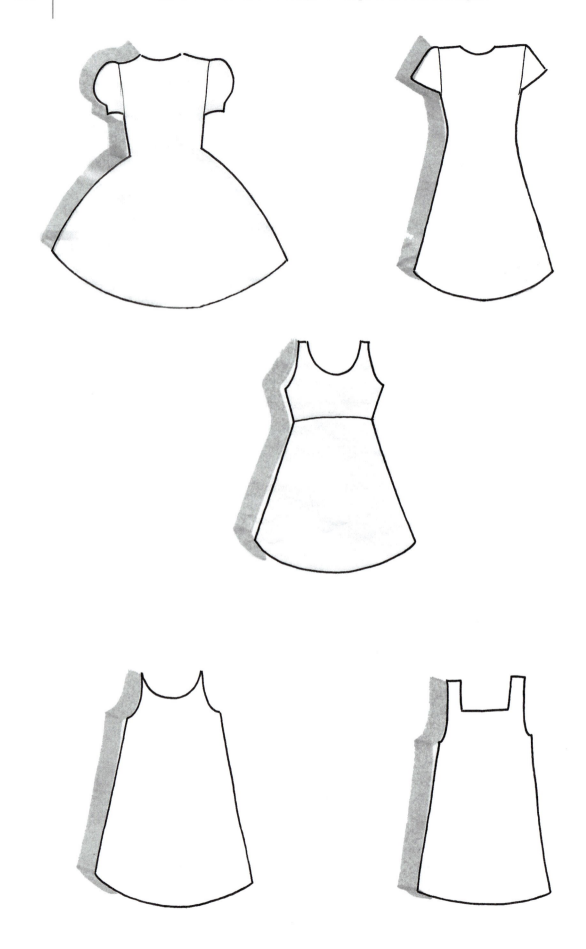

Children's Illustrations with Flats

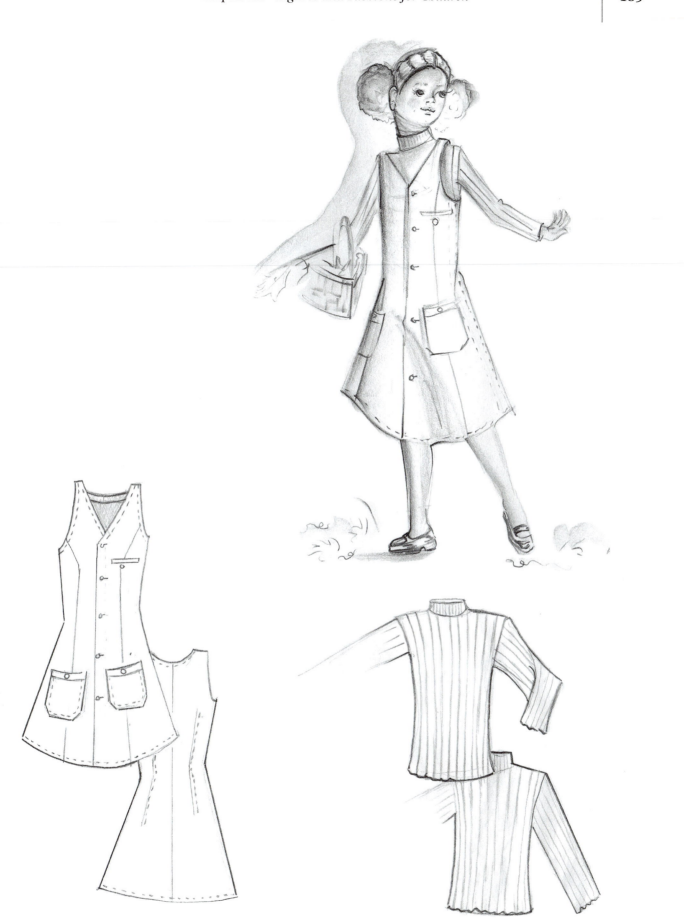

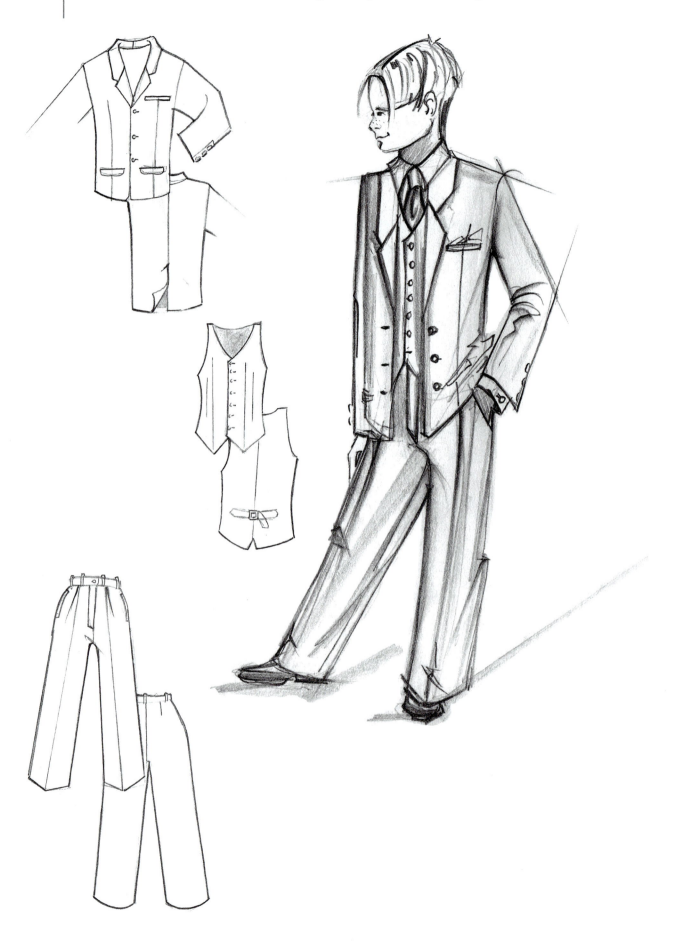

CHAPTER 7

Photographs and Illustration

Composition is key to achieving spectacular artwork. Careful study of the body and its movement are necessary for a fashion designer to master his or her craft. A variety of poses not only works toward gaining good composition but they also can serve to showcase a garment at its most favorable and informative angle. It may be difficult to obtain the services of a professional model, and it may be economically impossible for most artists, so designers studying fashion usually have magazines or catalogs available for studying the art. These periodicals provide an extensive source of information. When looking for economic resources, catalogs are the best bet. They attractively present garments in order to spark a viewer's interest, and subsequent business, very much like a good illustration.

Before photography, catalogs were illustrated by hand. They were primarily used by people to order merchandise without ever having actually seen it. Today, almost all catalogs use photographs for their artwork. Although this has depleted some of the venues for which illustrations are needed, photography has stood models still for countless artists who otherwise might not be able to afford this service.

In this chapter you will learn to examine photographs, break down the poses in the photographs to their most basic gesture, and use those images to create a croquis to illustrate any design. A word of caution: Try to avoid the temptation to trace photographs. Tracing diverts your eye to the life-like proportions seen in fine arts, which is discouraged by most fashion illustrators. Instead, focus on achieving an idealistic figure, which will keep your designs fresh and fun.

To select a good pose, first consider the garment you wish to illustrate. Then, choose a pose suitable for it. For example, when drawing active sportswear, choose a pose that shows plenty of movement. This will give the viewer a sense of freedom. The opposite is true for evening wear or formal garments. The more subtle the pose, the more elegant the figure will appear. To avoid awkward angles, do not use images of celebrities at events and other photographs taken in a controlled environment. The method discussed here will work for any pose; however, for illustrating fashion, contrapposto positions have proven to be the most successful and attractive. Avoid any photograph not taken for the specific purpose of exhibiting clothes.

Breaking Down a Pose

Step 1

On your drawing, find the pit of the neck or, if this is not clearly visible, the deepest point of the collar. The collar is a good indicator.

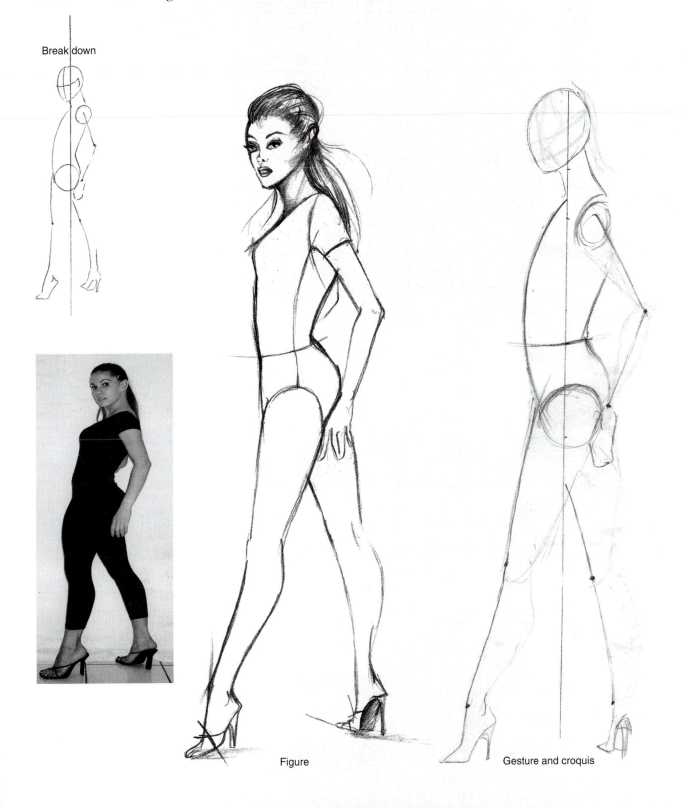

Break down

Figure

Gesture and croquis

Step 2

Draw a line from top to bottom along the entire figure. Ensure it extends through the pit of the neck. This is the plumb line or balance line of the body.

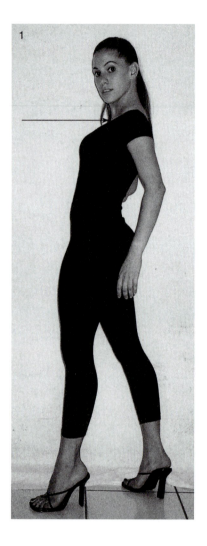

Step 3

Draw the head at an angle and divide it vertically down the center and horizontally.

Step 4

Find the angle of the shoulders and waist.

Step 5

Find the center of the body. There are four key points in the body that will help you distinguish the center line of the body.

a. The pit of the neck is the only point shared by both the center of the body and the plumb line.

b. The center area between each breast.

c. The bellybutton.

d. The end of the pelvic area.

Begin drawing the center line of the body at the pit of the neck. If the model is clothed, find the lowest point of the neckline. In most cases this will be located at center front. The center front closures may also provide some clue.

Step 6

Close the body using straight lines.

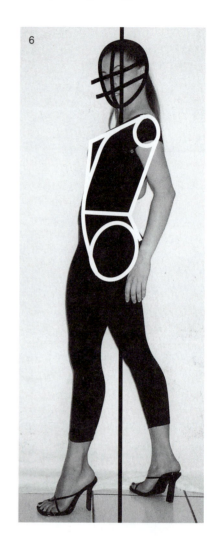

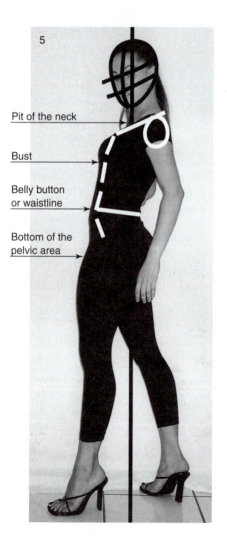

Step 7

Draw straight lines down the center of each leg, dotting at the knees and ankles. Then, sketch the angle of the foot.

Step 8

Repeat the same process with the arms, dotting at the elbows and wrists and sketching the gesture of the hand.

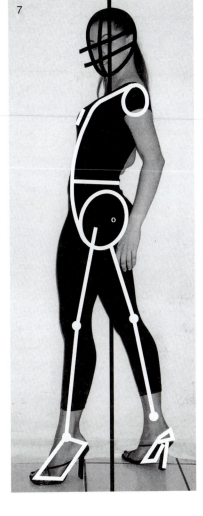

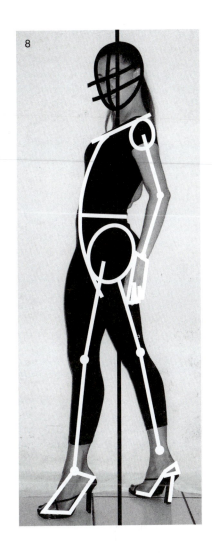

Creating a Croquis

The gesture drawing with human proportions can be used to create an elongated figure.

Step 1

Begin by drawing a new plumb line.

Step 2

Sketch the head in order to accurately copy the angle. First draw the center line of the face, then draw around it.

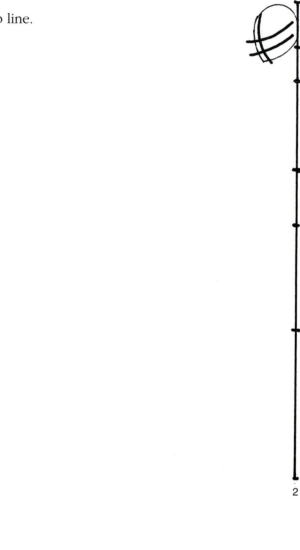

1

2

Step 3

Draw the shoulder line and exaggerate the angle. Do the same for the waist.

Step 4

Draw the center line of the body, exaggerating its movement. Begin at the pit of the neck, and draw a line down to the end of the pelvic box measurement. This point will rarely coincide with the plumb line.

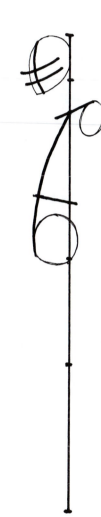

3

4

Step 5

Shape the contours of the body. Keep in mind that on most good poses one side will show more contour than the other if the model is swayed to either side.

Step 6

Transfer the lines for the legs referencing yourself to the plumb line as you dot for each joint. Usually one leg is in front. This leg must be drawn lower on the page, thus rarely are the knees or feet even.

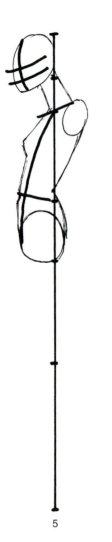

5

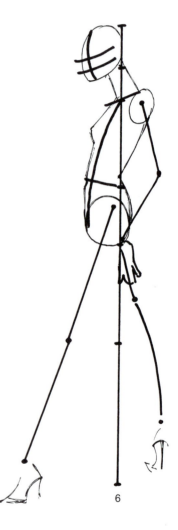

6

Step 7

Shape the arms and legs.

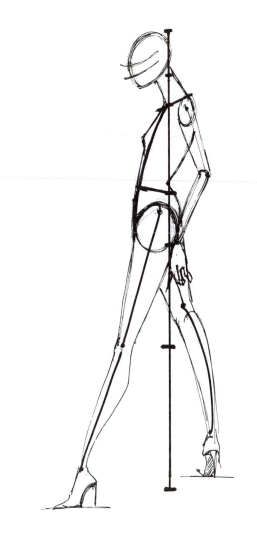

Keep in mind that proportion and body mass are your choice. The photo simply provides gesture.

Add the style lines according to the pose, remembering the position of each on the body. This will vary from pose to pose. Here are a few examples.

A good composition is achieved by choosing poses that work well together. They must play off each other without obstructing any design element. Here is an example of good compositions.

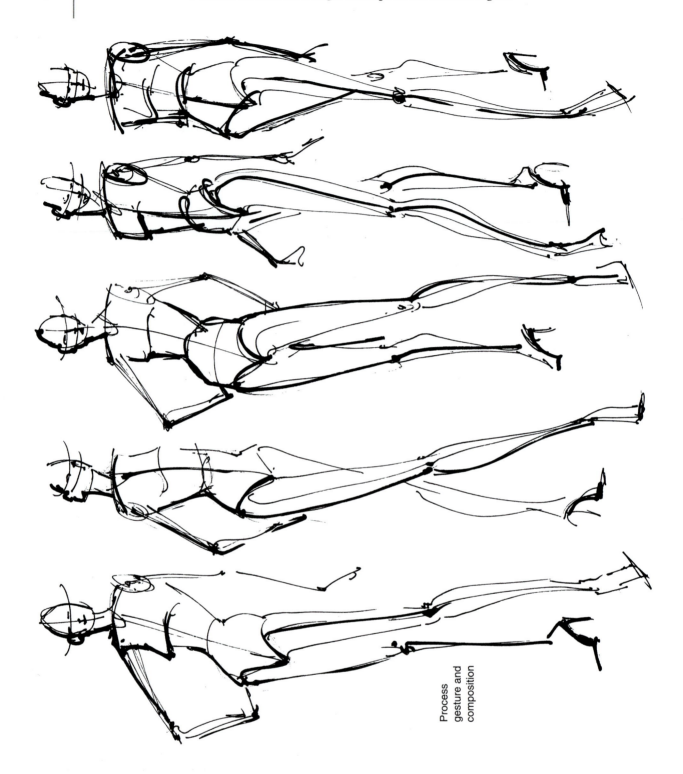

Process
gesture and
composition

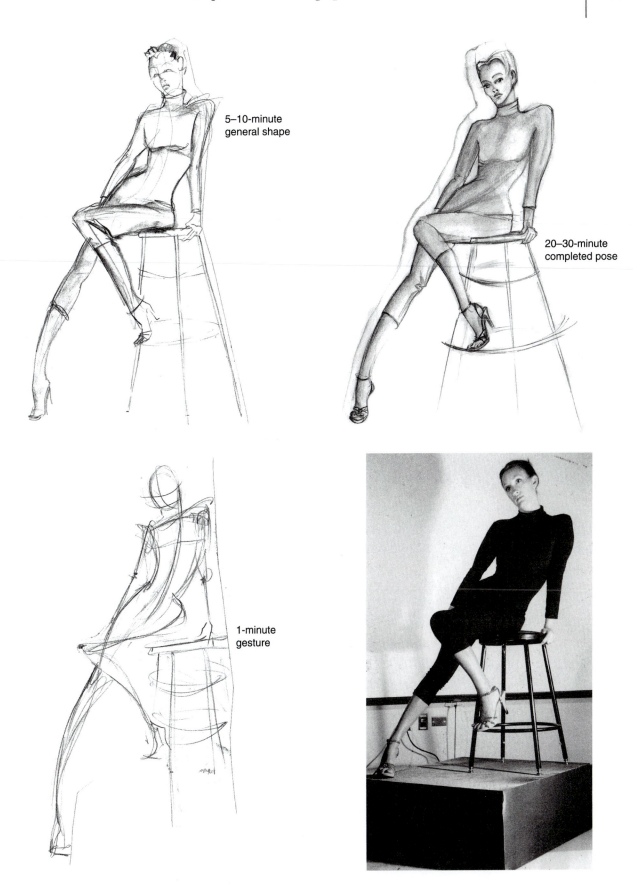

5–10-minute
general shape

20–30-minute
completed pose

1-minute
gesture

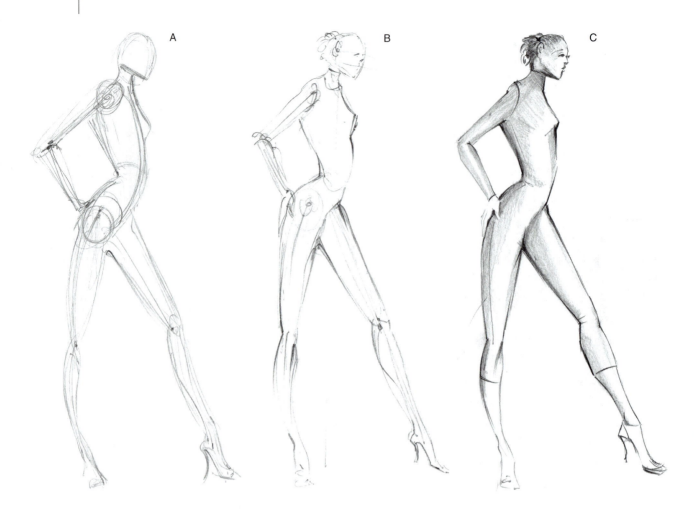

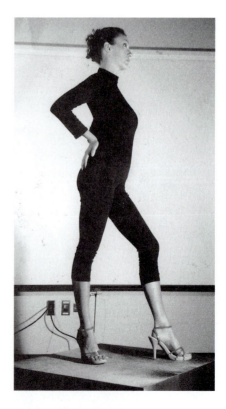

Suggested Exercises and Assignments

Choose two, three, or four photographs of poses that will interact nicely. Break them down and create your own composition of croquis on one page. Remember, artists may exercise creative license. If one particular part of a pose is not suit- able for either your design or composition, change it. However, avoid changing the position of the body entirely; this will defeat the purpose of the figure study.

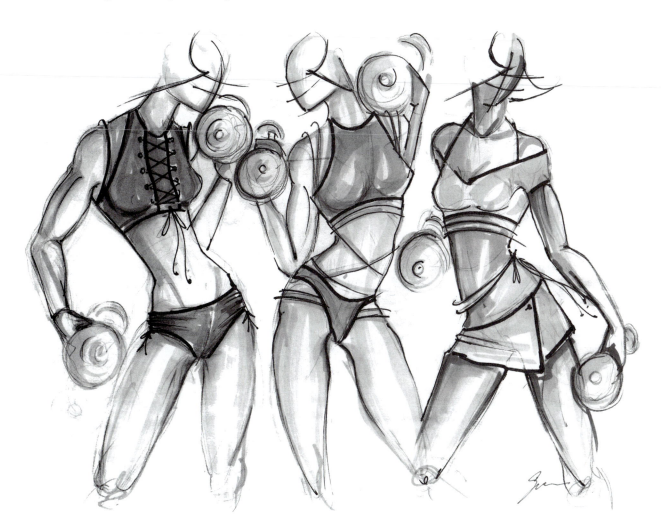

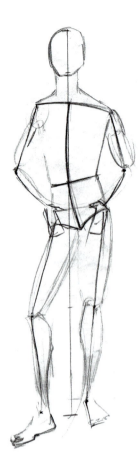

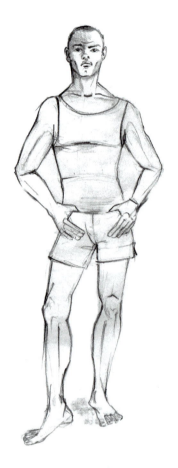

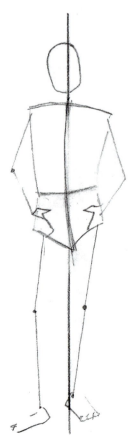

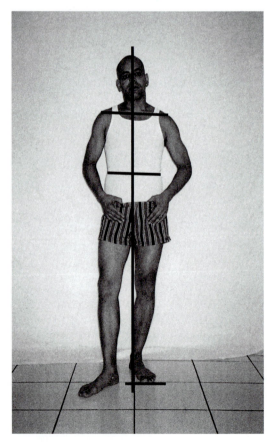

CHAPTER 8

Full-Figure and Maternity Fashions

People need clothes regardless of their size, condition, or body type. This chapter explores two areas of design that remained widely ignored for a long time; it was not until the later part of the twentieth century that fashion for plus sizes and maternity came to the forefront. Shops for these specific body types are now common in most cities, and although some of the old notions of what is attractive have been dispelled, high fashion still remains a thin woman's game. For designers, the challenge becomes whether to create fashions for large sizes or continue to perpetuate a visual stereotype of thin women. In reality, people are more the same than different. What large-size women want in fashion designs is no different from what smaller-size women want: to assert a personal style and individuality. Traditionally, designs for larger-size women have been general and primarily concerned with providing cover and comfort. When designing clothes in general, keep in mind one thing: The clothes are only fashionable as long as people perceive them to be.

In the following pages you will explore two different body types: full figures and those of maternity. You will explore the figures, how to dress them, and how the fit may vary. Use the information contained within this chapter to express your ideas, not to limit your creativity. Remember the old adage "beauty is in the eye of the beholder." Have fun and be creative.

The Full-Figure Croquis

The dynamics of the body remain the same regardless of size or shape. The difference takes place only in the thickness of the torso and limbs, especially below the bust. It is not necessary to add weight to the face for the illustration. One other helpful hint: Draw the feet and hands a bit smaller than you ordinarily would draw on the fashion figure. This will help the figure look fuller without necessarily making it look much bigger. Follow the 12 steps in Chapter 1 or break down the figure as described in Chapter 4. Keep the waistline three-quarters of the width of the shoulder line and the pelvic area three-quarters wider than the shoulder line.

Shaping the Figure

The extremities should be thicker from the top of the figure to the ankle and wrist areas. Do not eliminate the shape; keep the curves in the figure.

Keep the feet and hands small. This will make the legs and arms look fuller.

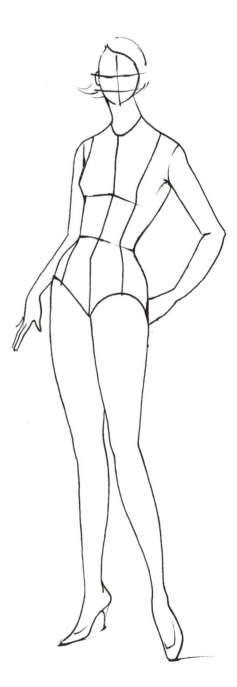

Maternity Croquis

To create maternity fashion designs, begin by drawing a figure using the 12-step method. However, enlarge the hip area by one-third. This area must be larger than that on a normal croqui because a pregnant woman's hips are wider. The other more obvious change is to the abdominal area. To achieve this effect, add a circularly curved line from the bottom of the pelvic box to the base of the bust. Keep the poses subdued; do not use too much movement and keep the garments the focus of your drawing.

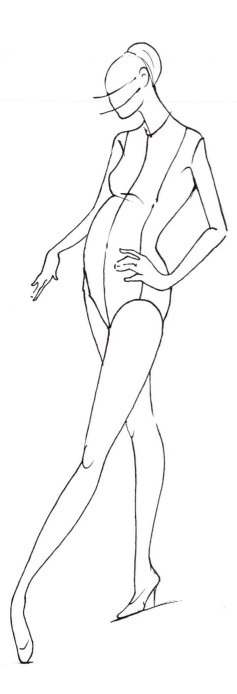

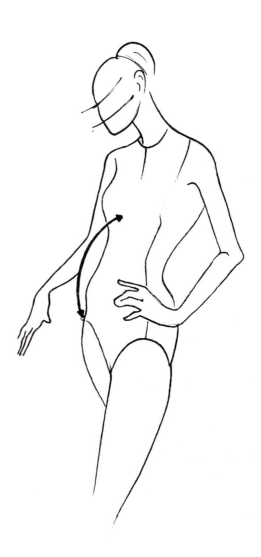

Preferred Silhouette and Dressing the Figure

When dressing any figure that has less shape in the torso, the princess lines are used less frequently. These seams are created to shape the area from beneath the bust to the waist. As this area becomes less shapely, darts become obsolete. However, necklines, center seams, side seams, waistlines, and hip lines are all still relevant. The accompanying diagrams show some frequently used silhouettes.

CHAPTER 9

Flats

Technical sketches, or flats as they are most commonly referred to, contain the factual information of a design. The elements that make a design unique and functional must be clearly presented in a linear and easy-to-understand fashion unlike the illustration, which is the more complex counterpart whose main functions are presentation and inspiration. Within the fashion industry, the flats play an integral role for all involved in garment construction. They keep the designer artisans and factories in sync as to a style's particular design. Today, there are computer programs that help with drawing technical flats and that are readily utilized in big companies. However, designers often find themselves resorting to pen and paper to record ideas when computers are not available. Designers who work in smaller businesses, where styles change frequently, and design houses still draw most of their flats by hand. Although the flat sketch lacks the freedom and appeal of the illustration, it must not be taken lightly. In fact, a poorly or improperly drawn sketch could cause confusion and loss of revenue.

As part of a presentation, the flat sketches must provide the precision worthy of a well-calculated design. The lines must be deliberate and well structured to avoid error of interpretation. Equivalent to a floor plan, a flat sketch may be accompanied by specific measurements, which are called specs. Specs are used to further clarify the proportions and construction of a garment. Factories frequently use what are known as cutting sheets. Cutting sheets contain specific measurements accompanied by a sketch with arrows pointing in the direction of the area measured. Flats and specs are important parts of presentations. They provide detailed and necessary information.

Free-Hand Drawing

To begin a free-hand drawing, first establish the size of the design and enclose it with a shape that mimics the general shape of the garment. For example, begin drawing pants with a rectangle; a blouse or top may be more square in shape.

Next, divide the shape in the center and begin drawing in the neckline and silhouette of the body. Make sure both sides of the garment are the mirror images of one another. Choose a line and clean up the remaining marks. Using a straight edge or ruler, clean up your drawing by darkening in the contour. Erase the remaining lines.

Use three different liners to draw varying weights of lines. Outline only the outer edge of the sketch with the heaviest liner. For example, a number 7 liner would work well. Then, using a number 3 liner, draw in the seams and design details. Finally, using the thinnest liner, or a number 005 liner, draw in the stitches.

1
General shape

1 Establish center of your shape and sketch general shape

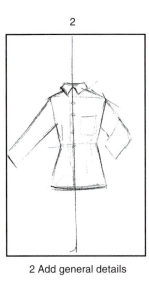

2

2 Add general details

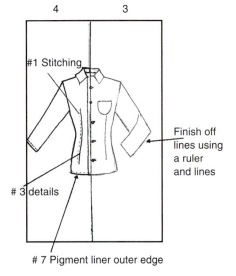

4 3

#1 Stitching

Finish off lines using a ruler and lines

3 details

7 Pigment liner outer edge

USING A TEMPLATE

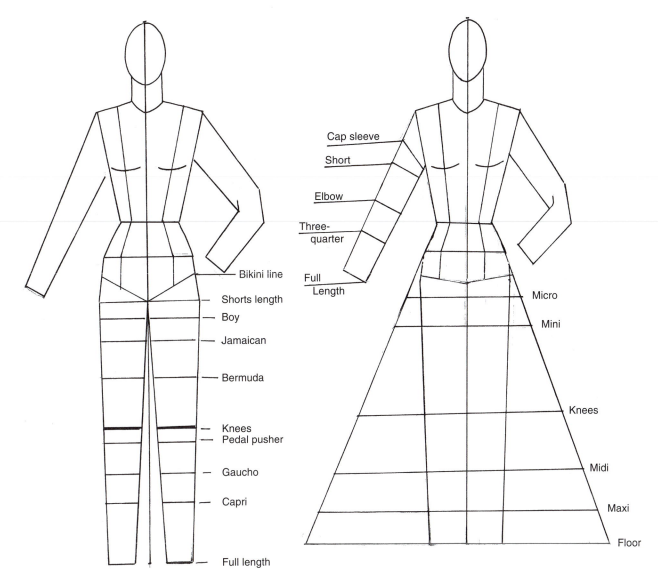

Cap sleeve
Short
Elbow
Three-quarter
Full Length

Bikini line
Shorts length
Boy
Jamaican
Bermuda
Knees
Pedal pusher
Gaucho
Capri
Full length

Micro
Mini
Knees
Midi
Maxi
Floor

EXAMPLES OF FLATS

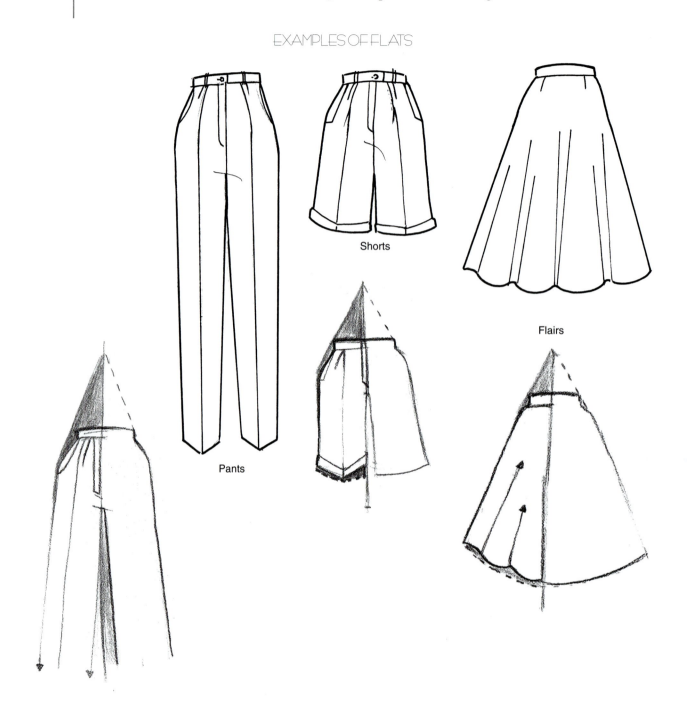

Shorts

Flairs

Pants

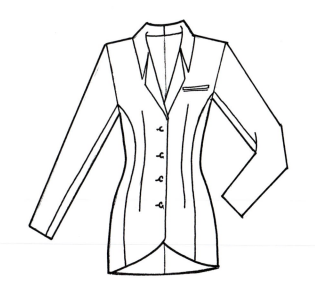

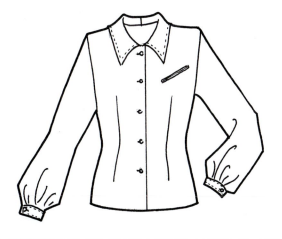

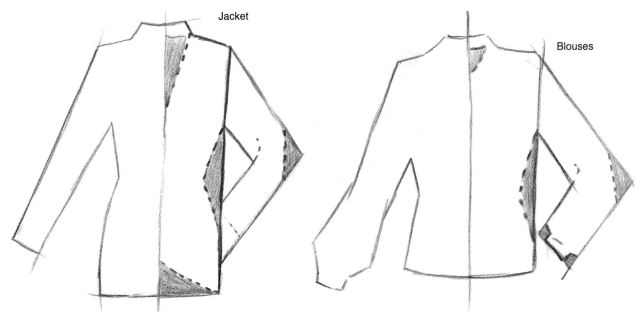

Jacket

Blouses

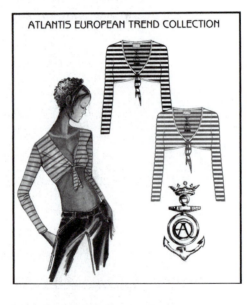

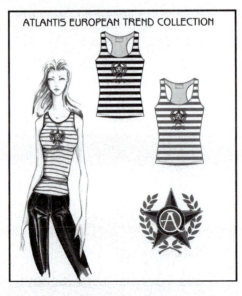

CHAPTER 10

Drawing Accessories

Drawing Shoes

Accessories are a huge part of the fashion industry. They also play an important part in our lives. From the shoes we wear to protect our feet, to the jewelery that adorns us, accessories can take many shapes and serve many more purposes. Drawing them can be fun and sometimes less complicated than the human body. Accessory designers, how-ever, carefully study the form of each design and meticulously ensure its proper function. Follow the steps outlined carefully and remember that these will have to be altered for each design.

When drawing shoes, provide at least three angles of the shoe for the viewer. The most important are the side, back, and top or bottom.

Side View

The side angle view offers the largest plane of the shoe. Therefore it is not surprising that most of the design happens here. This makes for an in-teresting artwork as well. It is also the part of the shoe that changes most frequently as opposed to the sole or the last of the shoe which holds its place in fashion longer.

STEP 1—Draw a flat, horizontal line.

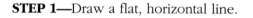

STEP 2—Establish the height by drawing an angled line beginning at the starting point on the horizontal line.

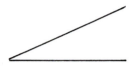

STEP 3—Shape the back.

STEP 4—Shape the top or throat of the shoe and the instep.

STEP 5—Shape the front.

Details

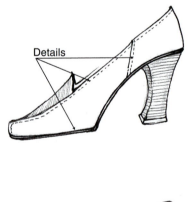

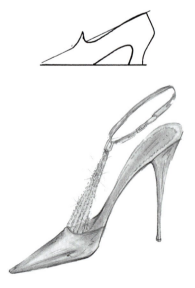

Back View

This is where we showcase the heel of the shoe. In women's shoes, this is the cherry on the cake.

For various reasons which include shaping the leg and fitting the body forward, the heel on women's shoes is a constant focal point in fashion.

STEP 1—Draw a triangle.

STEP 3—Draw a curved line at the bottom and erase the straight lines as shown in the diagram.

STEP 2—Draw a curved line across the top about a third of the way below the tip of the triangle.

STEP 4—Shape the heel. The shape of the heel will vary depending on the style you choose. Add the bottom of the shoe.

Back

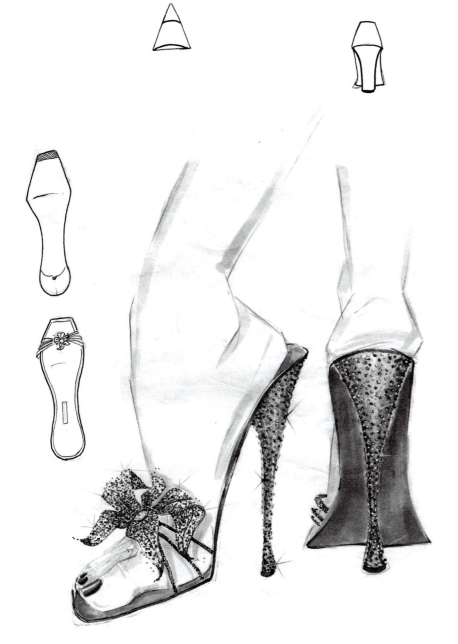

Bottom View of Sole

This view has become increasingly interesting with the new athletic shoes and urban shoes which have as much design on the sole as on the top of the shoe. Once used more for manufacturing and technical purposes, today the bottom view provides a new canvas for a new generation of designers.

STEP 1—Draw a rectangle and divide it into three sections.

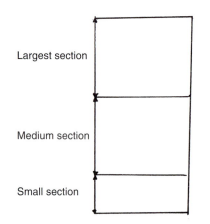

STEP 2—Draw the shape for the front of the shoe.

STEP 3—Add lines for the sides and instep. The inner part of the foot curves further in than the outer part of the foot.

STEP 4—Add a rounded shape for the back of the shoe.

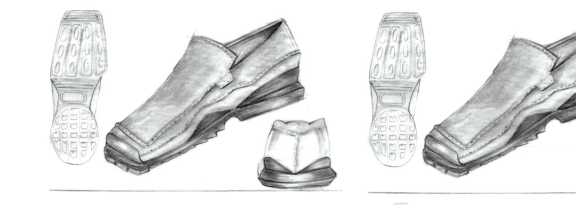

Drawing Bags

When drawing bags, it is best to begin using a general shape. Use a three-quarter view of the bag or purse whenever possible in order to facilitate viewing the most angles. Any shape is possible.

STEP 1—Begin by drawing a shape. Decide which side of the bag you want to be in front; start there.

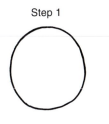

Step 1

STEP 2—Draw the same shape smaller and diagonally placed from the first shape (see diagrams).

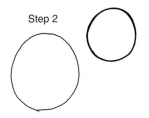

Step 2

STEP 3—Divide the second shape diagonally and erase the area that will not be seen.

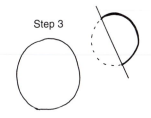

Step 3

STEP 4—Connect the shapes at the top and bottom.

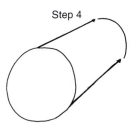

Step 4

CIRCULAR BAG

This will create a drawing with greater depth and one that is more conducive for compositions and exhibition.

RECTANGULAR BAG

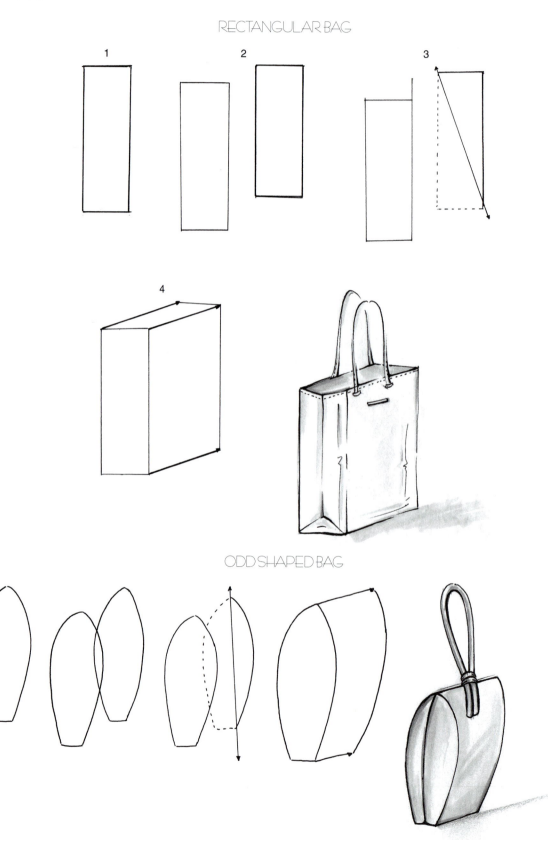

ODD SHAPED BAG

Drawing Necklaces and Bracelets

STEP 1—Developing a repeat.

Any motif can be developed into a pattern so it is up to the designers to imagine anything from geometric shapes to animals that can be developed into a pattern. Just remember these will most likely have to be repeated multiple times and joined the same way. This is what will ultimately dictate the final result or pattern.

STEP 2—Draw the general shape.
This shape should be the final desired shape. The motif will be placed over or inside this shape.

STEP 3—Divide the shape.
Divide the shape at least into quarters. Some jewelery will diminish the size of the motif to better fit the body. Bracelets may remain the same. However, it is important to give enough of the pattern to the viewer.

STEP 4—Developing a pattern.
Using your motif or repeat, begin at the center of your shape and place the first one. Follow along the shape and going with the next and so on until your entire shape is covered.

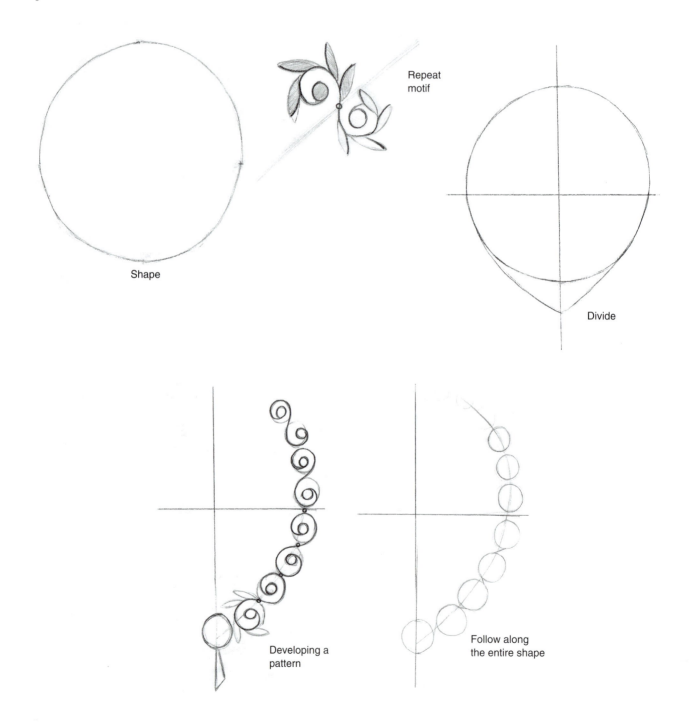

Shape

Repeat motif

Divide

Developing a pattern

Follow along the entire shape

Rendering Stones

Stones are the most prevalant material used in jewelery. Their luster and luminescence are their most important feature and are often tricky to capture on paper. Different artists use different mediums, however, they all require some type of opaque white pencil or paint in order to bring out the reflections of light on their surface. Follow the steps below—either using markers and a marker blender, or quash water color paint. The process is the same.

STEP 1—Establish the shape and cut of the stone.

1

STEP 2—Color the shape using the lightest shade.

2

STEP 3—Using an opaque white pencil or paint markers, bring out the cut of the jewel. By going over the lines used to establish the cuts of the stone.

3

STEP 4—Use a darker shade over the first color, leaving some of the original color exposed closest to the white areas.

4

STEP 5—Blend and repeat the process until the desired color is achieved.

5

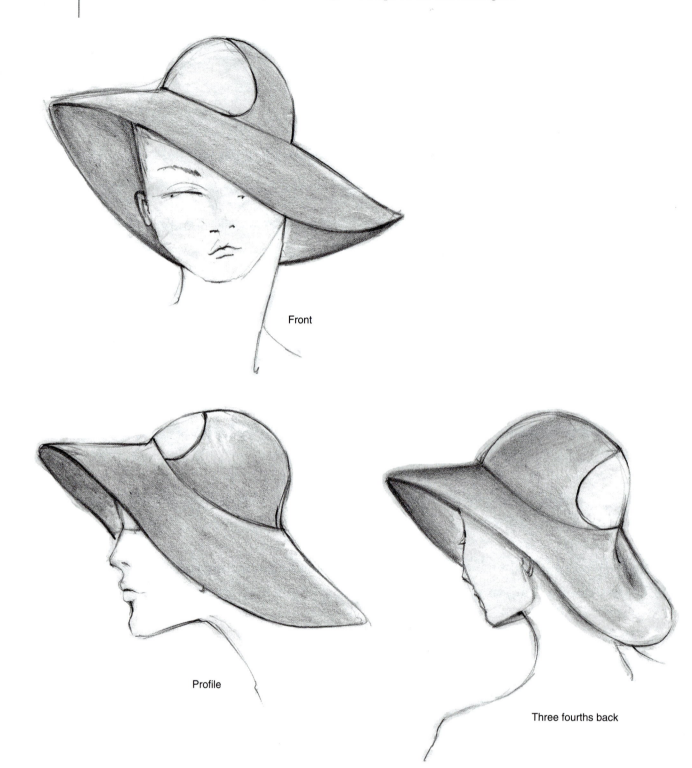

Front

Profile

Three fourths back

Drawing Millinary Styles

Provide at least two views of hat fashion designs. Keep the presentation focused on the head. Do not draw faces unless this is something you can do well because a distorted face may shift the focus of the viewer. Use instead a silhouette or stylized version of the face.

Remember first to generalize the shape and tighten the sketch as you proceed. Do not attempt one-shot perfection; this is nearly impossible.

Drawing Glasses

Drawing eye wear is relatively simple when working from simple shapes. When presenting these, remember to include close-ups of the leg and any decorative elements that may play a role in their design.

STEP 1—Begin by establishing the basic shape for the face or front plane of your glasses. It is recommended you begin with a rectangle.

STEP 2—Divide your shape in the center vertically and horizontally.

STEP 3—Shape out the shape of the frame and lens as desired.

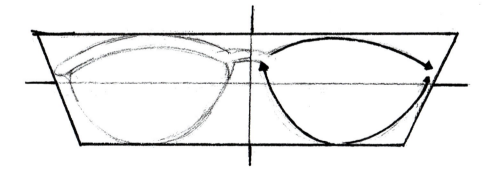

STEP 4—Add the legs.

CHAPTER 11

Portfolio
Presentation

Art by
Francisco Gonzalez

A designer's portfolio is, literally, the key that opens the door to a future in creation and confection. This body of work must represent the designer's abilities in their entirety. No question must be left unanswered. Conceptual ideas and information about the materials and methods used to develop and create a good three-dimensional garment that fits and enhances the human figure are critical in fashion design. Most designers demonstrate concepts by illustration, thus creating the most commercial and easily understood part of a portfolio. Flat sketches provide basic information, maps of sorts, used by industry professionals to properly cut and construct the garment according to the designer's specifications. Fabric swatches, trims, and embellishments provide further information about materials that work well together to make a garment as close to the idealized illustration as possible.

An experienced designer knows how the properties of individual fabrics interact with each other and understands individual technicalities, such as the care for garments that involve more than one material.

In this chapter, the focus is on the three main elements of a good portfolio: illustration, information, and presentation. These are the focal elements for any good body of work. Designers must keep in mind that each aspect is as important as another.

One important note to remember is that when applying yourself to your studies, do not pick and choose the areas you like by how easy they may be, rather focus on those particular aspects that are challenging and the end result will be a well-rounded professional.

Illustration

Illustration exists in all areas of design. It may be in the form of computer-generated art, which is common in architecture or free-hand drawings. Illustration provides the perfect representation of an original concept. All measures are taken to ensure the final product matches this ideal form. Illustration is also a perfect vehicle for adding all aspects of the design to reach its maximum potential impact, including accessories, hairstyles, and even the ideal body shape that will cast a favorable light on the garment.

Illustration appeals to anyone who can see it, but it obligates the viewer to see a design from the designer's perspective with no room for interpretation. There are three components to keep in mind when first developing your drawing: stylization, composition, and rendering. It is not necessary to illustrate every piece in a collection. Choose only the ones that best represent the collection.

Stylization

Many artists choose to express their ideas on figures that they have developed and that best suit their style of design. This is fine for established professionals. However, a designer must be versatile because fashion and the concept of beauty are ever-changing. When sketching your ideas, use a figure that is easy to draw. But to really showcase your garments, begin by picking a style that matches that of the general mood of your line. For example, a very urban, young line may make use of a figure that looks robotic or of a popular culture icon. However, for a bridal illustration, you may want to retain a bit more of the traditional because of the nature of the social custom associated with marriage.

Composition

Composition plays a part in every aspect of presentation. Your figures are no exception. They must retain a sense of interplay and relationship. Choose figures that work well together, but do not obscure any parts of the garments. Try to maximize your use of space. Avoid confusion in your composition. There must be symmetry in any good body of work. Small bodies of work comprise the main aspects of a portfolio, illustration being the first important element, information and presentation the other two.

Rendering

There are many details to consider when rendering for fashion and, indeed, illustration as a whole. For the designer, it is important to capture the fabric accurately. This is usually the main part of the drawing and always the focal aspect.

Information

Information falls into three categories: written, drawn, and actual components. Fabrics, buttons, and trims are all components that may actually be part of the garment. It is important to have swatches and other samples of integral design elements.

Flat sketches provide vital information on the actual construction. All seams and stitches must be present as well as back and front views of every garment. Allthough it is not necessary to illustrate every garment, it is necessary to have a technical sketch for every single piece.

Written information is used to further eliminate any question the viewer may have. Fabric is a good example of an aspect of fashion design for which written information should be provided. It is important to incorporate four statistics of the materials: price, source, width, and content. These elements will help determine retail price range, availability, and care labeling.

Other written information may include identification numbers, naming groups, or brief descriptions of garments. Do not handwrite these details because this looks unprofessional and sloppy, rather all written information should be formally typed for presentation.

Presentation

The overall layout of components and their ability to co-exist with even, seamless harmony and symmetry makes the presentation. Nothing should be overlooked; even the font used for the writing should reflect the general mood of your designs.

When choosing colors, the best sources are your fabrics. The colors which exist on the materials are usually the most suitable palette. In fact, in most good layouts, they dictate the color for the entire project. Choose colors that have the same color values. Avoid completely black or white backgrounds. This will tend to make things look as if they are floating and creates a void difficult to overpower.

Mood Boards or Vignettes are a good idea in small doses. They are effective in conveying an overall mood. Photography is also a powerful media and difficult to compete with in color and impact. These elements (photos and computer generated elements) must be strategically placed and rarely used as an entire background. Instead, opt for more geometric patterns or varying colors. This will complement rather than complicate.

Swatches must have their own composition and should be accessible to anyone, because the feeling of the materials on the skin is so important for comfort. Therefore, only glue the top half or less. If they are behind actual protection, slit the acetate and draw out 1/3 or a corner. This will keep people from reaching across the acetates and potentially harming the project. Pinking sheers for fabrics is very desirable. It is neater and creates more symmetrical shapes. Most fabrics will fray, but this will minimize that effect. Avoid three-dimensional objects such as buttons or beads; however, it is a good idea to include a color copy and respective information. Make sure that glue does not show through anything including fabrics. This can be prevented with a paper tab across the top of the swatch where the glue is or by double mounting the paper in order to preserve the intensity of the colors.

Fold-outs are a good idea when extra space is needed. One group should be shown all at once. Do not continue on the back of the page as not to fragment the project. Instead, add onto the edge of the two main pages to create smaller inserts such as booklets. Anything that is not under an acetate protection should be laminated or in some way protected. Do not leave any paper exposed.

Finally, when choosing a portfolio, do not worry about expressing your individuality, get something professional. The basic black vinyl portfolios available at most art stores will work. Keep the portfolio clean, do not write anything on the outside, and keep it free of irrelevant materials. Express your creativity on and individuality with its pages—not on its cover and avoid anything larger than 11x14. Remember, your portfolio is the best way to show what you know and the best chance of landing the right job.

Conclusion

As a body of work, a good portfolio represents all the capabilities of a designer. Some are the conclusion of years of study, others a chronology of accomplishments and experience. Whatever the area of expertise, it is an evolving project that needs to be revised and updated frequently. And while they have morphed from being cumbersome books to sleek disks, their contents are what is important and they should be addressed throughout the lifetime of one's career.

WDL. 140
Blue knit body suit

WDL. 141
Body jacket with fur
Lining and Sports zipper
down Center front

WDL. 150
Knee length dress
With fur neckline
Off the shoulder.

WDL. 151
Long dress with
Fur turtle neck collar
Cut out shoulders
And princess seam
On right side of front

WDL. 152
Full floor length dress
With piped Princess seams.

WDL. 153
Mini dress with empire waistline
And built in shawl.

All dresses come with optional
Knit fringe at hemline.

By Nicole Doran

By Nicole Doran

42% Acr, 28% Wool, 24% Poly, & 6% Nylon

Sequins International Inc 3.50 per yd.

Bark Knit

NBS542

NSS540 One piece mini shorts with
Sleeveless draped top

Poly / Cotton mix

Jo Ann's Fabrics
4.99 per yd.

ort fitted jacket with hidden
acket, flare sleeves, and collar

ared three quarter sailor pants
ith hidden zipper on s.s. and satin
m on hem and waistline

mpire satin dress with beaded
ower appliqué

othered mini skirt with double
ation closure

tted collared dress skirt with
estern yoke (available in fatigue,
andy, and bronze)

NTS547

By Nicole Doran

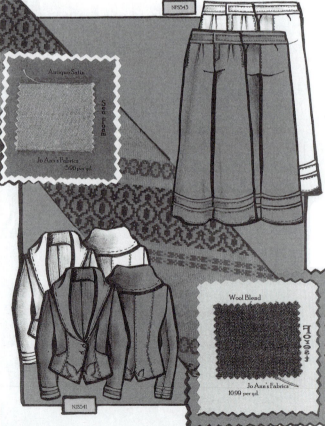

NPS543

Antique Satin

Sea Foam

Jo Ann's Fabrics
5.90 per yd.

Wool Blend

Forest

Jo Ann's Fabrics
10.99 per yd.

NJS541

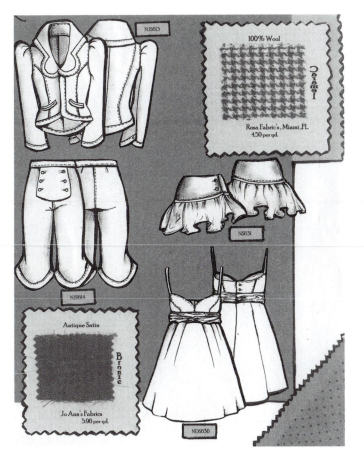

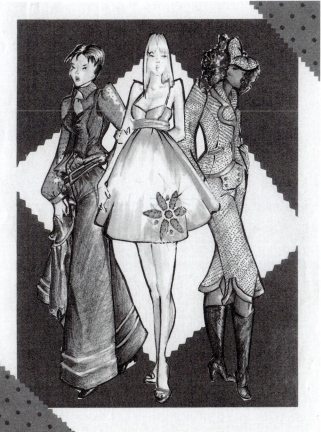

By Nicole Doran

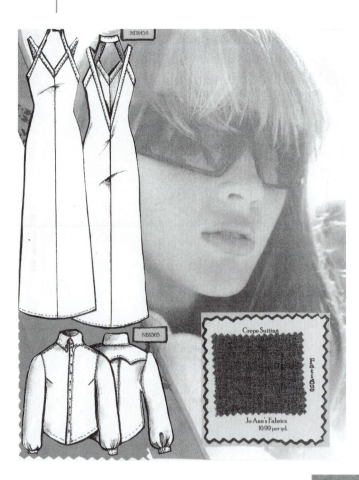

By Nicole Doran

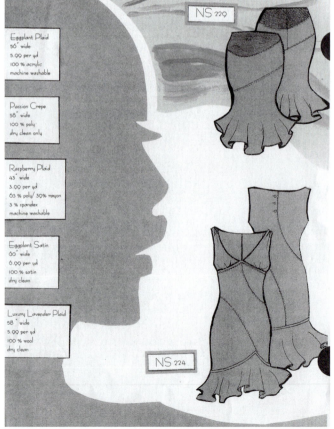

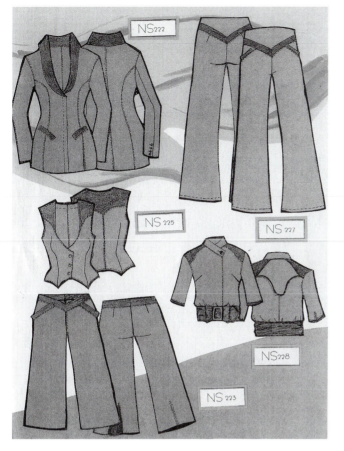

By Nicole Doran

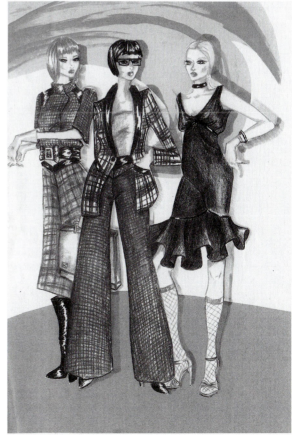

NS222 Cowl draped collared jacket. Four-button cuff and princess seams with welt pockets. Comes in luxury, and raspberry plaid.

NS 224 Bias cut dress made with passion crepe.

NS 223 Culottes with godet in back and welt pockets. V cut waistline. Comes in raspberry plaid, luxury plaid and eggplant all with satin accents.

NS 225 V cut vest with satin yoke comes in eggplant plaid, passion crepe, luxury lavender, and raspberry plaid.

NS 227 Wide leg natural wasted pants. With satin yoke. Comes in eggplant and raspberry Plaid.

NS228 Banded collar shirt with ¾ sleeves and hidden placket, open cut out on back. Yoke make of satin. rap around bow belt at hem. Made with satin and eggplant plaid

NS 229 Bias cut skirt with asymmetrical yoke. Yoke made from satin and skirt comes in eggplant plaid, raspberry plaid or passion crepe

By Nicole Doran

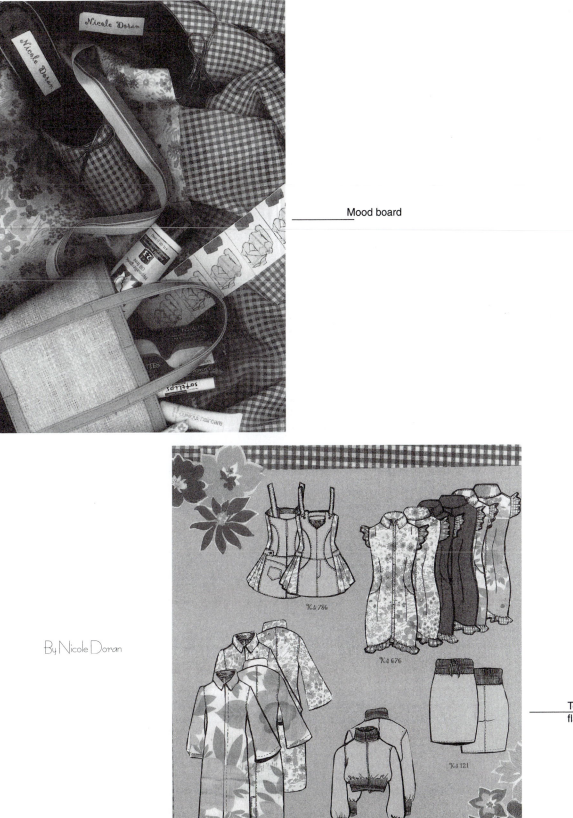

Mood board

By Nicole Doran

Technical flats

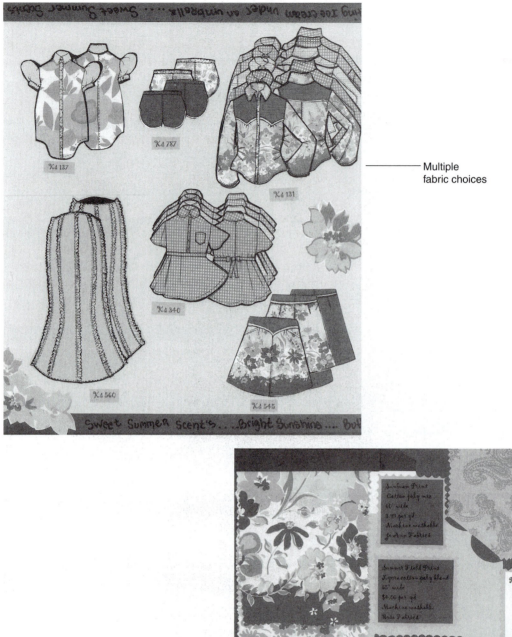

Multiple
fabric choices

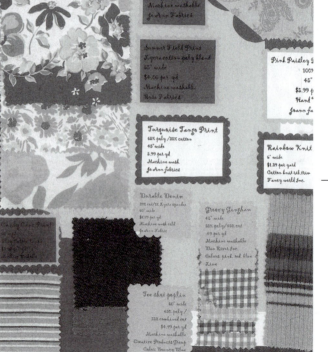

Trims
and
fabric

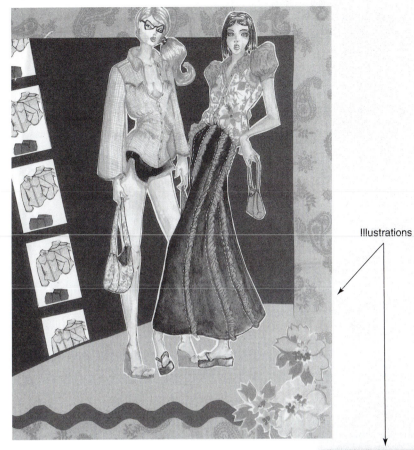

Illustrations

By Nicole Doran

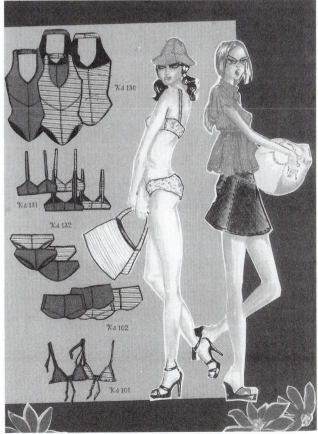

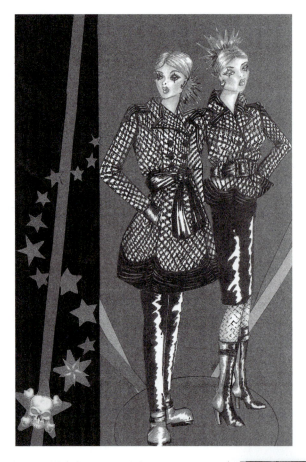

By Nicole Doran

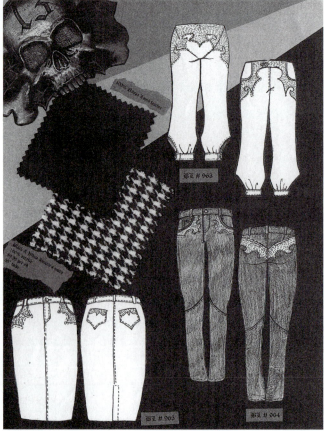

Flats
and
pertinent
production
information

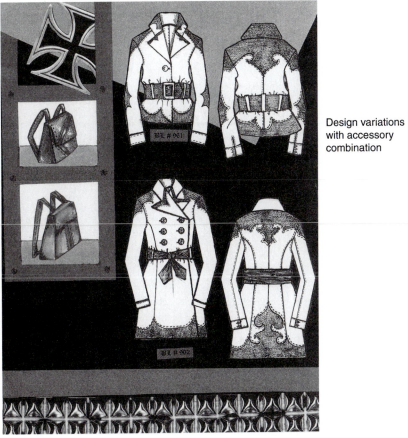

Design variations
with accessory
combination

By Nicole Doran

Fabric
group
and pertinent
information

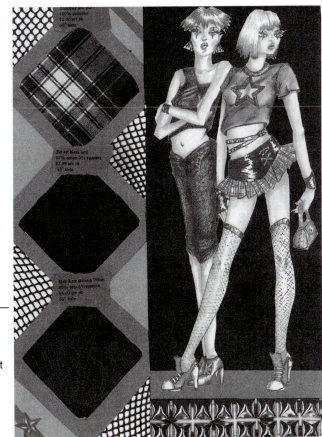

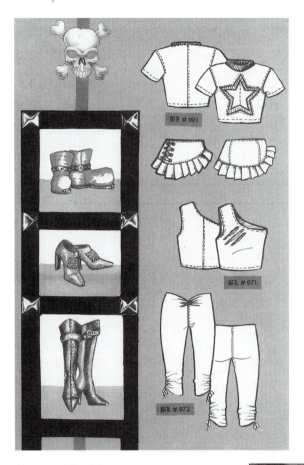

By Nicole Doran

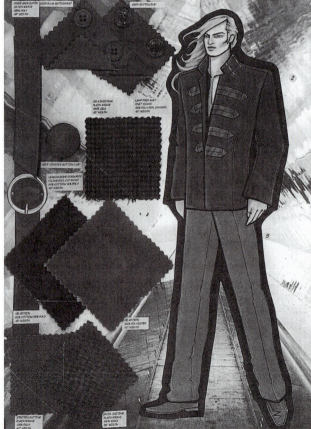

By Luis Escudero

Menswear
layout

Illustrations utilizing
inspirational elements as
background components

By Luis Escudero

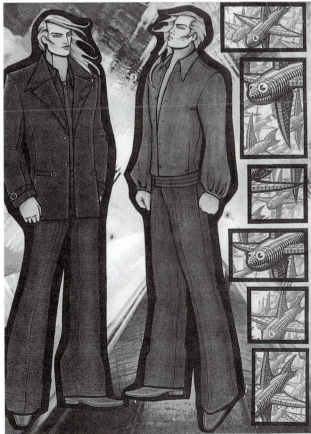

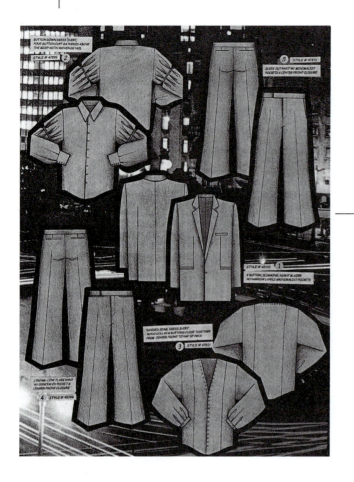

Composition of technical flats. Overlapping certain elements helps to conserve space.

By Luis Escudero

Illustration with emphasis on patchwork embellishment

Trims

By Luis Escudero

Illustration as
focal element

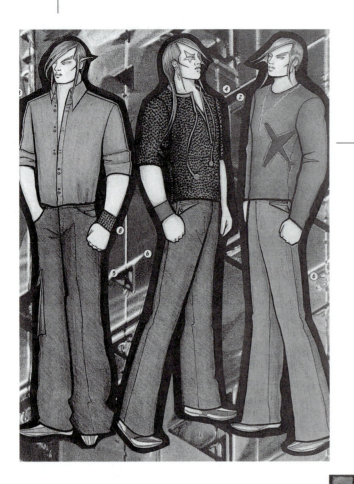

—— Multiple figure layout

By Luis Escudero

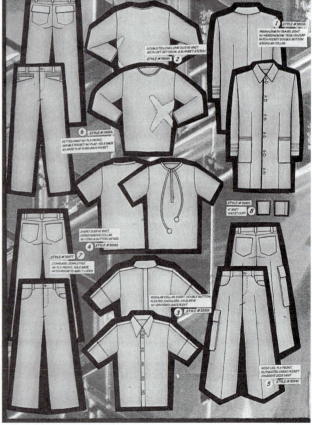

Overlaying fabrics helps
the viewer get
a better feeling for
overall combination
of relevant components.

By Luis Escudero

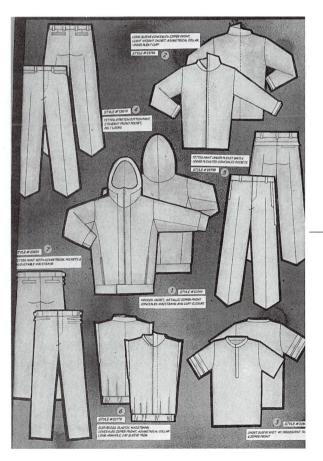

Multiple
flat
layout

By Luis Escudero

Graphic outlines help achieve a clean graphic image

Geometric composition of
shapes provide a great background

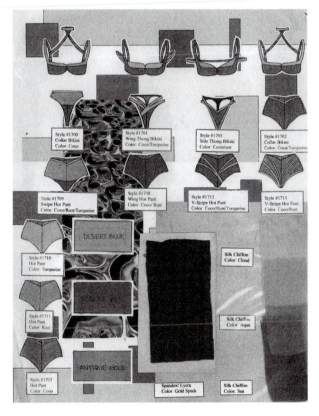

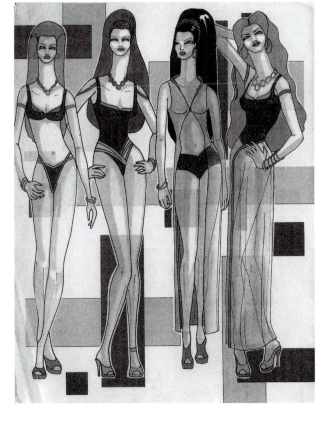

By Gaston Ali

By Nicole Doran

Photographs and graphic images should be used carefully and not as a focal point. They should be used to enhance the overall layout.

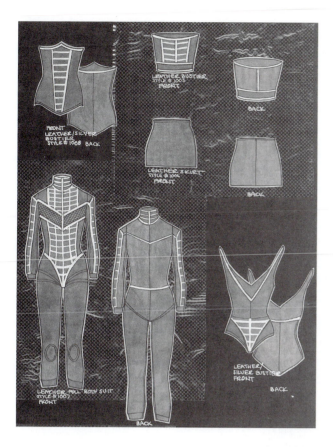

By Nicole Doran

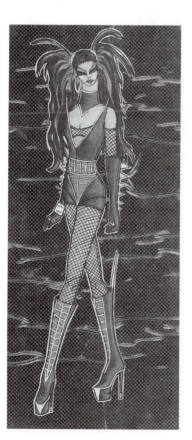

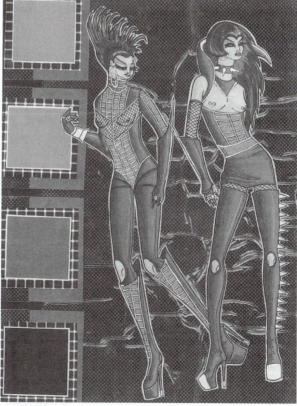

Interplay between the figures creates a good fluid image and cuts down on awkward negative spaces.

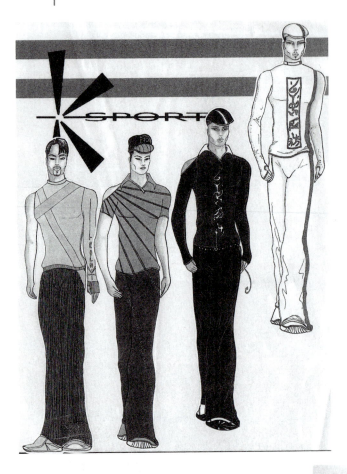

By Gaston Ali

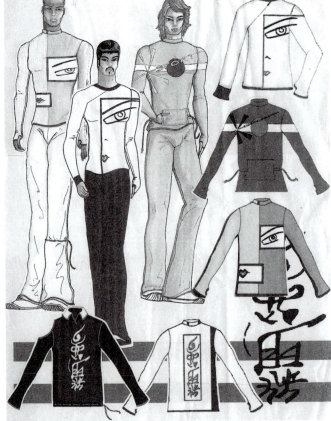

Simple layouts work best on projects with intricate designs

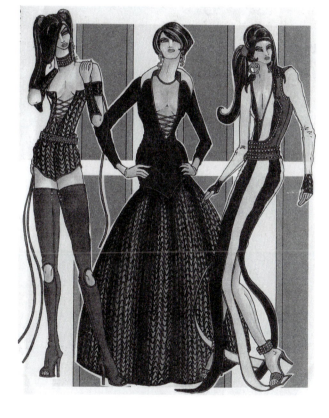

By Gaston Ali

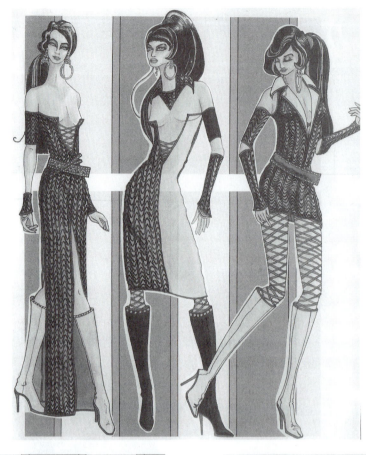

By Gaston Ali

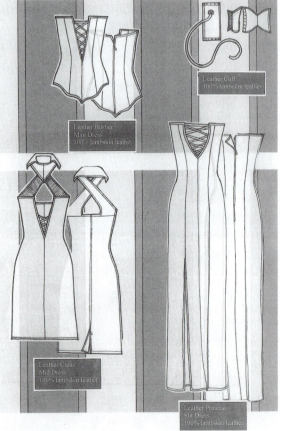

Leather Bustier
Mini Dress
100% lambskin leather

Leather Cuff
100% lambskin leather

Leather Cross
Mid Dress
100% lambskin leather

Leather Princess
Slit Dress
100% lambskin leather

Designer Eveningwear Collection
By *Eliasgali*

CHAPTER 12
APPENDIX

Fashion
Designs

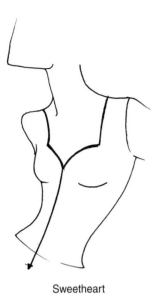

Sweetheart

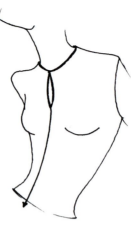

Key-hole opening

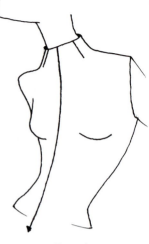

Funnel

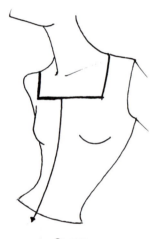

Square

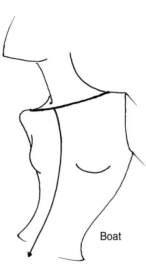

Boat

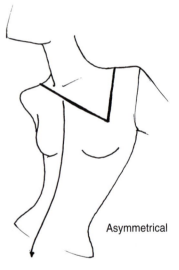

Asymmetrical

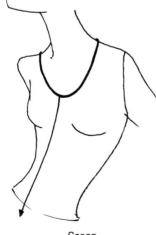

Scoop

Necklines

Various necklines are presented in the accompanying diagrams. Collars may be added to any of these. Note that the center line of the body presents the deepest part of the collar, giving a better view of one side than of the other. This side should showcase any noteworthy details. Equally important to note are the arrows that show the trajectory, or direction, of the center front of the garment. Any details that belong in center front must be placed in accordance with the position of this line.

Basic Collars

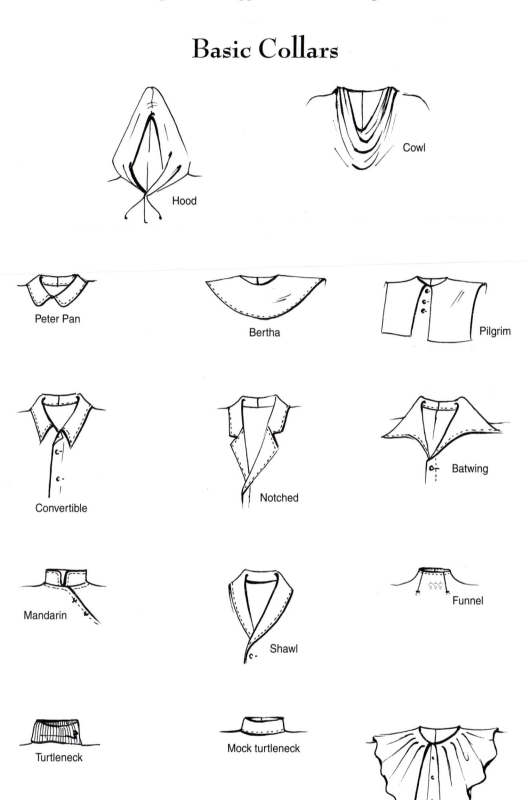

Hood

Cowl

Peter Pan

Bertha

Pilgrim

Convertible

Notched

Batwing

Mandarin

Shawl

Funnel

Turtleneck

Mock turtleneck

Flutter

Collar Variations

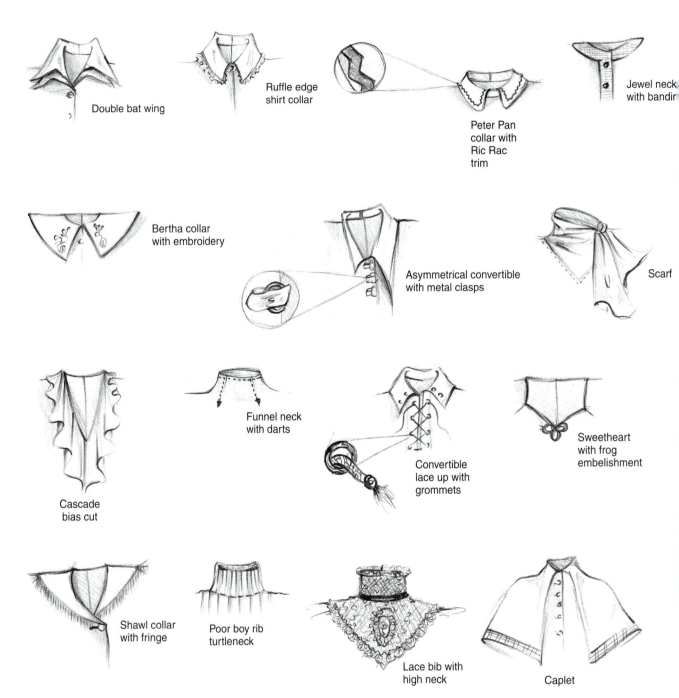

Double bat wing

Ruffle edge shirt collar

Peter Pan collar with Ric Rac trim

Jewel neck with bandin

Bertha collar with embroidery

Asymmetrical convertible with metal clasps

Scarf

Cascade bias cut

Funnel neck with darts

Convertible lace up with grommets

Sweetheart with frog embelishment

Shawl collar with fringe

Poor boy rib turtleneck

Lace bib with high neck

Caplet

Armholes

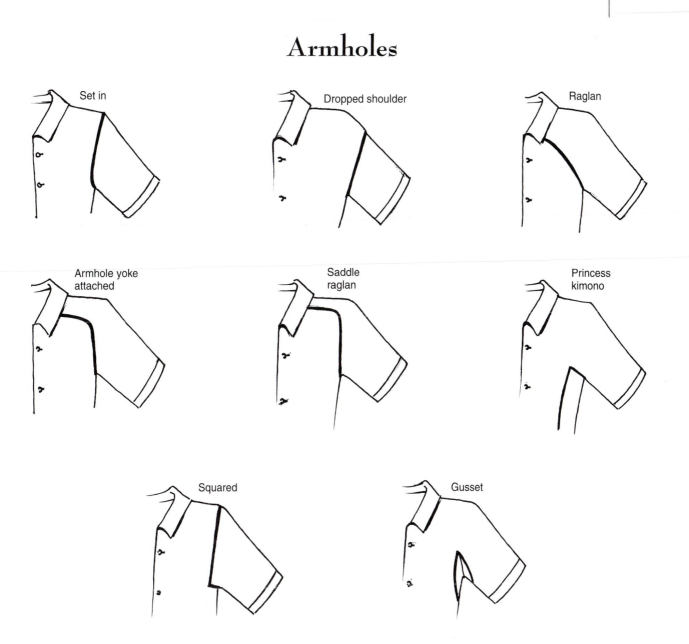

Basic Sleeve Patterns

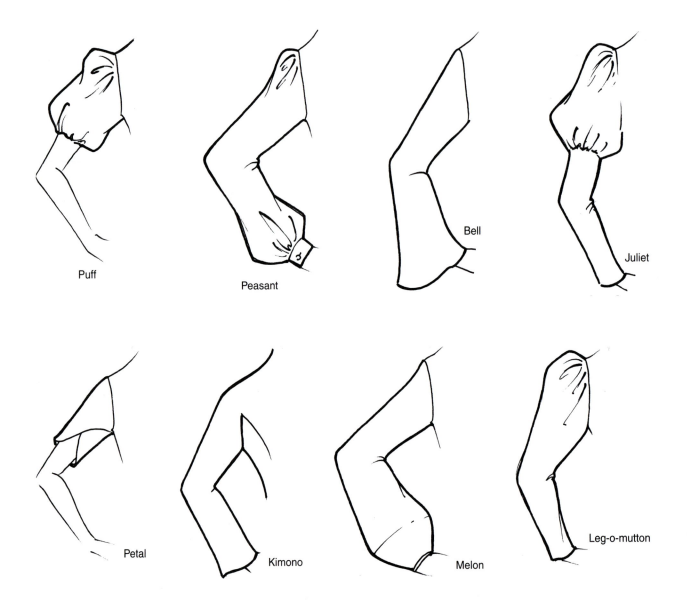

Puff

Peasant

Bell

Juliet

Petal

Kimono

Melon

Leg-o-mutton

Stylized Sleeve Patterns

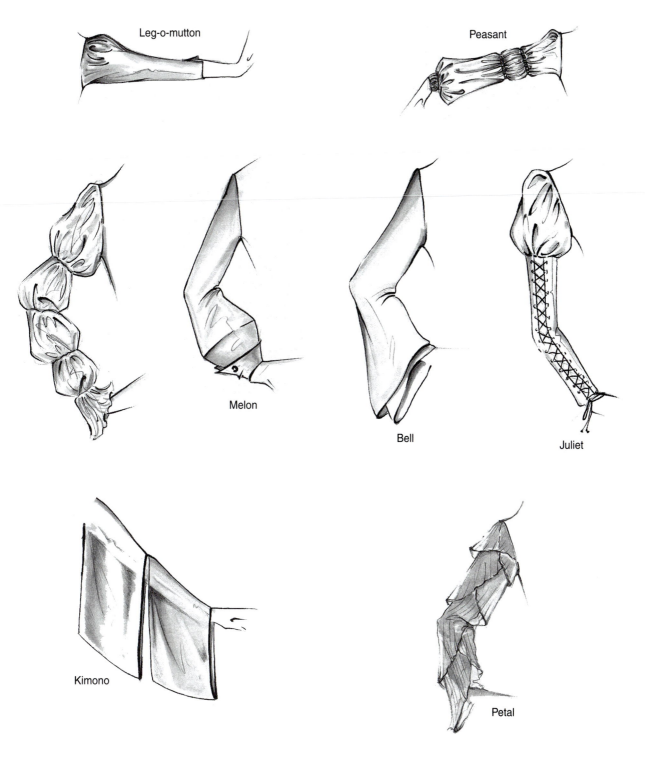

Leg-o-mutton

Peasant

Melon

Bell

Juliet

Kimono

Petal

Lapels

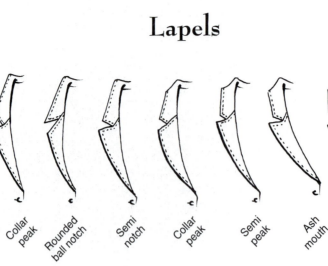

Rounded peak Collar peak Rounded ball notch Semi notch Collar peak Semi peak Ash mouth Mall clover Peak

Cuffs

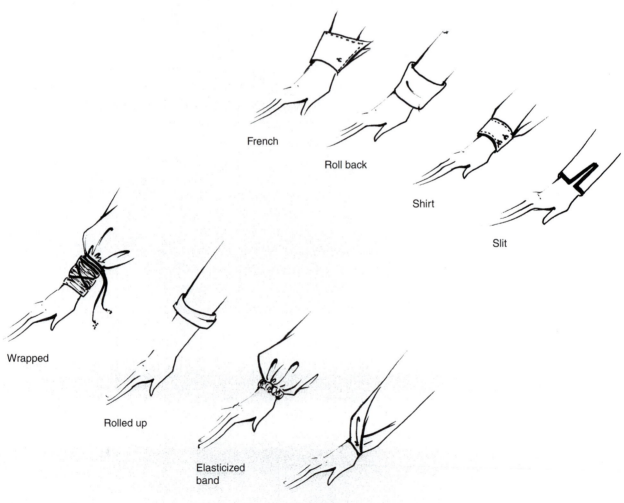

French

Roll back

Shirt

Slit

Wrapped

Rolled up

Elasticized band

Overlapped

Cuff Variations

Poor boy rib

French cuff turned down

Banded

Belted

French cuff

Elasticized

Back stitch

Wrapped

Layered ruffle

Gathered or shirred

Tipits

Rib trim

Contrast banding

Rolled up sleeve

Waistline Treatments

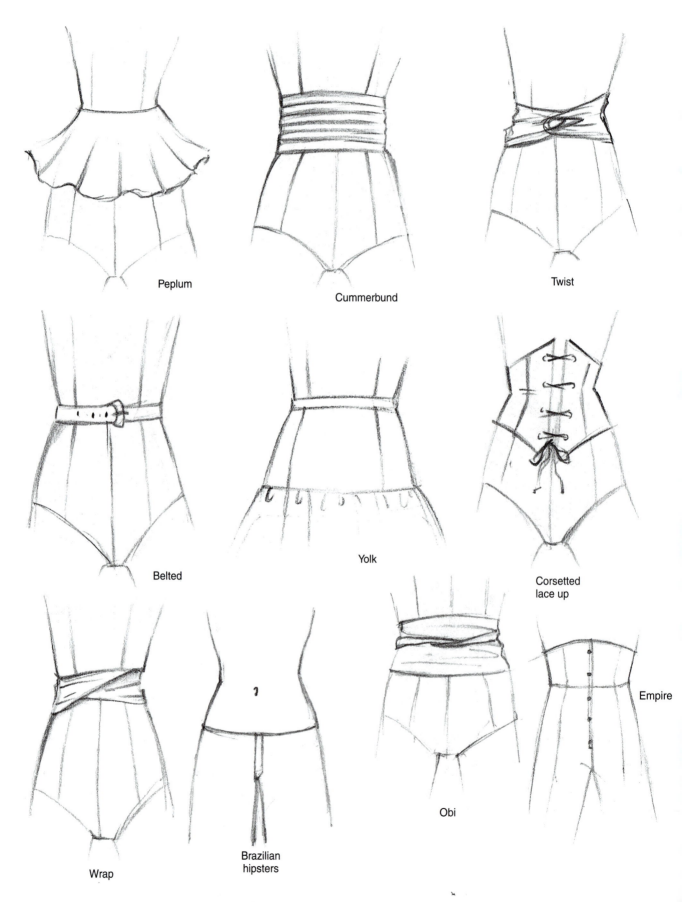

Peplum

Cummerbund

Twist

Belted

Yolk

Corsetted
lace up

Wrap

Brazilian
hipsters

Obi

Empire

Skirt Variations

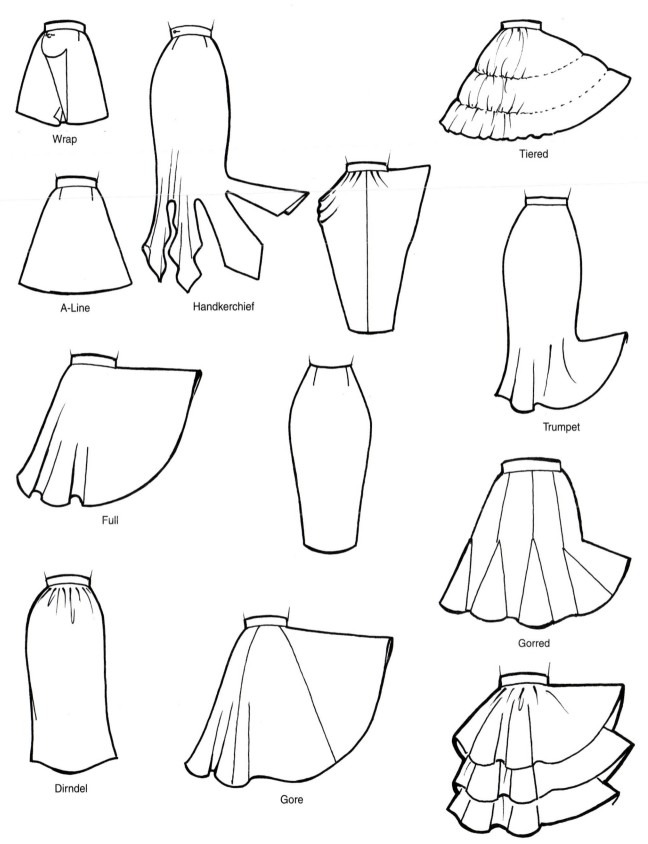

Wrap

Tiered

A-Line

Handkerchief

Trumpet

Full

Dirndel

Gore

Gorred

Layered

Skirts in Motion

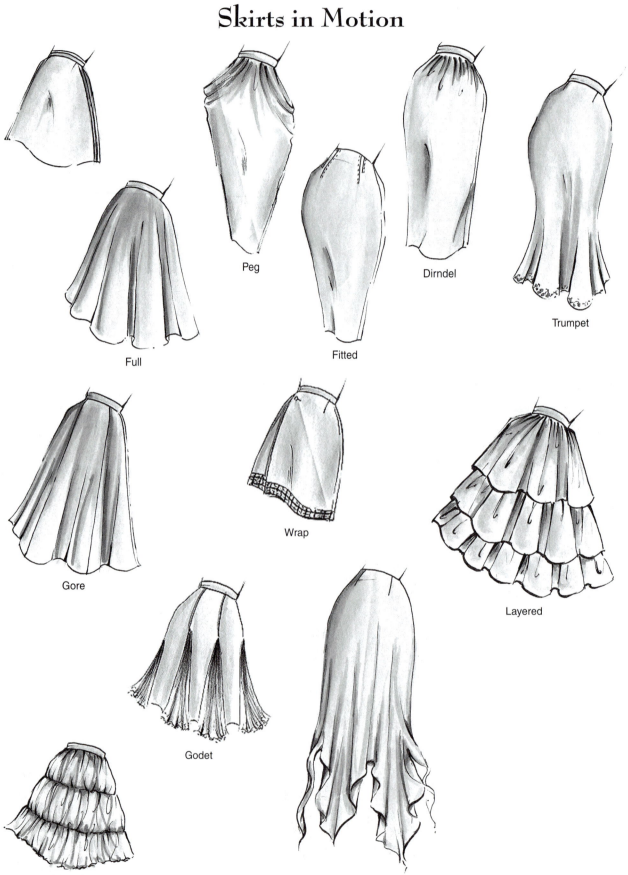

Full

Peg

Fitted

Dirndel

Trumpet

Gore

Wrap

Layered

Godet

Handkerchief

Tiered

Pants and Shorts Variations

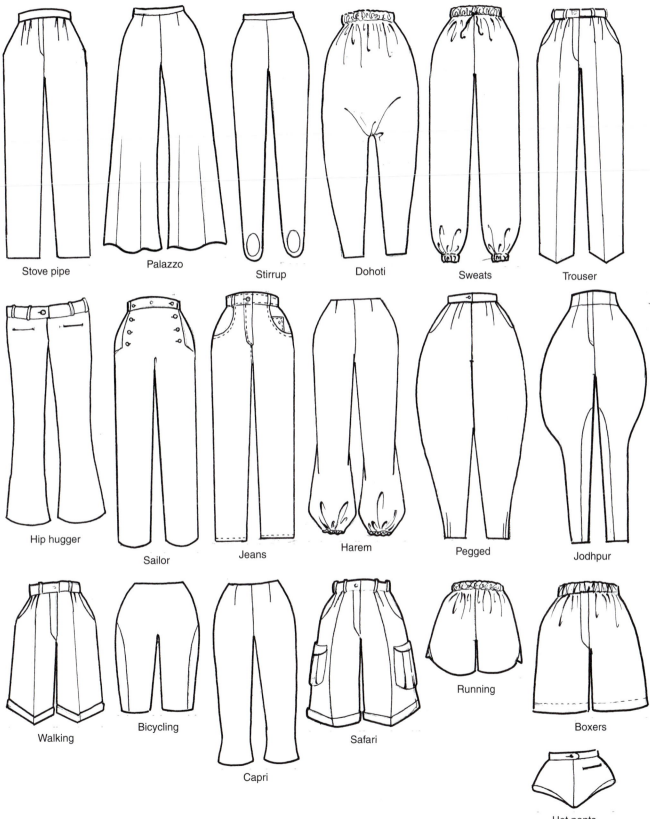

Stove pipe

Palazzo

Stirrup

Dohoti

Sweats

Trouser

Hip hugger

Sailor

Jeans

Harem

Pegged

Jodhpur

Walking

Bicycling

Capri

Safari

Running

Boxers

Hot pants

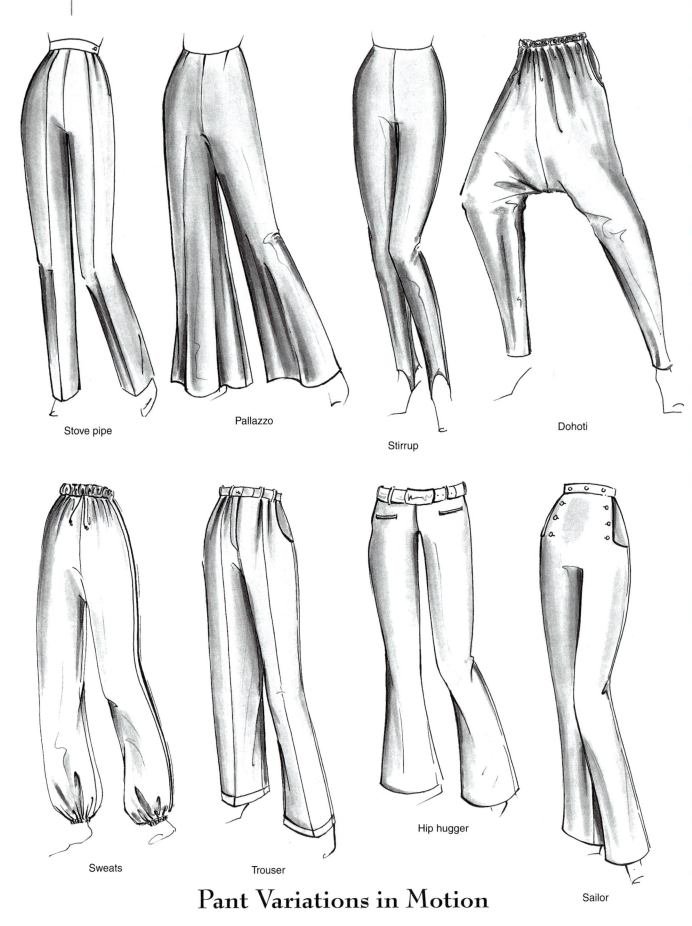

Stove pipe

Pallazzo

Stirrup

Dohoti

Sweats

Trouser

Hip hugger

Sailor

Pant Variations in Motion

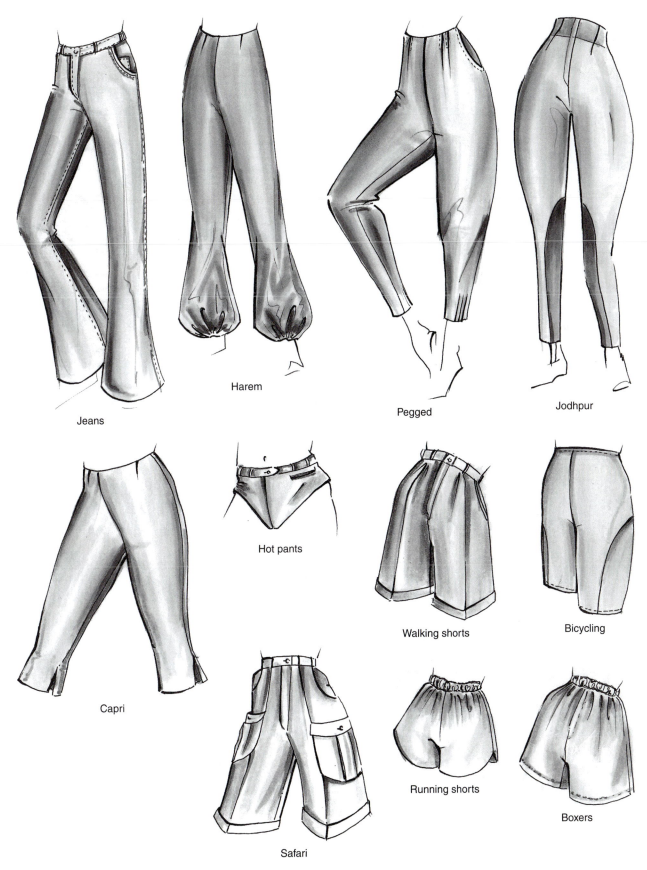

Jeans

Harem

Pegged

Jodhpur

Capri

Hot pants

Walking shorts

Bicycling

Safari

Running shorts

Boxers

Pant Variations in Motion

Pockets

Kangaroo

Welt

Besom

Bellows

Shirt or patch

Cargo

Western

In-seam
pocket

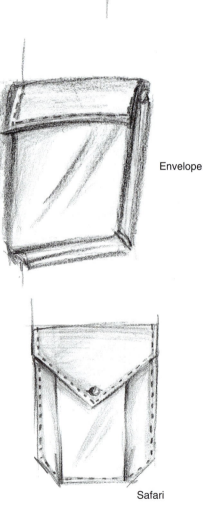

Envelope

Safari

Flap

Sleep Loungewear

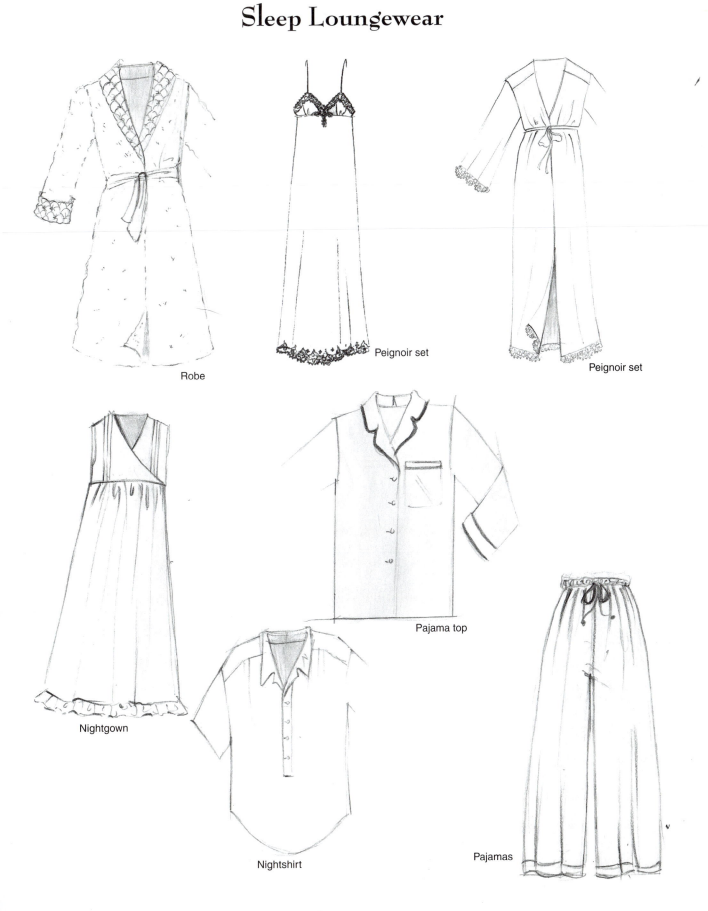

Robe

Peignoir set

Peignoir set

Nightgown

Nightshirt

Pajama top

Pajamas

Foundation Garments

Traditional brassiere

Underwire

Soft brassiere

Strapless brassiere

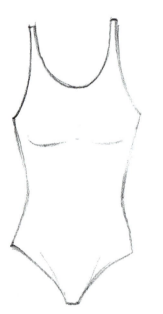

Leotard/body suit

Bustier

Control-top girdle

Garter

Bandeau

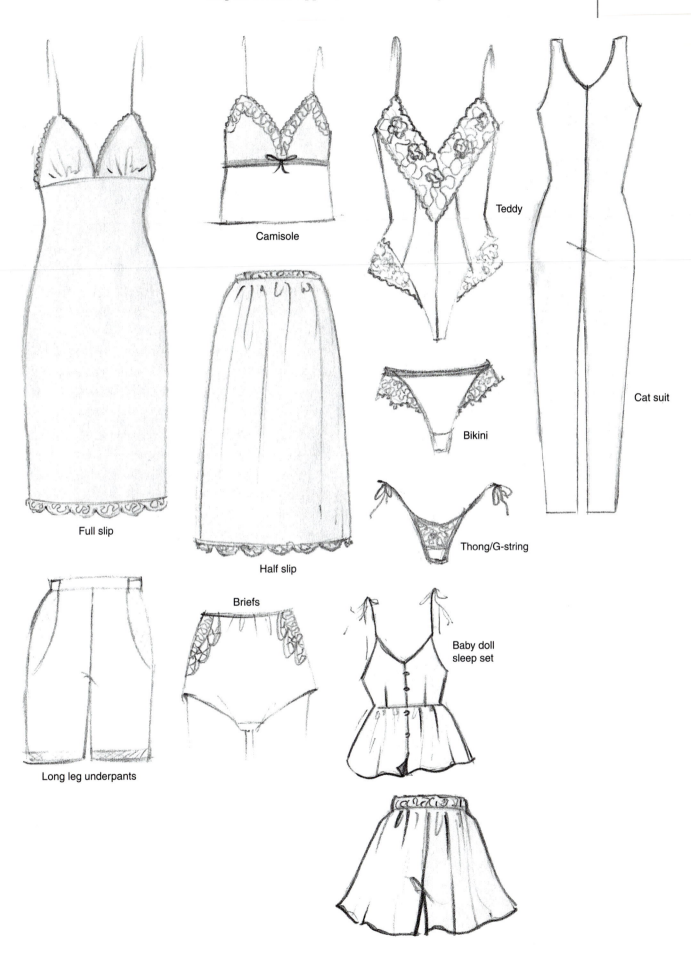

Full slip

Camisole

Half slip

Teddy

Bikini

Thong/G-string

Cat suit

Long leg underpants

Briefs

Baby doll
sleep set

Closures

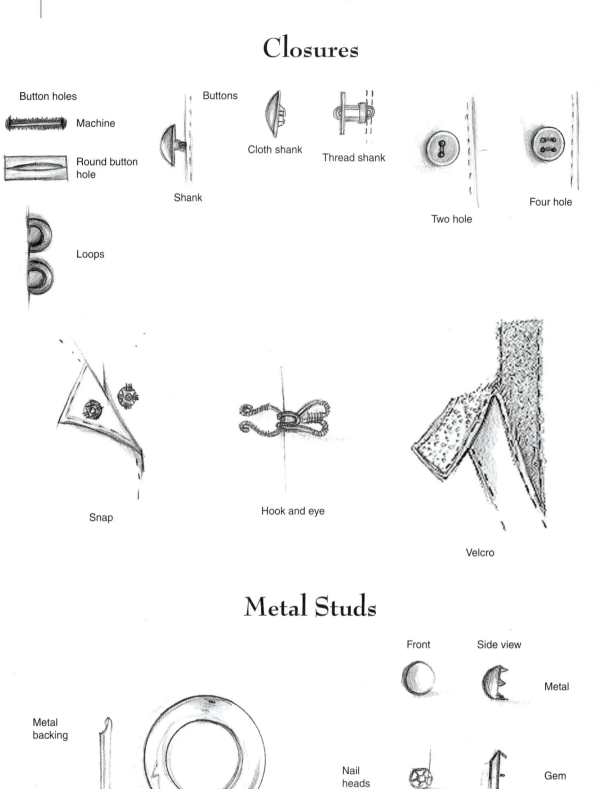

Button holes

Machine

Round button hole

Buttons

Shank

Cloth shank

Thread shank

Two hole

Four hole

Loops

Snap

Hook and eye

Velcro

Metal Studs

Metal backing

Side view

Grommets

Front

Side view

Metal

Nail heads

Gem

Novelty

Men's Coats and Jackets

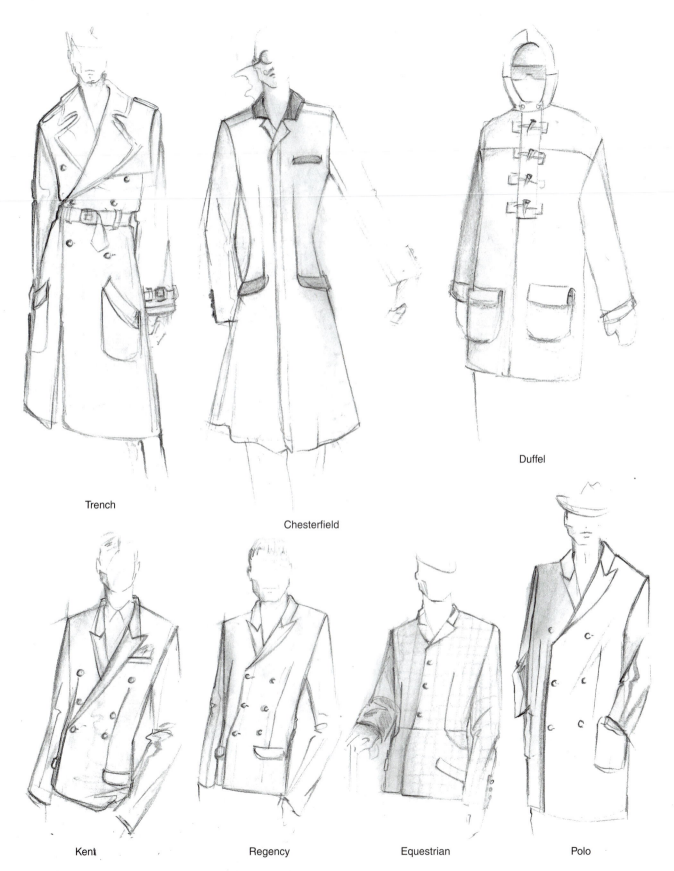

Trench

Chesterfield

Duffel

Kent

Regency

Equestrian

Polo

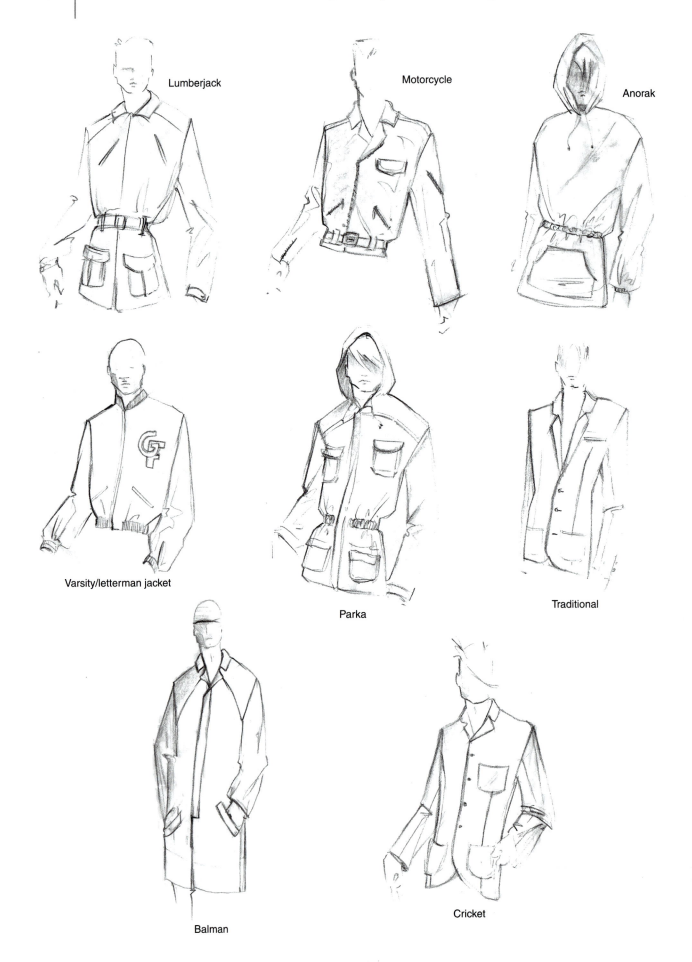

Lumberjack

Motorcycle

Anorak

Varsity/letterman jacket

Parka

Traditional

Balman

Cricket

Embellishments

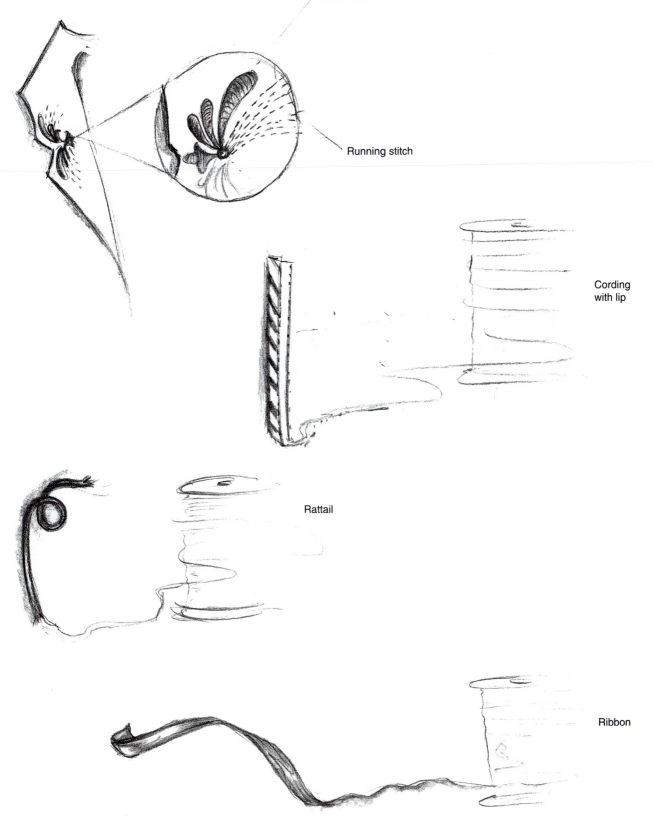

Statin stitch

Running stitch

Cording
with lip

Rattail

Ribbon

Trims
Bows & Knots

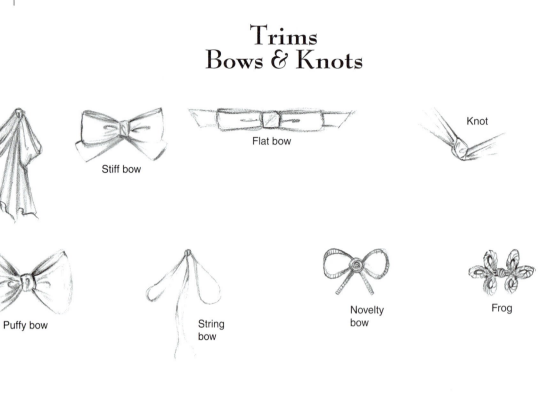

Soft

Stiff bow

Flat bow

Knot

Puffy bow

String bow

Novelty bow

Frog

Tassel

Pompom

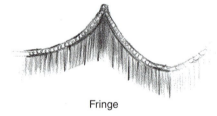

Fringe

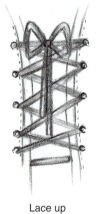

Lace up

Feathers

Ostrich

Peacock

Goose

Rooster

Duck quil

Fabric Treatments

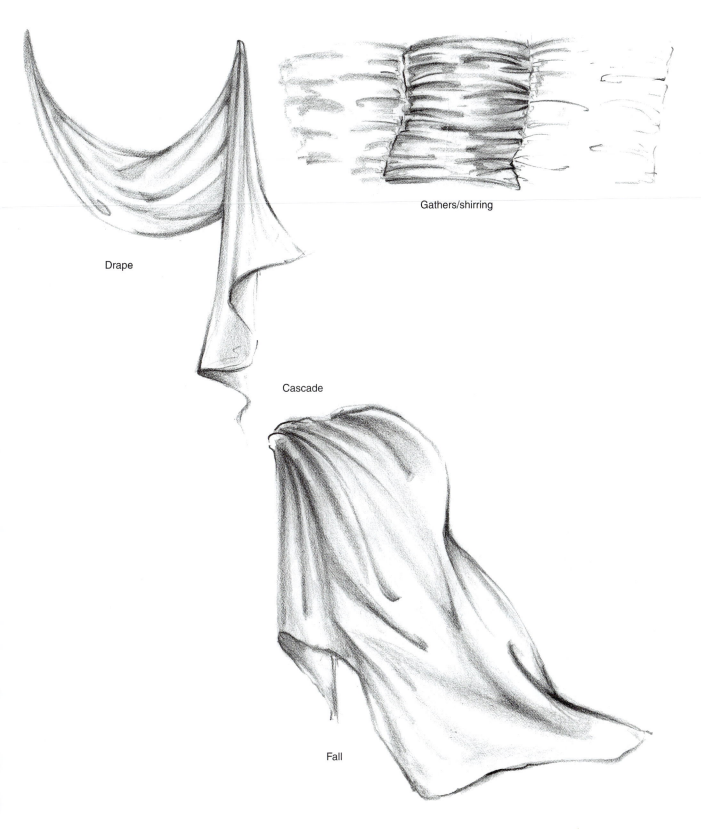

Drape

Gathers/shirring

Cascade

Fall

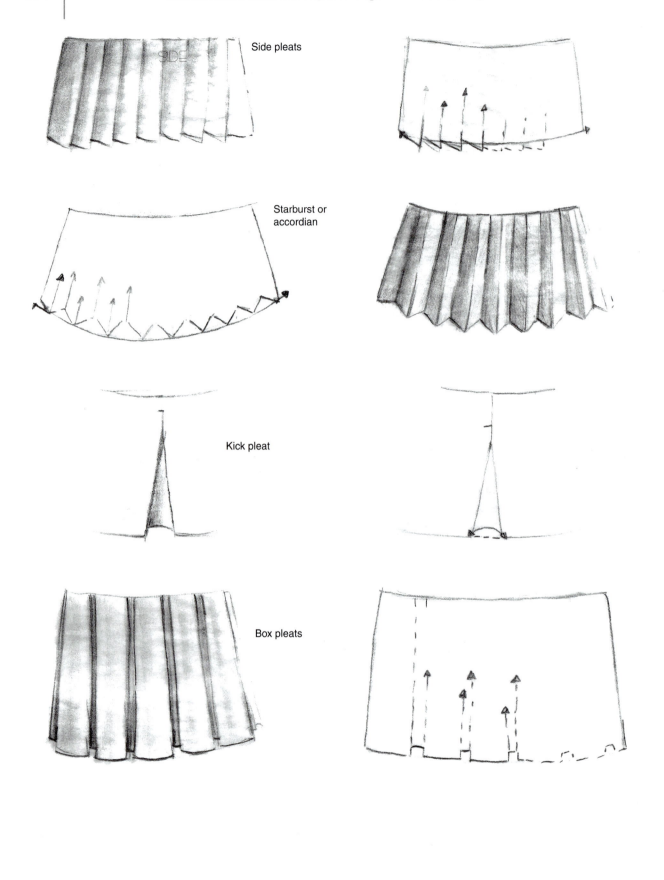

Side pleats

Starburst or accordian

Kick pleat

Box pleats

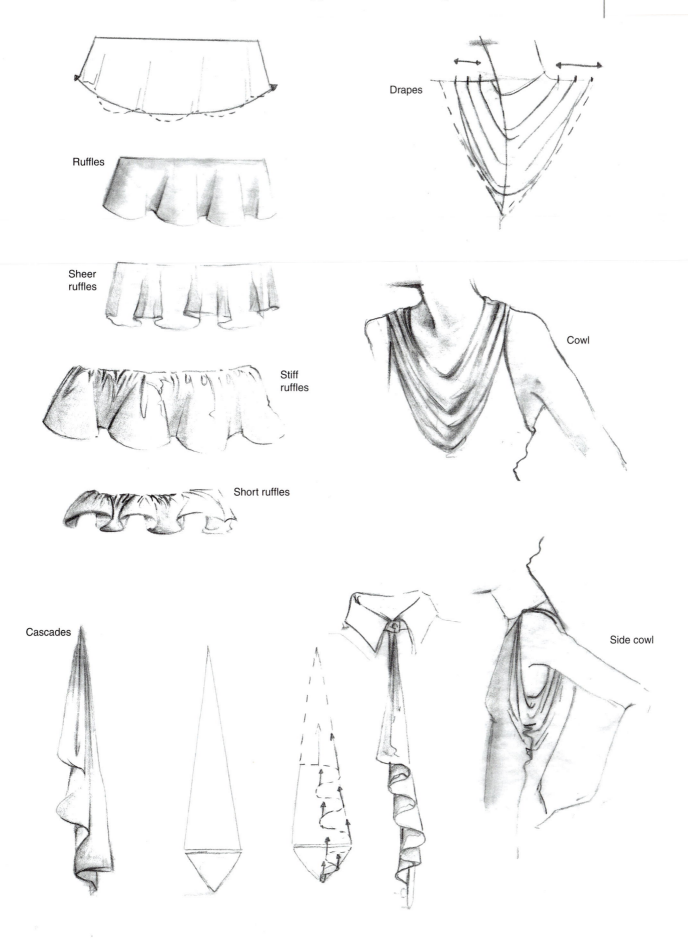

Ruffles

Drapes

Sheer ruffles

Stiff ruffles

Cowl

Short ruffles

Cascades

Side cowl

Embroidery Treatments

Ribbon
passementerie

Passementerie

Fabric
braids

Faggoting

Applique
embroidery

Basket
weave

Passementerie embroidery
with nail head stud

Seam Finishes

Satin stitch scalloped edge

Top stitch

Cross stitch

Flat felt seam

Piping

Basting

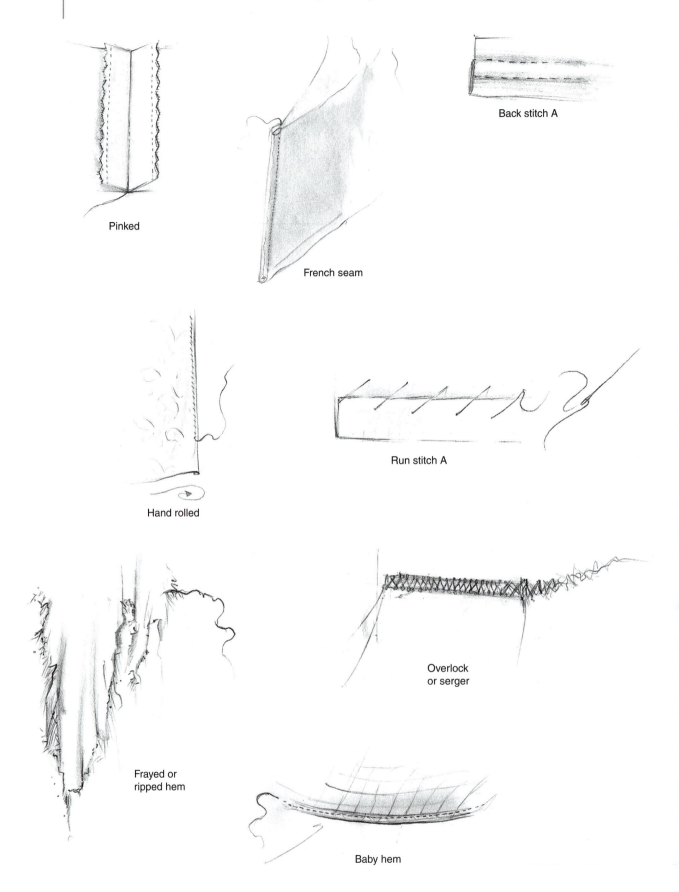

Pinked

French seam

Back stitch A

Hand rolled

Run stitch A

Frayed or
ripped hem

Overlock
or serger

Baby hem

Shoes and Boots

Mule

Boater

Wedge

Clog

Platform

Gaiter

Sling back

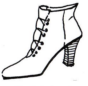

Granny boot

Pump

Ballet slipper

Espadrille

Huarache

Ghillie

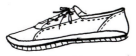

Sneaker

Cleat

Step in

Cowboy boot

Thong

Dorsay

Sandal

Alpargata

Spectator pump

Zori

Loafer

Mary Jane

Boot

Moccasin

Ball

Bags

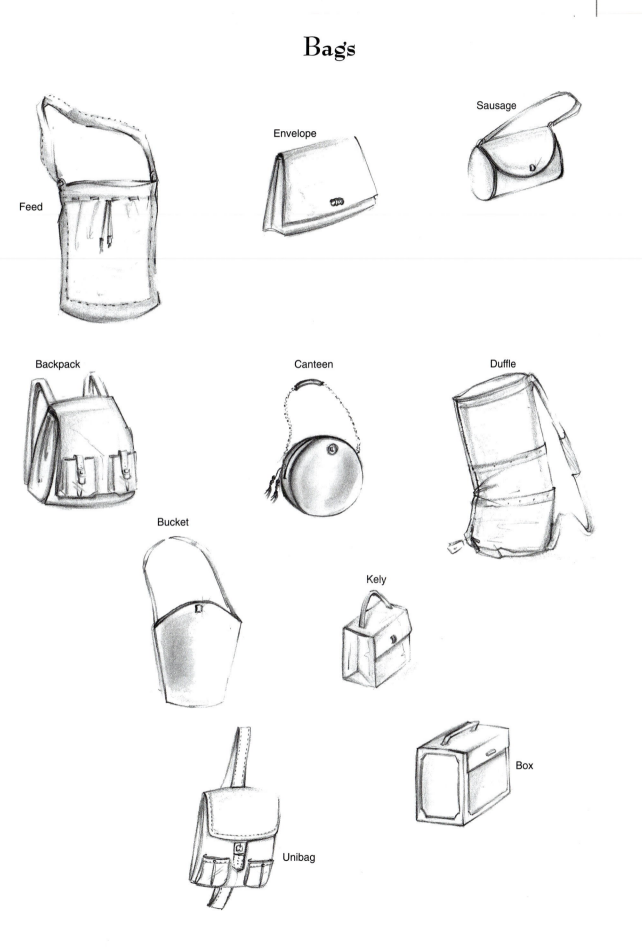

Feed

Envelope

Sausage

Backpack

Canteen

Duffle

Bucket

Kely

Box

Unibag

Drawstring

Muff

Hobo

Channel

Fishing creeal

Half moon

Satchel

School bag

Pouch

Swagger

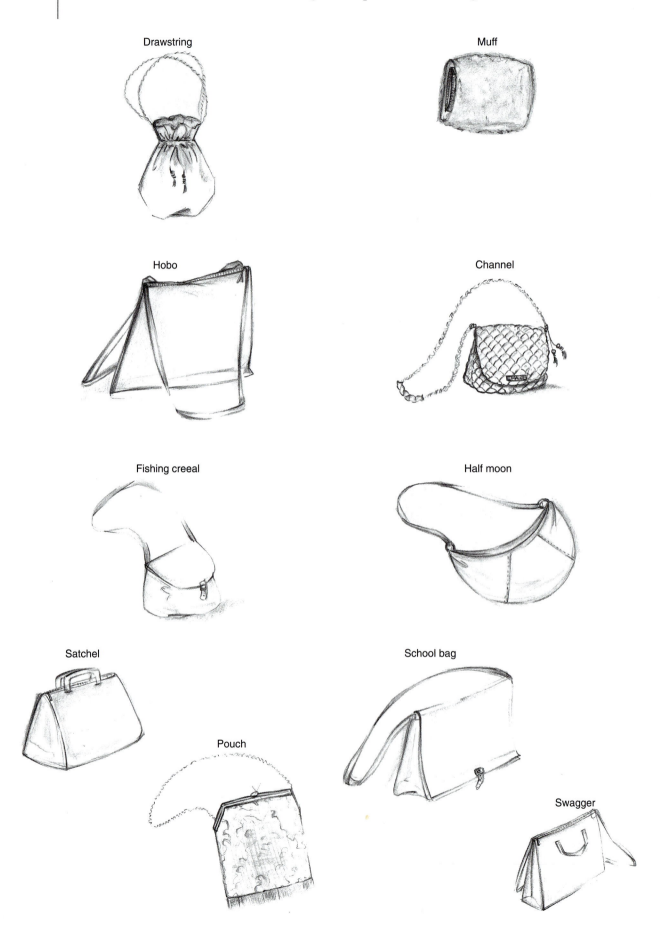

Hats

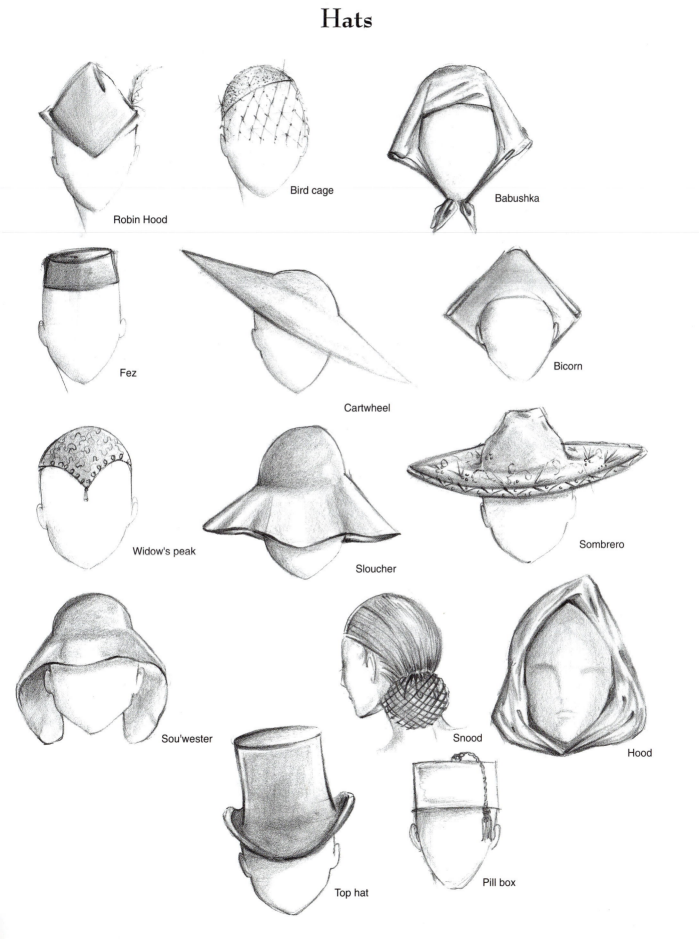

Robin Hood

Bird cage

Babushka

Fez

Cartwheel

Bicorn

Widow's peak

Sloucher

Sombrero

Sou'wester

Snood

Hood

Top hat

Pill box

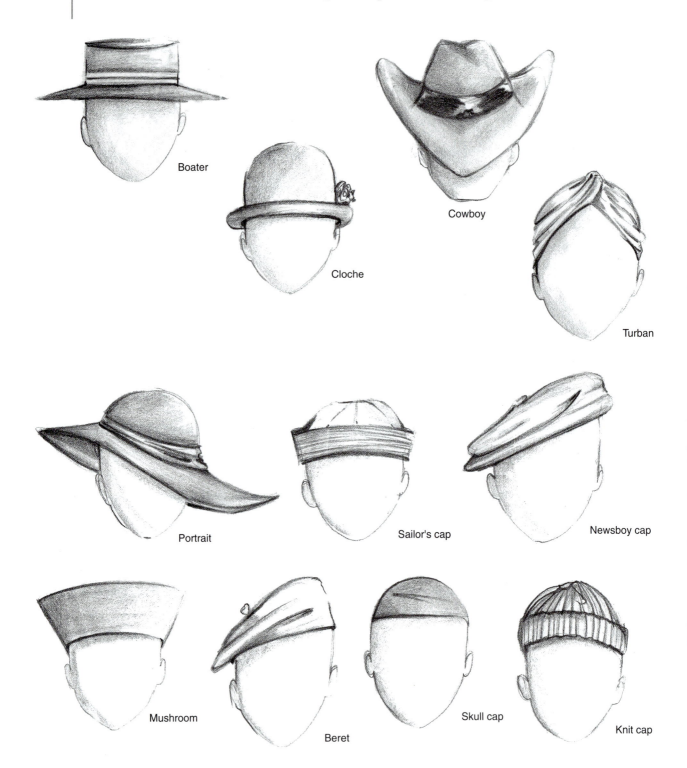

Boater

Cloche

Cowboy

Turban

Portrait

Sailor's cap

Newsboy cap

Mushroom

Beret

Skull cap

Knit cap

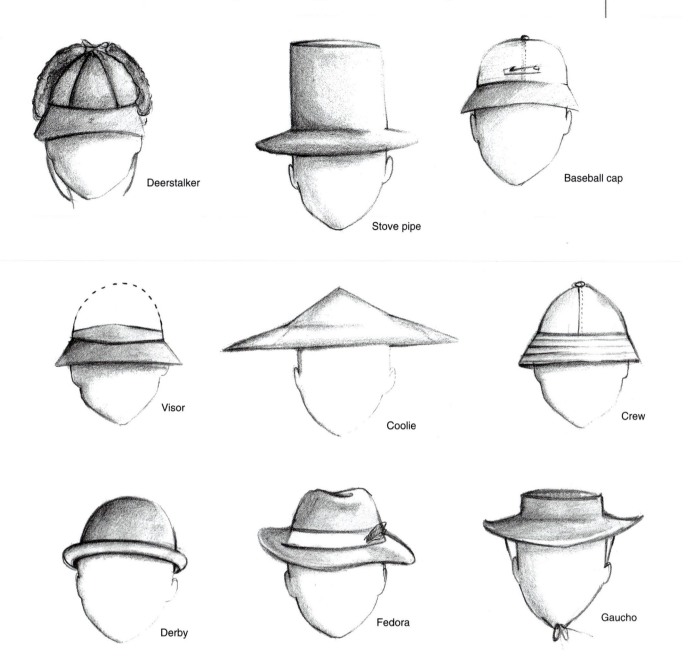

Deerstalker

Stove pipe

Baseball cap

Visor

Coolie

Crew

Derby

Fedora

Gaucho

Women's Jackets

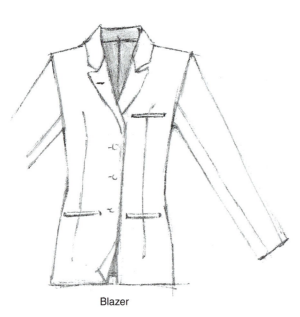

Blazer

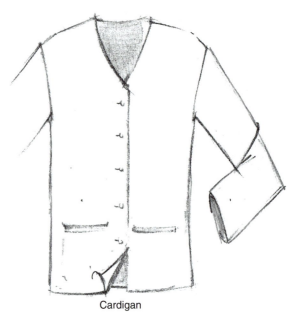

Cardigan

Bellboy

Pea/reefer

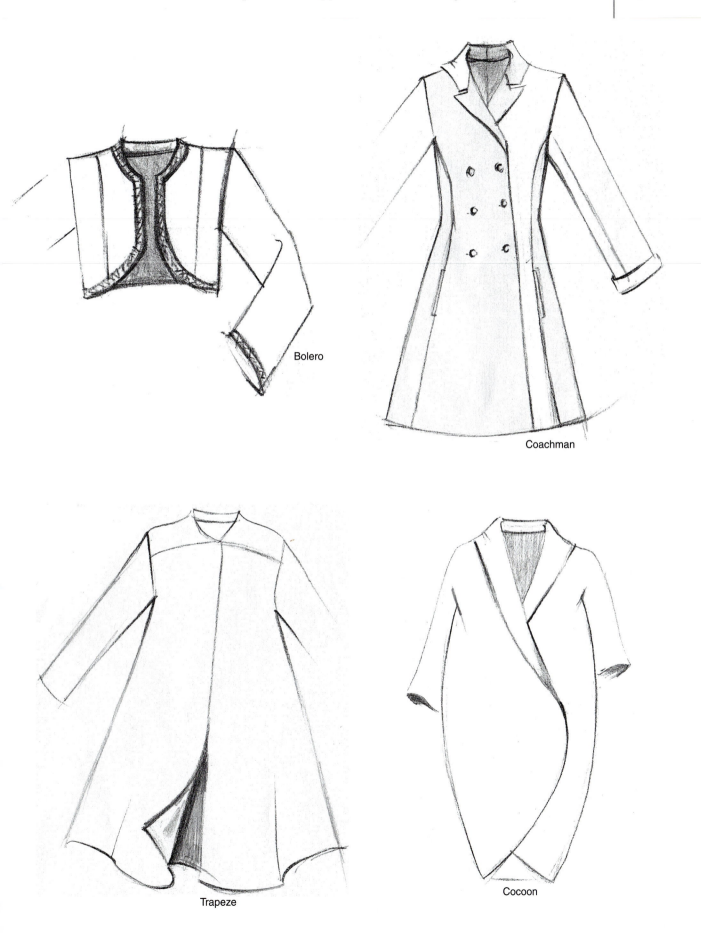

Bolero

Coachman

Trapeze

Cocoon

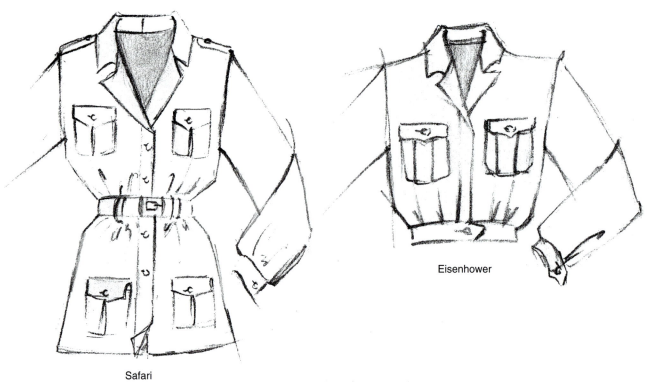

Safari

Eisenhower

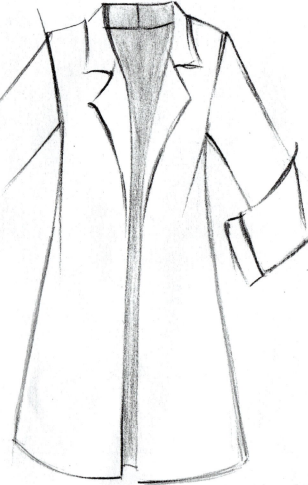

Stadium

Women's Coats

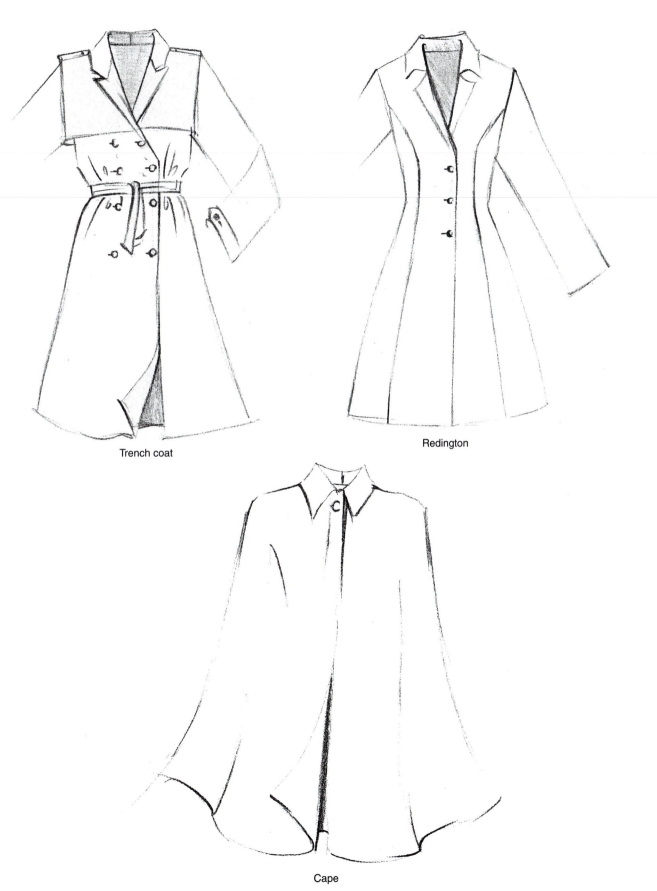

Trench coat

Redington

Cape

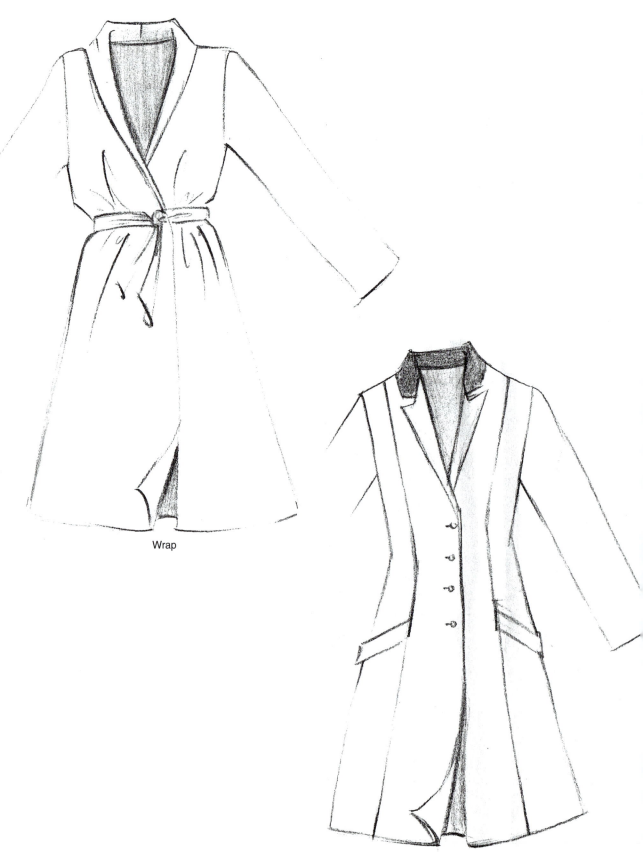

Wrap

Chesterfield

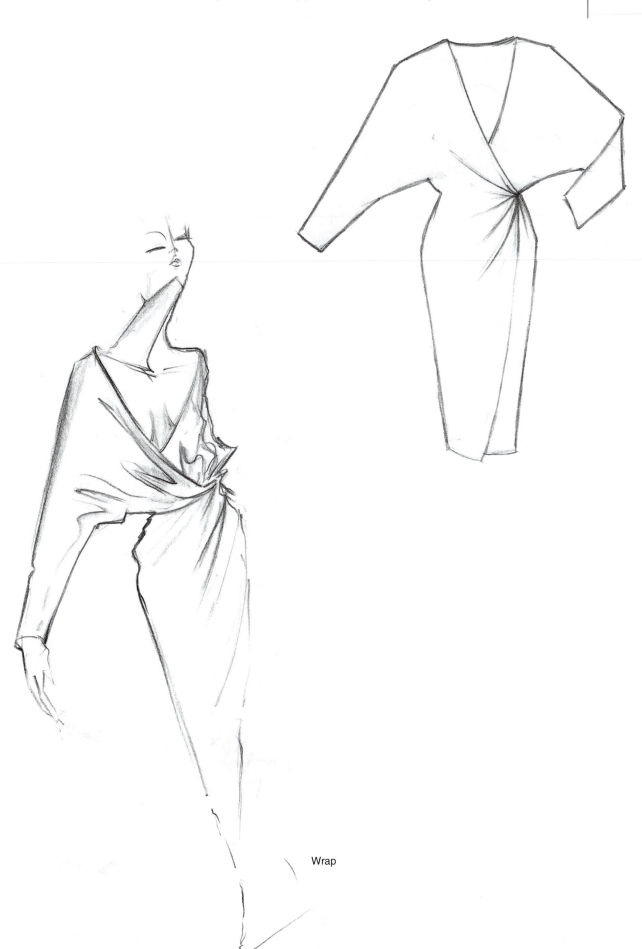

Wrap

Apron

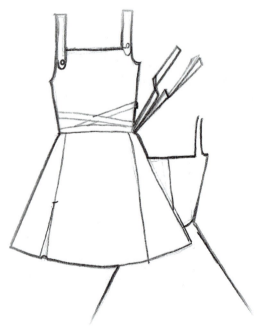

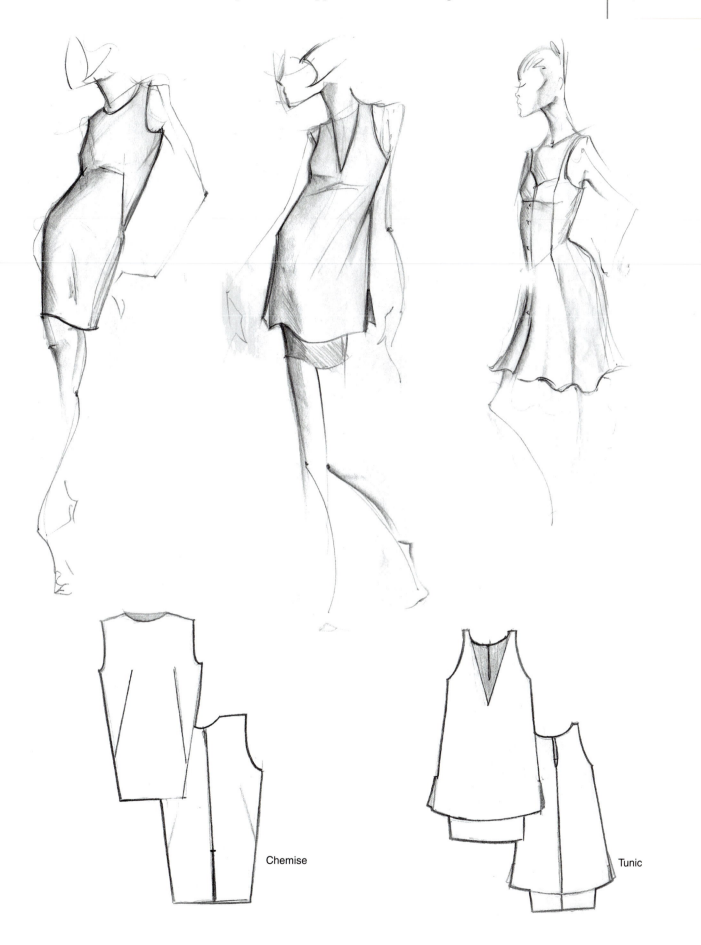

Chemise

Tunic

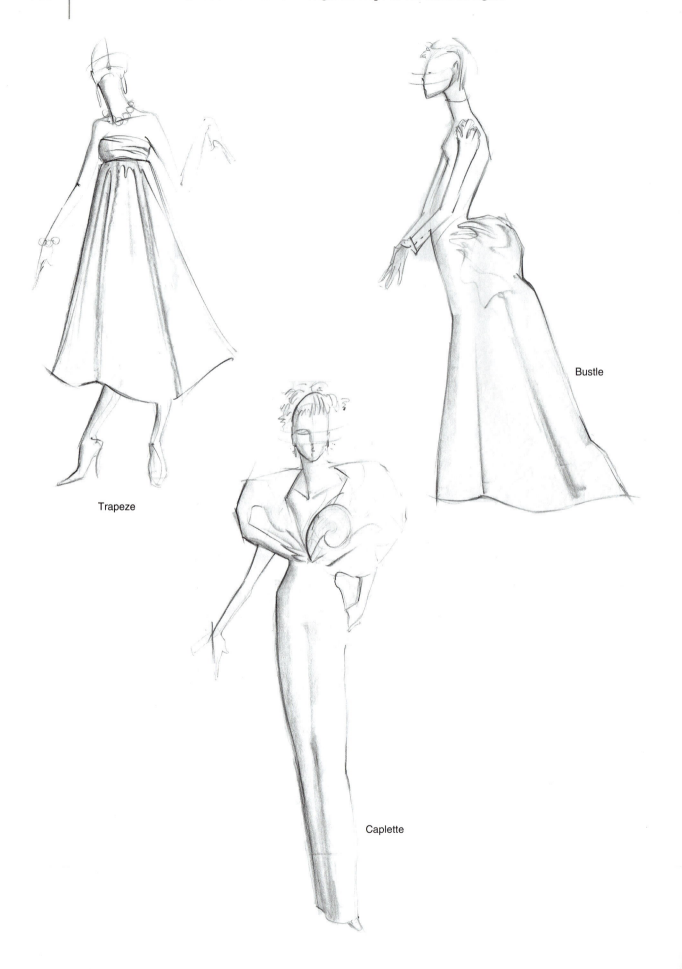

Trapeze

Bustle

Caplette

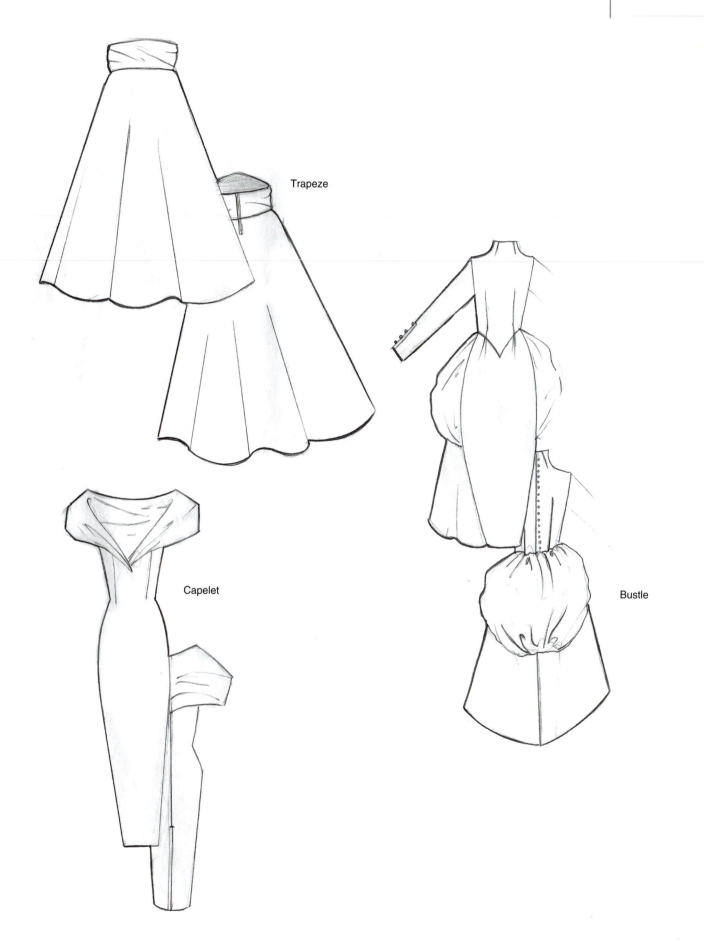

Trapeze

Capelet

Bustle

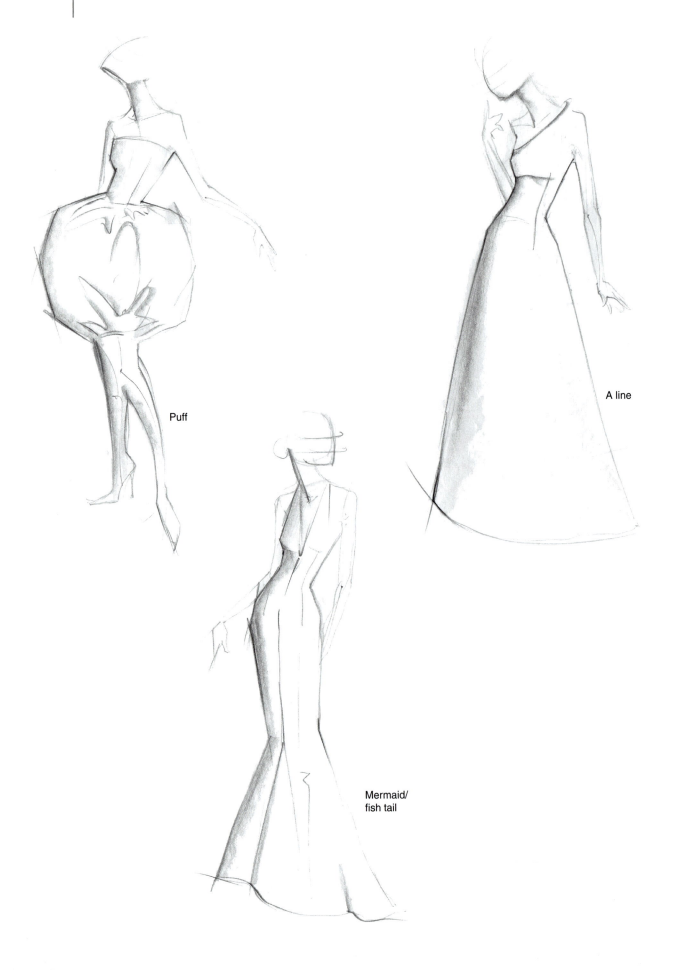

Puff

A line

Mermaid/
fish tail

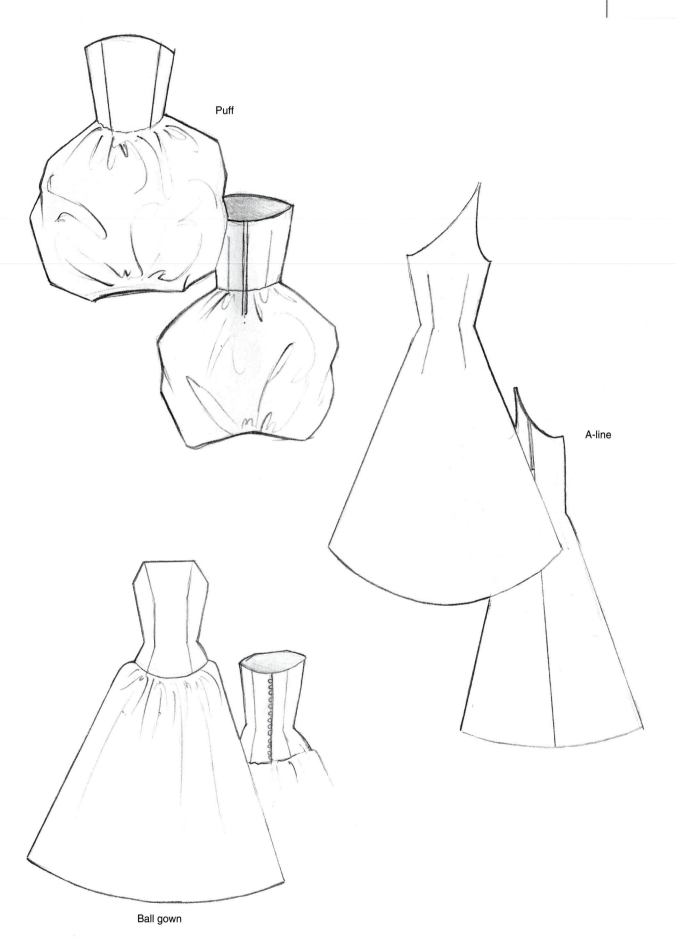

Puff

A-line

Ball gown

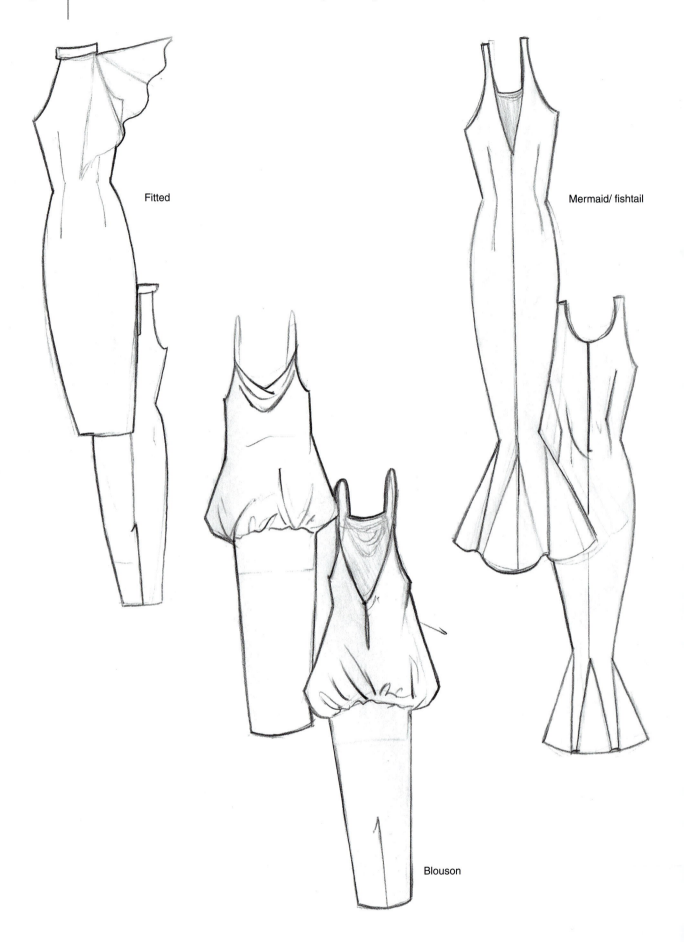

Fitted

Mermaid/ fishtail

Blouson

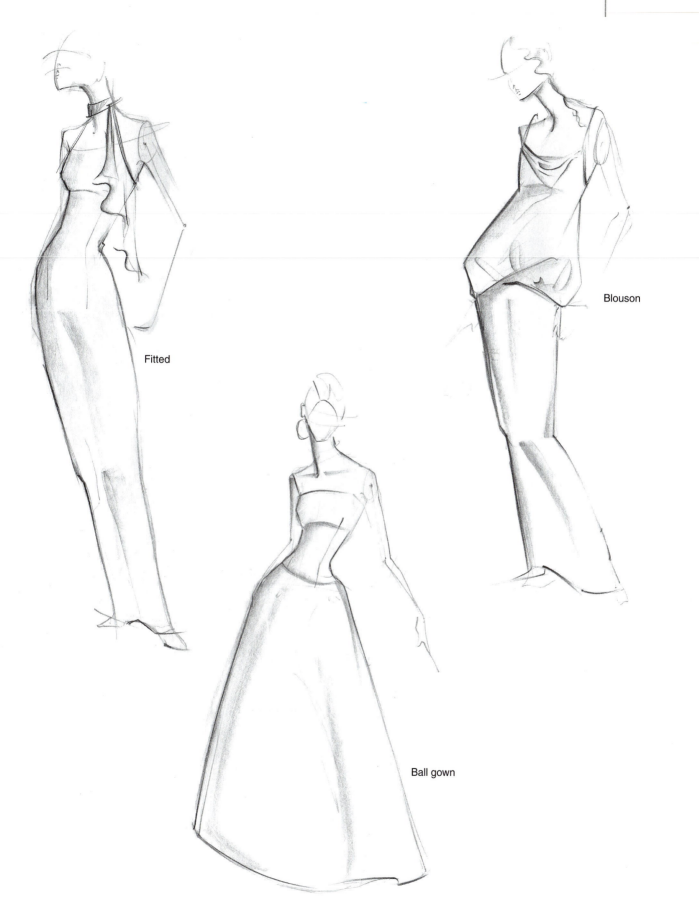

Fitted

Blouson

Ball gown

Corset Variations

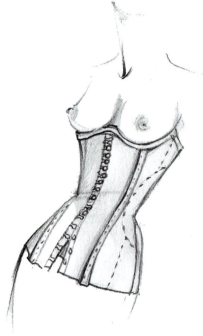

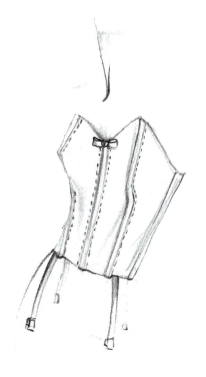

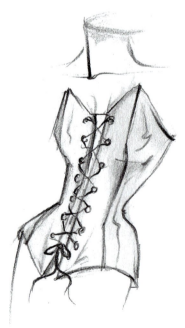

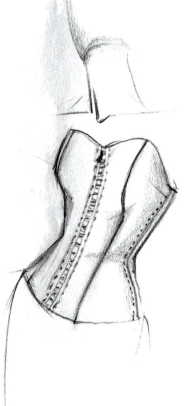

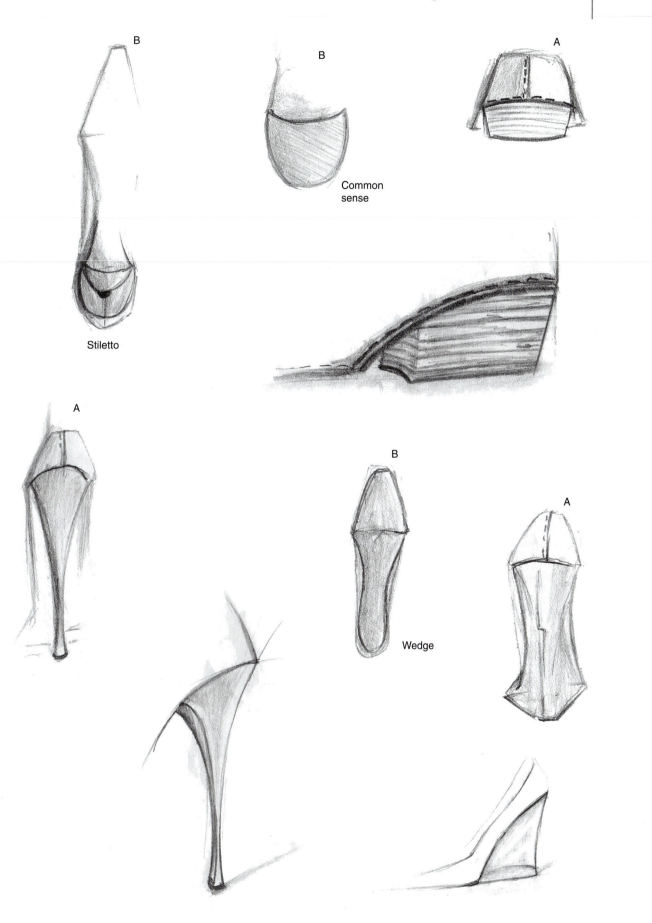

B

B

Common
sense

A

Stiletto

A

B

A

Wedge

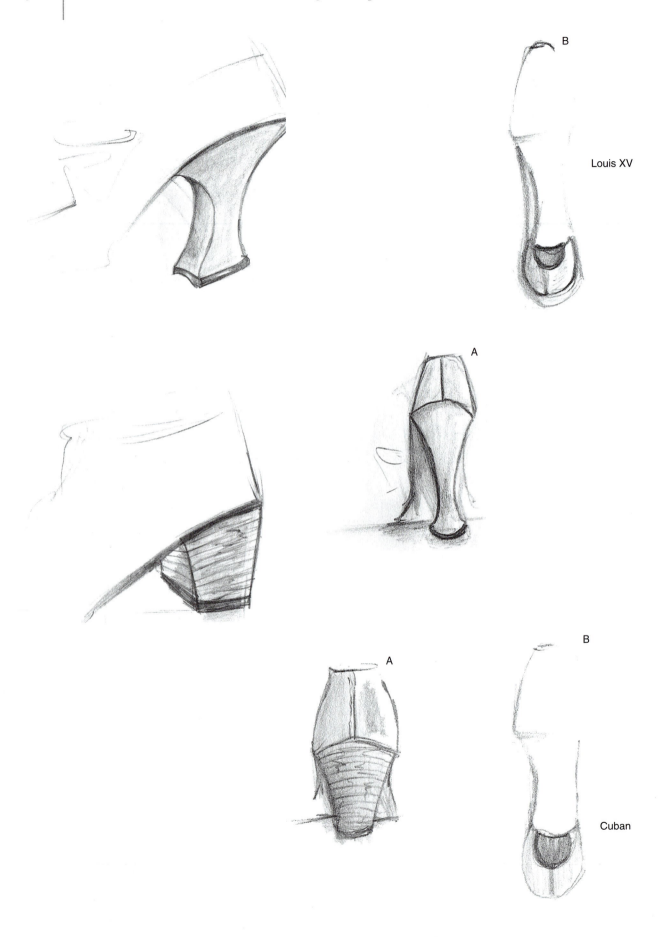

B

Louis XV

A

A

B

Cuban

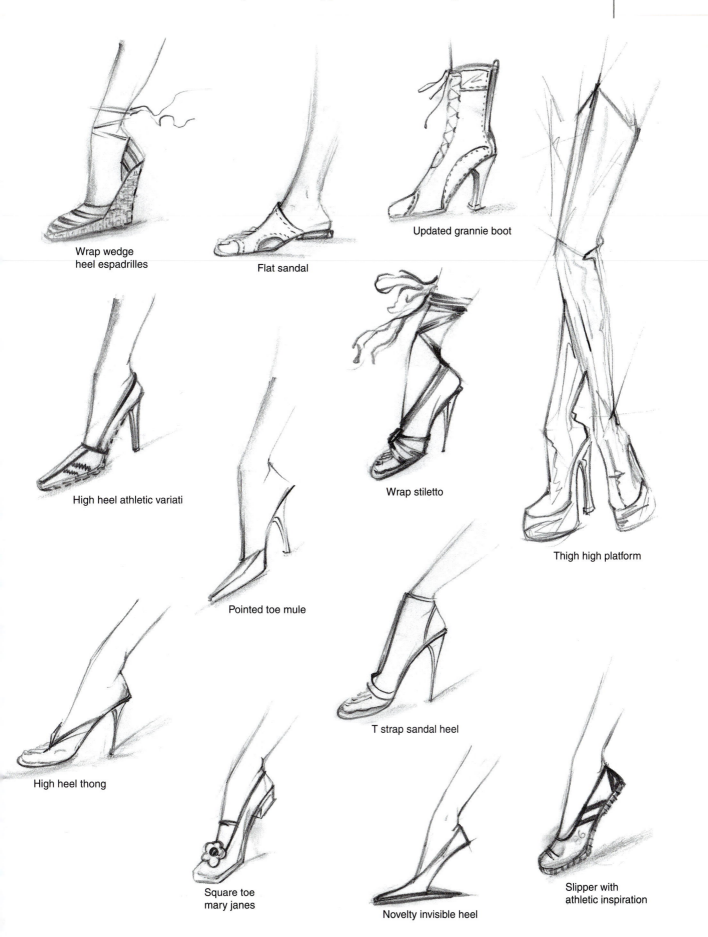

Wrap wedge
heel espadrilles

Flat sandal

Updated grannie boot

High heel athletic variati

Wrap stiletto

Thigh high platform

Pointed toe mule

High heel thong

T strap sandal heel

Square toe
mary janes

Novelty invisible heel

Slipper with
athletic inspiration

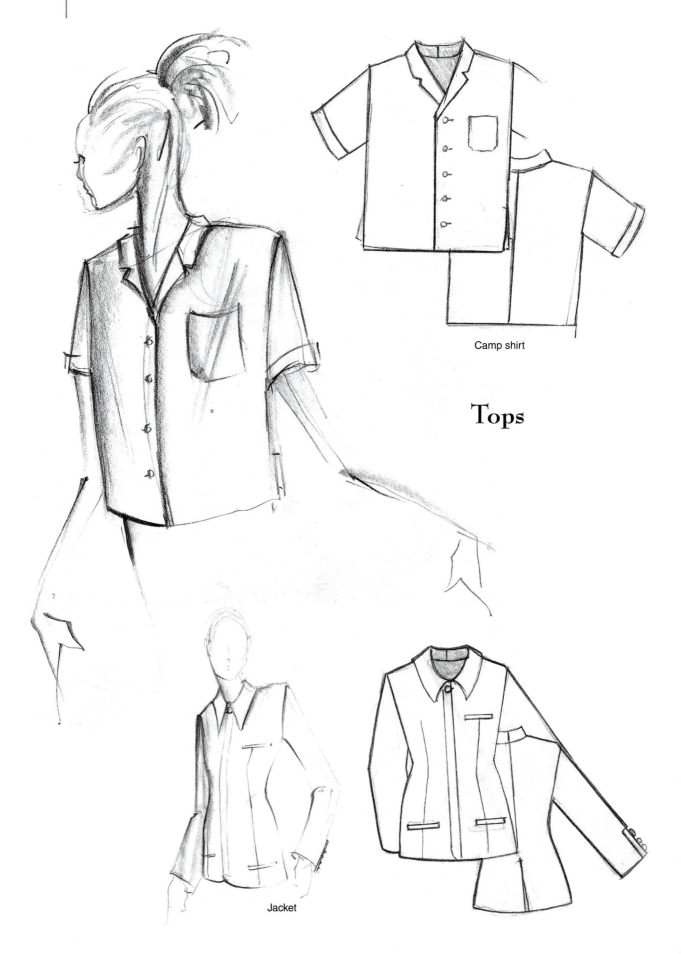

Camp shirt

Tops

Jacket

Tops

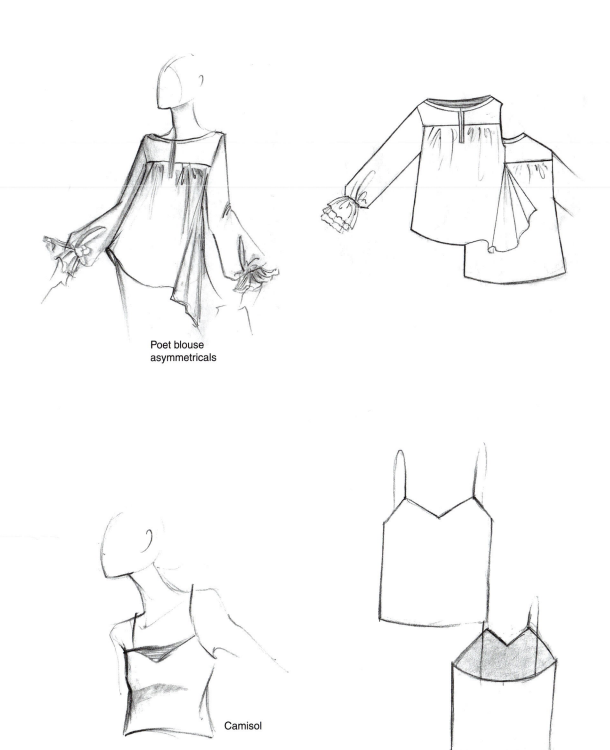

Poet blouse
asymmetricals

Camisol

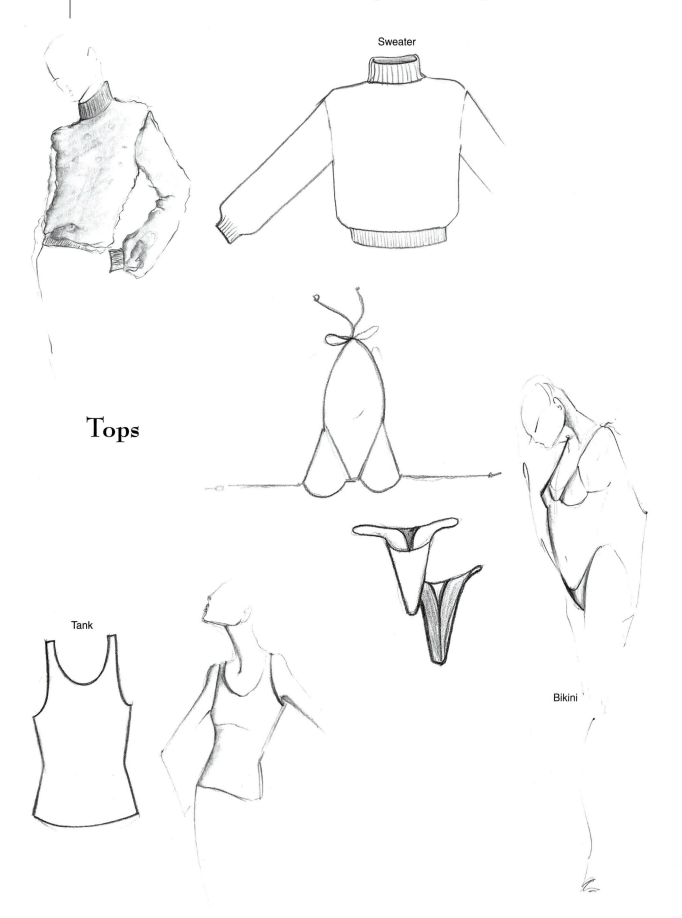

Sweater

Tops

Tank

Bikini

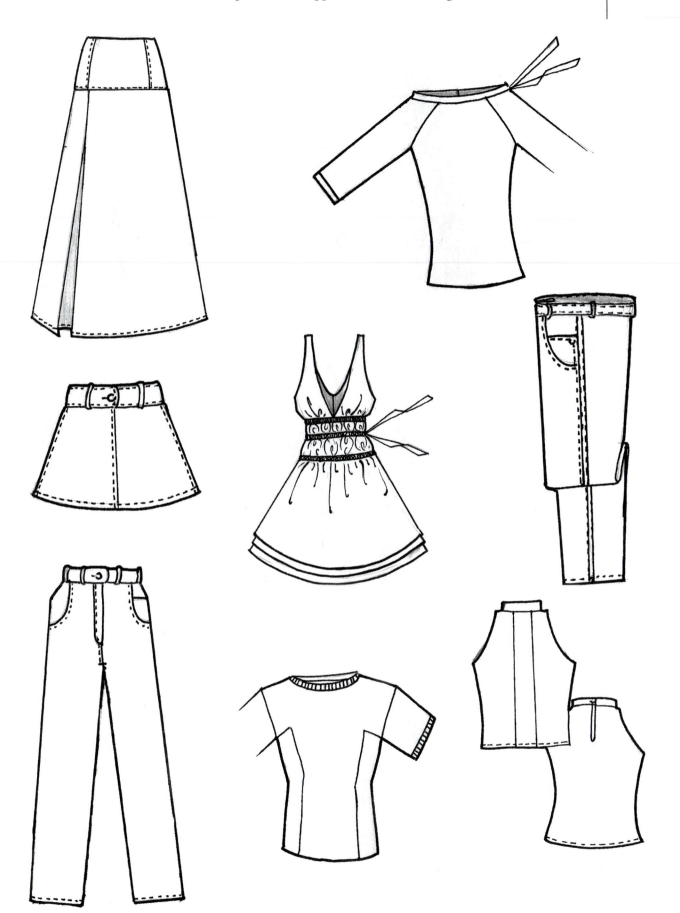

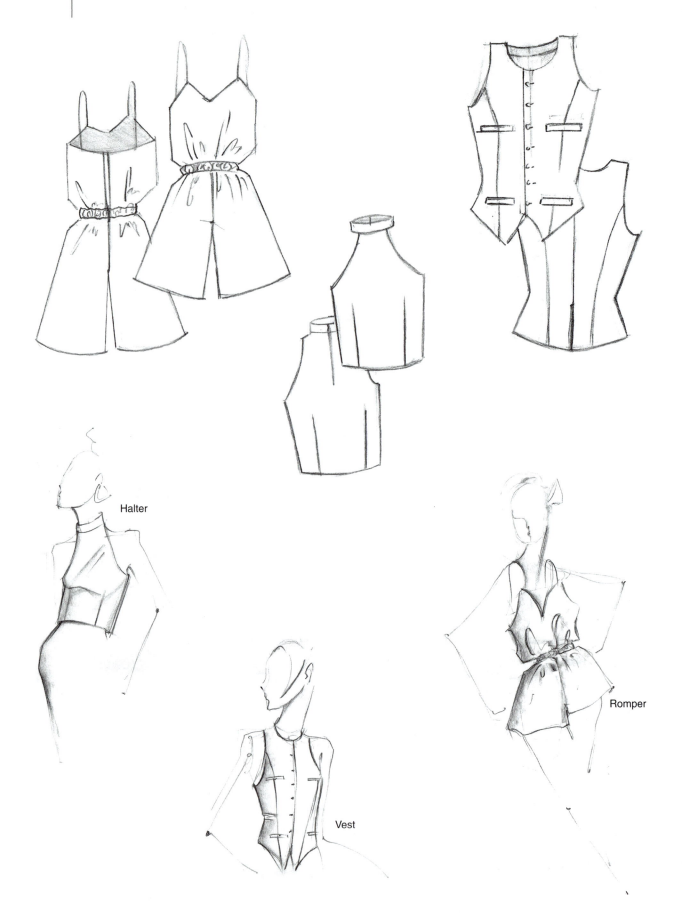

Halter

Vest

Romper

Index

315